MW00613651

movement and dance
in young children's lives

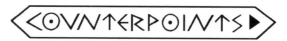

Studies in the
Postmodern Theory of Education

Shirley R. Steinberg
General Editor

Vol. 407

The Counterpoints series is part of the Peter Lang Education list.
Every volume is peer reviewed and meets
the highest quality standards for content and production.

PETER LANG
New York • Washington, D.C./Baltimore • Bern
Frankfurt • Berlin • Brussels • Vienna • Oxford

ADRIENNE N. SANSOM

*movement and dance
in young children's lives*

CROSSING THE DIVIDE

PETER LANG
New York • Washington, D.C./Baltimore • Bern
Frankfurt • Berlin • Brussels • Vienna • Oxford

Library of Congress Cataloging-in-Publication Data
Sansom, Adrienne N.
Movement and dance in young children's lives: crossing
the divide / Adrienne N. Sansom.
p. cm. — (Counterpoints: studies in the postmodern
theory of education; v. 407)
Includes bibliographical references and index.
1. Dance for children—Study and teaching. 2. Movement education. I. Title.
GV1799.S35 792.8083—dc22 2010053633
ISBN 978-1-4331-1264-5 (paperback)
ISBN 978-1-4331-1265-2 (hardcover)
ISSN 1058-1634

Bibliographic information published by **Die Deutsche Nationalbibliothek**.
Die Deutsche Nationalbibliotek lisths this publication in the "Deutsche
Nationalbibliografie"; detailed bibliographic data is available
on the Internet at http://dnb.d-nb.de/.

The paper in this book meets the guidelines for permanence and durability
of the Committee on Production Guidelines for Book Longevity
of the Council of Library Resources.

© 2011 Peter Lang Publishing, Inc., New York
29 Broadway, 18th floor, New York, NY 10006
www.peterlang.com

All rights reserved.
Reprint or reproduction, even partially, in all forms such as microfilm,
xerography, microfiche, microcard, and offset strictly prohibited.

Printed in the United States of America

For Leila, Gabriel and Sofia

Table of Contents

Acknowledgments

I am deeply indebted to all of those who have made the production of this book possible and acknowledge the many people who have influenced me through their scholarship, mentorship, and salient advice. In particular I would like to acknowledge Sue Stinson, Deb Cassidy, Svi Shapiro, Sherry Shapiro, and Shirley Steinberg for their encouragement, support, and affirmation of my beliefs and passions. As it pertains to getting this book 'off the ground' my very special gratitude must go to Leila Villaverde whose expressed confidence in my abilities and belief in my work spurred me on to make this book a concrete reality. Her insightful wisdom, unparalleled inspiration and gift of friendship will always be held in the highest esteem. I feel extremely fortunate to have been in the presence of such an inspiring person and to have the opportunity to share in the gifts she so compassionately and benevolently shared. Finally, I hope this book finds its place in the hearts and minds of all of those who believe in the wisdom and spirit of our very youngest citizens and I dedicate this book to dancing children everywhere.

Introduction

When they discovered, however, that I was serious, they asked whether it was true that in our day we had to have schools and teachers and examinations to make sure that babies learned to talk and walk.

John Dewey (1933)

In the pedagogical landscape of early childhood, movement is purported to be central to the holistic development of the young child. Yet, movement-related experiences and other bodily activities such as play and dance often present contradictions and multiple conundrums for early childhood educators. As a mode of learning, movement has endured a questionable existence despite the evidence of supportive research and theory, which provides sound reasons for the inclusion of movement in early years curricula. When movement is linked to dance and the transition between these two areas are examined, there are further provocations to consider. The intent of this book is to look at the place of movement in young children's lives and address how movement as a form of expression can become dance. Together with this examination the book will discuss the variety of concerns and confusions that accompany dance in education and interpret what this means for children, students, and teachers in teacher education programs and early childhood settings.

As one of the arts in education, dance sits precariously on the edge of educational curricula, even within the context of early childhood. Together with other bodily pursuits such as movement and play, dance often experiences a restricted or limited existence. Consequently, dance is barely visible within educational programs as well as, on occasion, completely absent. As noted by other authors, dance as a subject is often marginalized within educational institutions being seen as something that is done as extra-curricular or of limited pedagogical value, or to expend children's energy in preparation for other more serious areas of

learning (Koff, 2000; Schiller & Meiners, 2003; Wright, 2003b). From this standpoint, dance and its counterpart movement are considered as something frivolous and, therefore, not taken seriously as ways of learning.

When dance is evident in the curriculum, its use is sometimes justified as a way to learn about other things, thus devaluing the status of dance as a distinct discipline (Bond & Stinson, 2007; Stinson, 2005). Dance can also be favored when used to showcase an educational setting (Wright, 2003b) or, alternatively, used as a redemptive agent when it comes to health and exercise, especially in these times of record obesity (Stinson, 2005). Conversely, because dance is of the moment and generally only visible when actively occurring (Liu, 2008), dance can become the forgotten subject.

An array of social issues surround dance and these matters only go to ostracize dance even further (Shapiro & Shapiro, 2002b). Aspects such as eroticizing dance as a sensuous and, therefore, seductive activity (Ehrenreich, 2007) as well as the taboo of touching tends to place dance in serious jeopardy (Jones, 2003; Tobin, 2004; Sapon-Shevin, 2009). Societal views about the body thwart the presence of dance, and dance as an elitist pursuit destined for only a talented few renders dance as unattainable by the general population (Blumenfeld-Jones, 2004; Shapiro, 1998; 1999). Gendered, racial, and cultural attitudes about dance can effectively dictate who or how one should dance (Bond, 1994a; 1994b; Henry, 2001; Matos, 2008; Risner, 2007a; 2007b; 2008; Walker, 2008) and the pervasive presence of popular culture (Woodson, 2007) is also evident as a prevalent and sometimes detrimental construct of dance. Those in early childhood are not immune from these societal factors as many of these attitudes and ways of thinking often have their genesis during the early years. As a consequence, there is a never-ending stream of disadvantageous antagonisms to consider as well as, at times, resistance against dance from students and teachers, which challenges dance educators especially at the levels of university or teacher education.

The general trend for the erasure of the physical in education, especially within educational institutes in the United States (Tobin, 2004), rings alarm bells for heightened vigilance regarding the presence of the human body in learning. Threats to areas such

as physical education, limited recess, or times for play act as pertinent reminders for the need to combat the constant, yet subtle elimination of bodily pursuits in the day-to-day pedagogy of teachers and students. Dance education can provide a liminal space to encompass the performance of the endangered body, thus rendering the possibility of a renaissance of physicality in education.

Concomitantly, when viewed from the other side, or as an outsider to the mainstream educational curricula, dance can prosper by being in a position that affords less scrutiny, i.e. under the radar or panoptical eyes of the all-seeing mantra of education. Such a position affords dance the opportunity to revel in the possibility of pursuing a creative and even subversive role as a counter-narrative to narrow educational objectives or limitations of mis-education generally designated for the standardized curriculum. Sometimes being on the parameter has its own rewards, which is important to consider when staking claims for movement and dance or other creative pursuits in early childhood educational programs (McArdle, 2008).

Aligned with revolutionary views about alternative approaches dance might offer are the percepts of the new sociology of the image of the child, especially in early years education. With edges between adult-culture and child-culture blurring and merging, different pedagogical approaches are now emerging that challenges the traditional (and fairly recent) power relationships that have existed in teaching and learning environments (Fleer, Anning, & Cullen, 2009; Cannella, 2002; 2010; Dahlberg & Moss, 2005; MacNaughton, 2005; 2009; Soto, 1999; 2010). Such a revolution prompts a call for counter narratives related to teaching practices, which, in dance, challenges the dominant use of abstract language and conventional pedagogical practices (Anttila, 2003; 2007; Lindqvist, 2001).

An unveiling of the myths and misconceptions surrounding the functions of movement and dance is required, as well as shedding light on the possibilities that these ways of knowing and being can offer. Although this has been done before to a limited extent, further voices need to join the fray. This is where I lend my voice as a dance educator to unpack and reconceptualize dance (with links to movement) drawing from my experiences as an early

childhood educator and as a university lecturer teaching dance in a teacher education program for early childhood generalist teachers.

Movement and Dance in Young Children's Lives: Crossing the Divide addresses the aforementioned concerns, whilst offering alternatives. The intention of this book is to look at movement and dance education in the early years from a critical and socially conscious perspective. Incorporated in this approach are the cultural, political, and historical aspects that influence the place of movement and dance in young children's lives as seen through the lens of the author. The writing includes some autobiographical accounts of the author as a dance educator and shows how this process of autobiography uncovers particular stories, which, while personally significant, may be pertinent to others in the field of dance, arts, or early years education. These accounts may be especially relevant to those who might also be exploring the social and cultural factors that impact what they do and how they see the world. The intent is to open up those places and spaces where assumptions, fears, and misconceptions about movement and dance can be examined, analyzed, and reconceptualized, and search for the interstices to create a new vision for the role of movement and dance in education.

The book is intended for dance educators and teachers at college or university level in teacher education programs and in educational settings (both early childhood and elementary/primary sectors). The focus of the content will specifically relate, but not necessarily be confined to, the context of Aotearoa New Zealand. Other possible audiences could include interdisciplinary arts educators, and those involved in critical and cultural studies.

While other books published explore similar issues pertaining to movement and dance (for example: Ashley, 2002; Batt, 2004; Bresler, 2004a; 2007; Bresler & Thompson, 2002a; Davies, 2003; Hanna, 1999; Stinson, 1988; Shapiro, 1998; 1999; 2008a; Shapiro & Shapiro, 2002a; Wright, 2003a), there is a dearth of writing from a New Zealand perspective. Subsequently, a minimal account of dance education comes from the South Pacific area, which has a unique indigenous population. There is also very little written socially and critically about movement and dance or a pedagogy of the body from an early childhood standpoint. A particular approach this book might offer is another way to address issues pertaining to movement and dance through the lived experiences

of the author. In spite of the fact that there has been increased popularity in personal narratives or autobiographies, not much has been explored in the area of movement and dance education from this aspect.

I envision that the larger purpose for this book is to explore the idea of expressive bodily movement and by association dance as a form of liberatory education (Anttila, 2004; Shapiro, 1998; 2008b; 2009). The book also endeavors to connect the concept of liberation (emancipation) through dance to the early years of education. Even though these two ideologies may appear to be far apart, the intention here is to show how life from its very beginning can be conducive to understanding justice as a result of young children's propensity for bodily engagement and encountering dance. I maintain that it is never too soon to sow the seeds for social democracy and social justice. Such an understanding is developed through experiencing and respecting the body and, therefore, the self in multiple ways and involves how to make choices while connecting to the empathetic tendencies the young child possesses and exhibits. Movement and dance as corporeal ways of knowing can act as ways to comprehend the human condition through the specific (although not necessarily exclusive) characteristics these areas can offer, namely holistic or embodied learning.

The following chapters encompass a range of areas I view applicable to a critical discussion about movement and dance in education, particularly pertaining to the early years. It is my belief that one's lived experiences, conjoined with affective, visceral, and emotional traits in and through movement and dance can lead to fun, relationships, and an understanding of self and others. I also uphold that the opportunities to move expressively can enhance the connectors between movement and dance, which, in turn, deepens the possibility to foster creativity and imagination, while providing an artistic and aesthetic experience. Moreover, when one is fully engaged in dance holistically, complete in body, mind, and spirit, there is the possibility dance can become a way to understand difference because of the interconnected link between the physical body and being human. Dance can become a place where change can be created via the agency of the body because of a shared understanding about the body as the site for our common humanity (Shapiro, 2008b). Thus, dance can make a meaningful contribution to the world and the way we live our lives. This book

provides an entry into these possibilities for movement and dance in education, whilst critiquing claims made for movement and dance in the early years. The book also sets out to debunk specific ideologies and mythologies about dance and associated bodily pursuits.

In Chapter Two, I chronicle the trajectory of dance as education in Aotearoa New Zealand with a focus on the early years (covering early childhood and elementary/primary education) and the long-standing connection dance has had with physical education and, thus, movement. In this chapter I will also map the function of movement as it is taken up in kinesthetics, health and well-being, physical education, recess and play, and address how these areas factor into the overall function of schooling. Of particular note, the pertinent factors that contribute to my teaching in teacher education will be highlighted with consideration given to the historical overview of dance education in Aotearoa New Zealand and the implications this has for dance on the global stage.

The chapter covers the reformation of the New Zealand curriculum incorporating the development of the early childhood curriculum *Te Whāriki* (Ministry of Education, 1996). Built-in to this discussion is the significance of The Treaty of Waitangi *(Te Tiriti o Waitangi)*, and what this means for education in Aotearoa New Zealand. By association, the ideology that underpins such a reformation will also be addressed in relation to the ways changes in curriculum can either contribute to or detract from physicalized areas of learning, such as dance.

Embedded in this chapter is an examination of the broader implications of educational policy that threatens the existence of movement-related experiences in nations outside Aotearoa New Zealand. The chapter also addresses how a national reconceptualization of curricula can act as a way to argue for the reinsertion of movement and dance in other educational spaces for the betterment and well-being of students/children. Such a discussion will talk to the advancing erasure of the physical or kinesthetic in elementary education with reductions in physical education programs, time for recess and play.

Chapter Three situates what movement and dance mean in the context of education with particular attention given to the early childhood curriculum. This chapter also deals with distinguishing between movement and dance and attends to the broad and often

difficult task of defining both movement and dance for this purpose. As an extension to the function of movement in the lives of young children I also examine the question "Why dance?" pertaining to the societal, historical, political, cultural, and ideological conditions that impact dance. A component of such an examination covers the claims, fears, myths, and misnomers I find often associated with dance.

In Chapter Four I focus on the human body and things bodily in the context of movement and dance education. The contemporary discourses of the thinking body; embodied knowledge as well as the disembodied or absent body; lived experience or life-world and body image are analyzed and integrated. Chapter Four is a pivotal chapter in the book addressing the interconnections as well as interstices between the body, dance, and the human condition. Drawing from the disciplines of critical and cultural studies connections to humanity, social democracy, equity, and justice are critically scrutinized.

Borrowing from Shapiro's (1994; 1998; 1999; 2008b; 2009) salient examination of societal constructs as they relate to the body and dance, new ways of seeing the dancing body are provoked that engender a transition from object to subject embedded in somatic and personal narratives. The indiscriminate nature of labeling or categorizing, which either includes or excludes a person's right to dance, is critically spotlighted and unequivocally challenged. Territories included in this exposé are gender, age, and ability supported by research from authors such as Anttila, 2003; 2007; Bond, 1994a; 1994b; Bond & Stinson, 2001; 2007; Green, 2007; MacNaughton, 2005; Risner, 2007a; 2007b; 2008; Schiller & Meiners, 2003; Stinson, 1998; 2002; and Villaverde, 2008.

Chapter Five specifically focuses on the early years and addresses the oft mentioned but underutilized and, thereby, devalued learning modality of movement (including exploration through play). A component of the concentration on movement in the early years is the examination of the seemingly somewhat elusive connection between movement and dance. An attempt is made at crossing the divide between movement and dance to heighten awareness of the factors that contribute to transforming movement into dance (Stinson, 1991c).

Prior concerns related to the body are transferred into the context of early childhood where topics pertaining to touching,

control, and power are analyzed, interrogated, questioned, and debated (Cannella, 2002; Hanlon Johnson, 2009; Jones, 2003; Leavitt & Power, 1997; Sapon-Shevin, 2009; Tobin, 2004). Interconnections between dance and play are also highlighted in this chapter with particular reference to empowerment and access to cultural capital (Anttila, 2003; 2007; Bond & Deans, 1997; Bond & Stinson, 2001; 2007; Brooker, 2008; Cannella, 2002; Cannella & Viruru, 2004; Soto, 1999; Stinson, 1995; 2005; Wood, 2009). Discussions pertaining to movement and dance in the early years are traversed through the new sociology of childhood and the view of the young child as competent and confident (Anning, Cullen, & Fleer, 2009; Carr, 2001; Duhn, 2006; 2010; Edwards, Gandini, & Forman, 1998; Malaguzzi, 1998; May, 2009; Ministry of Education, 1996; Olsson, 2010; Rinaldi, 2006; Schubert, 2009).

Volatile, yet delicate inferences to indigenous and/or cultural knowledges are brought to the fore in Chapter Six, especially with regard to the context of Aotearoa New Zealand and the meanings they invoke for bi-cultural and multi-cultural aspirations for education. The interface between bi-cultural and multi-cultural approaches to learning as they relate to the body and dance is sensitively navigated in an attempt to gain a deeper understanding of the cultural values and beliefs regarding physical and artistic approaches to learning. There are a number of significant authors pertinent to the context of Aotearoa New Zealand whose voices are drawn on for this argument (for example: Ashley, 2009; Bolwell, 1998; Kaa, 1993; 1999; Melchior, 2009; Pere, 1994; 1995; T. Reedy, 2003; K. Reedy, 2007; Ritchie, 2001; 2008; 2010; Simon & Tuhiwai Smith, 2001). The power of personal storying as a decolonizing strategy is also discussed (O'Loughlin, 2009), particularly when associated with movement and dance during the early years.

Dance as a moving experience is encapsulated in Chapter Seven. Pinar's (1975; 1978; 1994; 2004; 2006) *currere*, as a living, breathing curriculum of humanity, acts as the interweaving thread for the transference of ideology and theory to applied practice in the educational environment. The theory of regressing, progressing, analyzing, and synthesizing, is put into practice as a way to concretize the dance experience with links to assessment pertaining to social democracy, social justice and liberation (Villaverde & Pinar, 1999). The particular relationship between

the young child's moving body and possible transference to experiencing dance is brought to life through an interpretive synopsis of young children's movement and dance drawn from relevant observations and experiences.

The concluding chapter extrapolates interpretive meaning from the aforementioned chapters to draw inferences about what might be (a proleptic vision) (Freire, 1970; 1996; 1998; Greene, 1988; 1995; Slattery, 1995; 2006) or Utopian view (Dahlberg & Moss, 2005; Dewey, 1933; Schubert, 2009) for movement and dance in the young child's life. As a process of forecasting and futuring implications for movement and dance in education are considered, including global and ecological connections, national and international communities, and educational settings. At no time am I attempting to solidify or cement a particular viewpoint; the intention is to offer possibilities for dance and other bodily approaches in education that remain fluid and flexible and continue to open up spaces for further dialogue [and debate].

The Development of Dance Education in New Zealand

History of Dance Education in New Zealand

Dance in education has had a checkered history in Aotearoa New Zealand, something that, no doubt, resembles the questionable and, thus, marginal status of dance education in other parts of the world. For many years in New Zealand, dance in schools was included within the physical education program. The predominant type of dance for most children in school, particularly in the early 1900s, was folk dance (usually of European origin), together with some form of specifically designed movement exercises developed to improve one's fitness and coordination, and physical posture (Bolwell, 2009). It was not until the 1950s–1960s that creative dance became evident in some schools where it was offered by those teachers who had an interest in dance. There were threads of dance emerging in New Zealand schools as a few individuals pursued their interest in modern and creative dance and the expressive mode of learning. These influences came primarily from England and the United States, together with some European incentives, which were slowly weaving their way to other corners of the world.

Prior Locations

Those within the educational domains who were responsible for the introduction of dance in education were located in physical education, where in the late 1940s and early 1950s perhaps the first real interest in dance as an educational pursuit began to take form (Bolwell, 2009). Following these early days of developing dance within education, a steady stream of New Zealand educators

and scholars have pursued graduate studies in dance mostly in countries overseas, (although this is now changing as graduate and postgraduate studies in dance blossom in New Zealand universities) in order to contribute to this burgeoning, yet relatively undeveloped field. Even as late as the 60s dance in schools before secondary or high school education, was still a distant dream, beyond the often half-hearted attempts at folk dancing and the occasional mandatory approaches to teaching social dance. Parallel with these approaches was the somewhat cursory treatment given to indigenous Māori cultural dance despite the groundbreaking work of Philip Ashton Smithells who introduced Māori dance into education as early as the 1940s (Bolwell, 2009).

Measures to include dance in the curriculum competed strongly, however, with other required activities within the physical education syllabus. Dance was not a major subject under the auspices of the physical education curriculum and, as a consequence, often had minimal application and, therefore, limited exposure. The predominant approach to physicality in schools existed primarily of sport-related activities, but also began to include outdoor education. Within the New Zealand psyche of nurturing the 'rugged individual' and, thus, favoring outdoor recreation, play during recess and after school sports and cultural clubs proliferated school life. New Zealand prided itself on being sports centered, especially in domains such as rugby, cricket, athletics, and water-related activities. The strong focus on physical prowess via sport, however, did not propitiously service the aesthetic and artistic bodily pursuits such as dance. Nevertheless, as dance made its presence felt, it gradually became seen as a contributing factor to other areas of learning such as music, which was evident in the introduction of teacher resource materials such as the *Music and Movement* (Department of Education, 1968) booklet, which supported other handbooks created for physical education and music in the primary (elementary) school years.

In 1987 there was yet another concerted effort to consolidate dance in education under the auspices of physical education. This was the development of the physical education document *Physical Education: A Guide for Success* (Department of Education, 1987) where dance was now significant enough to be identified alongside physical education components such as aquatics, athletics, ball

activities, fitness, gymnastics, and, eventually, *te reo kori*, which was a program developed to offer a Māori dimension to physical education (Naden, 1990; 1991). An important aspect of this new syllabus was the inclusion and, therefore, the support of Māori and other forms of cultural dance, especially those from within the South Pacific region (Hong, 2003).

It was during this development that the five key elements of dance were established in the New Zealand curriculum, namely Body Awareness, Space, Time, Energy, and Relationships. These elements were used to implement creative dance programs together with the continued exploration of movement skills as found in folk dance. The key elements of dance were drawn from the terminology Rudolf von Laban (1947) codified based on his study of the effort actions involved in human movement. Laban's effort actions were used by dance educators, initially in the United Kingdom, but followed closely by other countries such as the United States. Briefly, the four main categories that deal with the spectrum of movement the body can perform as observed and codified by Laban were Effort, Time, Weight, and Space (Ashley, 2002).

During this time of curriculum development in 1987 I was involved in developing curricular related to movement for young children in an adjunct document as part of *A Guide for Success* (Department of Education, 1987), which was designed for early childhood programs. Another document *Music Education: Early Childhood to Form Seven* (Department of Education, 1989) was also published. At that time the purpose was to solidify the coalition of movement and dance with physical education and music in the early years. The alliance between these areas was further strengthened with the production of *Music Education for Young Children: A Handbook for Early Childhood Staff and Teachers of Junior Classes* (Ministry of Education, 1993a), in which moving and dancing were signified as integral components of music.

Dance continued to assert its presence with dance in schools programs being created, particularly in association with programs of dance in education occurring in England and the United States. Dance survived in the education system under physical education but, unless the physical education teacher had an interest in dance, dance lessons were sometimes imparted more as a

movement exercise and without much expression, exuberance, or actual understanding as to the purpose of dance. These dance programs were well orchestrated to ensure that there was evidence of learning occurring. On the one hand, such programs fulfilled the principal components of the prescribed key elements of dance, but, on the other hand, began to confine dance to a particular code of movement unless the teacher had an unbridled passion for dance and was willing to enable children to experience a vast array of dance styles and, thus, have access to the multiple and variant languages of dance.

As the years progressed, dance programs of this nature became somewhat staid, restricted within a program where the emphasis was primarily on physical education rather than on the artistic or aesthetic component of dance. When kept within these confines, dance began to have little relevance to the children and their lives, or offer any in-depth understanding as to why dance exists. Dance became viewed as another way to acquire movement skills and to develop motor memory by imitating and learning set dance routines. These routines were often used as assembly items for the purpose of entertainment or showcasing. Dance as creative and artistic expression was less likely to occur, and children/students as the creators of dance were a rarity.

The contextual component of dance, its history and socio-cultural roots, including the indigenous dance forms of the Māori and peoples of the wider South Pacific Islands, were disregarded or overshadowed by Westernized Eurocentric developmental foci. This was based on what was deemed appropriate for physical education, albeit without the application of any historicity or contextualization for Western dance. Dance in schools was in need of something different. The opportunity for change arose in the impending reformation of the New Zealand curriculum.

Curriculum Reform in Aotearoa New Zealand

A reformation of the New Zealand education system commenced in the late 1980s and early 1990s with the development of *The New Zealand Curriculum Framework: Te Anga Mātauranga o Aotearoa* (Ministry of Education, 1993b). *The New Zealand Curriculum Framework* acted as a blueprint for the future direction of education in New Zealand. The reconceptualized New Zealand

curriculum was the result of some comprehensive reviews of curriculum, assessment, and educational administration in New Zealand. Because of the reviews, a new curriculum was agreed upon to address issues related to a rapidly changing society and for more equitable approaches to learning and assessment. The challenge was to create a new curriculum that provided those disadvantaged by an antiquated colonial education system inherited from the United Kingdom with a more just curriculum.

The New Zealand Curriculum Framework (Ministry of Education, 1993b) outlined new policy issues about teaching and learning, the essential skills that needed to be developed by all students, attitudes and values that would hopefully be nurtured within the school curriculum, and policies for assessment. As part of the curriculum reform, seven essential learning areas were identified: Language and Languages; Mathematics; Science; Technology; Social Sciences; The Arts; and Health and Physical Well-being. The seven learning areas were chosen as essential to a broad and balanced education for all children in New Zealand during the first ten years of schooling.

The seven learning areas provide the context for the essential skills, attitudes, and values that form the framework for the curriculum. These essential skills covered areas such as communication, literacy, numeracy, and information skills, together with problem-solving, self-management, work and study skills and physical, social, and co-operative skills. These skills are linked to attitudes and values, which formulate and reflect the society and culture of Aotearoa New Zealand. The attitudes and values correlate with Māori beliefs and values and are expressed in both Māori and English terms. For example such values include respect and tolerance (*rangimarie*) and caring and compassion (*aroha*). The New Zealand curriculum framework acknowledges that no education is value-free and that values are learned through students' experiences of the total environment, rather than through direct instruction (Ministry of Education, 1993b).

During the initial development each area resulted in a separate discipline-specific curriculum document. At this time dance emerged from beneath the mantle of physical education and became an essential learning area within The Arts in conjunction with drama, music, and the visual arts. The positioning of dance as a distinct learning area underneath the arts marked the beginning

of an opportunity to study dance as a subject in its own right (Hong-Joe, 2002). Dance was now mandated for teachers to teach as a discreet subject in the curriculum. As Hong-Joe (2002, p. 46) reiterates, dance has the possibility of being seen as a unique area of learning that encompasses "all of the traditions, purposes, practices and contexts of dance both past and present as artistic, aesthetic, and cultural education." Work on the establishment of a national curriculum *The Arts in the New Zealand Curriculum* (Ministry of Education, 2000) began in 1998 and this was followed by an extensive implementation of professional development funded by the Ministry of Education (Hong-Joe, 2002), a significant proportion of which went into the newest areas in the arts, namely dance and drama.

Since the inclusion of dance in the arts curriculum, mandating dance in schools has had variable success. Emerging from the sphere of physical education brought with it both encouraging possibilities as well as troubling outcomes. In some instances dance in schools, especially high schools, falls onto the shoulders of those teaching physical education or health and well-being, without that person necessarily having a strong knowledge base in dance or fully embracing dance as a viable subject. In primary schools dance competes for time and space in tandem with other areas of learning (including the other art forms of drama, music and visual arts), especially against prioritized areas such as literacy and numeracy. As a result, dance, despite a focus on the arts as a form of literacy (Hong, 2003; Thwaites, 2008) in the new arts curriculum, often becomes relegated to an integrated approach to learning, or used as a way to teach other subjects, rather than focusing on dance as a body of knowledge in and of itself.

An example illustrating such a factor can be found in a recent study of teacher attitudes with regard to incorporating dance in the curriculum (Ashley, 2009). It was found that teachers focused on the 'doing' of dance in conjunction with other subject areas and tended to negate the socio-cultural context of dance, which was a pertinent factor for the inclusion of the arts in education, as well as the reformulation of curriculum in general. The forbearance of other curricular pressures presents a constant threat to the status of dance in schools, which continues to require not only a precautious commitment to the stability of dance in schools, but

also a concerted effort to ensure dance education thrives and delivers the promise so valiantly offered in the new conceptualization of dance in the arts curriculum. Continued professional development in the area of dance education is still needed, but is often sadly lacking.

From an opposite point of view, the strides made in New Zealand regarding the inclusion of dance in all schools and recent success in achieving scholarship for dance in secondary schools offer promise to other nations outside Aotearoa New Zealand where there is evidence of educational policy that threatens the existence of movement-related experiences (something I return to in later chapters concerning the place of the human body in education). An available and workable model of a national re-conceptualization of curricula can act as a way to argue for the reinsertion of movement and dance in other educational spaces for the betterment and well-being of students/children.

More recently, the seven identified learning areas have converged into one document, namely *The New Zealand Curriculum* (Ministry of Education, 2007) and become eight identified areas of learning: English; The Arts; Health and Physical Education; Learning Languages; Mathematics and Statistics; Science; Social Sciences; and Technology. *The Arts in the New Zealand Curriculum* (Ministry of Education, 2000) and *The New Zealand Curriculum* (Ministry of Education, 2007) were written for the compulsory sector of schooling in both primary (elementary) and secondary (high school) education. Whether or not the conflation of all curriculum areas into one document increases the chances for the inclusion of dance in schools on a regular basis, is yet to be seen. Further changes took place in the 2007 edition of the New Zealand curriculum; namely the addition of five identified key competencies: thinking; using language, symbols, and texts; managing self; relating to others; participating and contributing. These competencies correlate with the strands found in the early childhood curriculum *Te Whāriki* (Ministry of Education, 1996), which is worth noting because of its pertinence to the area I teach in and will be focusing on in the following paragraphs, namely early years education.

The Early Childhood Curriculum

In juxtaposition with the re-development of curriculum for schools was the restructuring of non-compulsory early childhood programs for children before five years of age (May, 2009). Akin to the establishment of a blueprint that informed the shaping of the New Zealand curriculum for both primary and secondary education, the recommendations of an early childhood working group in a report *Before Five* (Lange, 1988) were used to guide new initiatives in early childhood education. *Before Five* set the scene for change within the early childhood sector incorporating, among many things, a focus on The Treaty of Waitangi, and upgrading early childhood teacher education qualifications to a three-year diploma as the benchmark requirement for trained personnel in early childhood settings (May, 2009). A new curriculum encapsulating the recommendations was eventually realized in the form of *Te Whāriki: He Whāriki Mātauranga mō ngā Mokopuna o Aotearoa: Early Childhood Curriculum* (Ministry of Education, 1996).

The early childhood curriculum *Te Whāriki* holds a unique place in the field of education within Aotearoa New Zealand being the first codified curriculum sanctioned by the government to evolve from bi-cultural values and beliefs. At the center of the curriculum is the child. The curriculum is founded upon the aspirations for children "to grow up as competent and confident learners and communicators, healthy in mind, body and spirit, secure in their sense of belonging and in the knowledge that they make a valued contribution to society" (Ministry of Education, 1996, p. 9).

As with the reformulation of the New Zealand curriculum for schools, *Te Whāriki* grew out of a need to address the diverse and changing face of early childhood education in Aotearoa New Zealand and was driven by initiatives from early childhood personnel. As stated earlier, a significant component underpinning the curriculum was a commitment to The Treaty of Waitangi (*Te Tiriti o Waitangi*) and, thus, bi-cultural aspirations. As such, the curriculum became the first bi-cultural curriculum document developed in New Zealand.

Te Tiriti o Waitangi is an important part of Aotearoa New Zealand's history because it was a contract between the indigenous Māori population and the British Crown signed off in 1840 between Captain James Cook and gathered Māori chiefs. In return for New Zealand sovereignty the Treaty guaranteed certain rights

for Māori (Richardson et al., 2005). Determined by New Zealand's commitment to creating an Aotearoa New Zealand in which Māori and Pākehā (white colonial settlers) recognize each other as full Treaty partners, educational curricula in New Zealand acknowledge the principles of the Treaty of Waitangi and the bicultural foundations of Aotearoa New Zealand. It is the right of all students to have the opportunity to acquire knowledge of *te reo Māori, me ōna tikanga* (Māori language, protocols and customs) as part of their education (Ministry of Education, 2007).

An aspect of the Treaty that has one of the most important repercussions for education is the concept of *tino rangatiratanga*, which Ritchie (2010, p. 360) defines as "absolute right of self-determination" because it places responsibility on all people to honor the indigenous viewpoint in matters pertaining to governmentality. *Rangatiratanga*, or empowerment (as it can also be interpreted) is an important concept for Māori, as emphasized by Reedy (2003, p. 51) with the saying "Toku rangatiratanga na te mana-mātauranga; knowledge and power set me free."

Consequently, New Zealand's early childhood curriculum is heralded as an empowering curriculum where children are seen as capable citizens (and participators) rich in knowledge and experience. Young children are seen as agents of their own learning, whilst being acknowledged as part of families and the wider community (Ministry of Education, 1996). The curriculum focuses on the critical role of socio-cultural learning and stresses the importance of reciprocal and responsive relationships for children with people, places, and things. As echoed by Reedy (2003, p. 74); "*Te Whāriki* has a theoretical framework that is appropriate for all; common yet individual; for everyone, yet only for one; a whāriki woven by loving hands that can cross cultures with respect, that can weave people and nation together."

The title *Te Whāriki* metaphorically represents a mat for all to stand on, where individuals and early childhood centers can develop their own curriculum through weaving and interweaving "talk, reflection, planning, evaluation and assessment" (May, 2009, p. 245). Just as in the weaving of fabric there is the possibility of many patterns serving the interests of children, the cultural, structural, or philosophical context of the early childhood service, and the interests of parents, staff, and community. As May (2009) stresses, there was a decidedly different shift away from

Westernized curriculum models in the conceptualization of *Te Whāriki*. Although homage is still paid to the educational theories of Piaget and Erikson learning through play, the socio-cultural theories of Vygotsky and Bronfenbrenner became emphasized together with Bruner's focus relating to the role of the teacher and constructivist theories of learning (Conway, 2007).

Ultimately, the teacher's role "was to 'scaffold' children towards more complex thinking and increasing competency" (May, 2009, p. 246). Carr (2001) adds further to the concept of scaffolding, which she sees as enhancing the learning dispositions of young children through responsive and reciprocal relationships. Carr views children creditably where they are seen as "being ready, willing and able to participate in various ways" (p. 21). Such a belief occasioned the development of assessment strategies in early childhood settings that revoked prior approaches of addressing observational deficits, as well as preparing children for school. Whilst surveillance is still evident, it is conducted from a positive constructive pedagogical viewpoint to ensure that all early childhood settings are safe and secure places in which children learn, socialize, and play (Carr, 2001).

What is perhaps even more pertinent to *Te Whāriki* is the politicized function it plays in the rights of children in Aotearoa, especially pertaining to their uniqueness and ethnicity, including indigenous rights and knowledges (Ritchie, 2001). *Te Whāriki* is seen as a way to achieve self-determination for both Māori and other ethnicities in Aotearoa New Zealand. As a Māori woman, Reedy pronounces; "Our rights are recognized and so are the rights of everyone else ... *Te Whāriki* recognizes my right to choose, and your right to choose too" (May, 2009, p. 246).

The curriculum is structured on "a framework for action guided by philosophical principles" (Te One, 2003, p. 32). It was decided that the curriculum was not to be content driven, but a document that was underpinned by goals based on beliefs about the well-being of children. The four principles are empowerment (*whakamana*), holistic development (*kotahitanga*), family and community (*whānau tangata*), and relationships (*ngā hononga*) (Ministry of Education, 1996). These are interwoven (like the weft and warp of a mat) with the strands of well-being (*mana atua*), belonging (*mana whenua*), contribution (*mana tangata*), communication (*mana reo*), and exploration (*mana aotūroa*).

It is clear that the strands of *Te Whāriki* can be aligned with the key competencies outlined in *The New Zealand Curriculum* (Ministry of Education, 2007). Contiguous to well-being is the key competency 'managing self' where students are seen as self-motivated and capable learners. Belonging equates to 'participating and contributing' where students make connections with others, and create opportunities for others in the group; students who participate and contribute in communities develop a sense of belonging. Contribution correlates with 'relating to others' where students learn when it is appropriate to co-operate, contribute, and work effectively together. Communication is clearly connected to 'using language, symbols, and texts' where students have access to appropriate information to communicate with others. Exploration links to 'thinking' where students "actively seek, use, and create knowledge ... intellectual curiosity is at the heart of this competency" (Ministry of Education, 2007, p. 12).

Adjacent to the strands and goals of *Te Whāriki* are examples of how these learning outcomes might be met using a variety of learning experiences for infants, toddlers, and young children. What is apparent from these examples is the provocative or guiding nature of the suggestions, as opposed to directive instructions. These exemplars provide room for maneuver whilst, at the same time, could be seen as broad possibilities. As with any new initiative, however, the broader ideology that underpinned the genesis of *Te Whāriki*, especially as a holistic, empowering, and interpretive curriculum, was not always readily embraced by all.

At the time of launching *Te Whāriki* in 1996–1997 early childhood educators were less prepared for this type of new initiative and there was a need to provide professional development, including the upgrading of early childhood teacher qualifications (May, 2009). There is no doubt that the principles of *Te Whāriki* still present challenges and raise implications for the professional knowledge base of early childhood educators (Cullen, 2003).

In parallel reconceptualizations of early childhood curriculum in countries such as Australia, the United States, and the United Kingdom there were similar innovations being made toward developing curricula that reflected the changing face of society and acknowledged the whole child. As described by Anning (2009, p.

68): "During the 1980s and 1990s preschool educationalists in the UK were battling to preserve a broader view of the learning needs of the child with attention not only to the mind but to the body and emotions of children." It is generally accepted that male-dominated approaches to learning, where there was a focus on the mind, underpinned policy for early childhood services in countries such as Australia, the United States, and the United Kingdom, despite the widespread awareness that women have traditionally dominated the field of early childhood education.

Programs such as 'HeadStart' in the United States, albeit established for specific reasons and populations, and the aim of nursery education in the United Kingdom as defined by Education and Employment (DfEE): "that all children should begin school with a head start in literacy, numeracy and behaviour, ready to learn and make the most of primary education" (Anning, 2009, p. 68) clearly indicate an androcentric or rational approach to learning that negates the body and associated feelings. The purpose was to prepare for schooling and what schools favored as educational priorities.

Just as in Australia, the United States, and the United Kingdom, developmental psychology was the most influential paradigm for early childhood education in New Zealand. As attested to by Anning (2009, p. 68): "In the discourse of practitioners the concept of 'developmental stages' was never far below the surface." As referred to earlier in the developing of *Te Whāriki,* names of theorists such as Piaget guided much of the work of early childhood practitioners based on what was considered appropriate developmental stages for young children's learning. A more holistic view of young children was needed in designing programs for early childhood education that gave credence to not only the mind, but also the body and emotions. In other words, there was a call for an embodied or holistic form of learning, which took into account experiential learning and sensory-based activities. As a tactic for teaching and learning in the early years an experiential and visceral engagement was far preferred to disembedded [disembodied] pre-prescribed 'school-knowledge' dominating the early childhood curriculum (Anning, 2009).

This was the promise *Te Whāriki* offered and although further professional development is still needed to achieve the potentiality

forecasted, *Te Whāriki* played a significant role in promoting critical reflection based on the principles that challenged "teachers to examine their own practices" (Cullen, 2003, p. 270). As a consequence a new era was forged in changing the prior perceptions of early childhood education being simply seen as preparing children for school. Because the New Zealand early childhood curriculum is distinct with its own specific values, rather than being prescriptively constructed around subject areas, it offers a more rounded as well as principled approach to learning.

In alliance with the ideology that underscores the New Zealand early childhood curriculum *Te Whāriki,* the Reggio Emilia approach, which caters for children aged 3–6 in Northern Italy, also comes from an informed base of principles, where, in a similar way to *Te Whāriki*, learning arises from multiple sources. The curriculum, as described by Rinaldi (1998, p. 119), "is at once defined and undefined, structured and unstructured, based more on flexible strategies than rigid plans." Collaboration with community is also promoted with invited involvement of parents. Similarly, parental and family involvement is strongly encouraged in the New Zealand early childhood curriculum; something that resonates with indigenous ways of knowing and being or *whanau tangata.*

Despite the promising direction *Te Whāriki* offers, resistances still remain. Changing practices evolving from developmental traditions and overt teacher control have not always been willingly forthcoming and the underlying principles and goals based on Māori values have had a variable and somewhat limited understanding and, thus, application. The interpretive nature of *Te Whāriki* makes it vulnerable to critique. Empowerment, as one of the founding tenets of *Te Whāriki*, can sometimes be perceived of as a commodity as if it were something to give, rather than something which is constituted in relationships (Dahlberg & Moss, 2005).

Concomitantly, however, *Te Whāriki* opens up liminal spaces for new meaning to be created through reciprocal and dialogic encounters. Just as the New Zealand early childhood curriculum challenges the early childhood education sector with its complex and innovative curriculum practices, so, too, is the acceptance of movement and play as prominent modalities of learning. As promulgated by Blenkin & Kelly (1994) cognitive development

cannot be separated from physical, social, and emotional development and the interactive facets of movement and play are essential in fostering such development. Through the conduits of movement and play inextricable links can be made to the teaching and learning of dance within early childhood settings.

As saliently reminded by Cullen (2009, p. 80), "*Te Whāriki* has been acknowledged internationally for its strong focus on children and their learning ... and reflects the notion of 'the rich child' that has been promoted by the highly acclaimed Reggio Emilia early childhood institutions in Italy." From this viewpoint, the interests of young children guide many of the pedagogical interactions that take place, whilst equally contributing to a possible negation of curriculum areas such as dance because they are neither mandated nor noticed.

There is a fine balance between teacher-set and controlled dance sessions, or non-interventionist approaches to dance, and child-initiated dance, which is recognized, responded to, and sustained by a wise and reciprocal adult. Such encounters fulfill the ideology of partnership and the sharing of power, which is the essence of *Te Whāriki*. Alternatively, these potential moments for dance may fall below the radar of adult acknowledgment, and, because dance, among other areas of learning, is not specifically prescribed, it can become an area that fails to be realized. As a consequence, the socio-cultural world of the young child becomes a little poorer, which is something that requires concerted vigilance.

Conversely, if the principles and beliefs that underpin *Te Whāriki* are upheld, and the vision of the child is one that encompasses a capable and affirming image, dance should exist together with all other areas of learning. In other words, an empowering curriculum that offers choice based on children's interests will enable children to select from a wide range of learning experiences. The responsive and reciprocal nature of adults' interactions in recognition and acknowledgment of the children's interests ensures that children become agents in directing their own learning. Therefore, recognizing that dance could be one of those interests would be a significant factor in an empowering and holistic curriculum. Recognition is dependent on knowledge. Consequently, knowing about dance; what it is and why, is crucial.

What Is Dance and Why Dance?

Movement in the Early Years

A strong component of early childhood education in Aotearoa New Zealand is the focus on creating stimulating learning environments that encourage play and exploration, much of which occurs outside. Such a focal point places a clear emphasis on movement, which is evident in the children's physical participation especially in the outdoor environment. A variety of manipulative items set in outdoor spaces, together with climbing equipment, as well as sand and water play together with natural resources, invite children's physical participation. Because prominence is placed on an integrated and holistic curriculum, the teaching and learning arises from observations and assessment of the interests of the child rather than from separate subjects and skills, and, as such, caters for the whole child. Play is the underpinning principle for learning where movement is a critical element as children learn to move and move to learn through play (Stinson, 1990a).

Located in the bounds of the New Zealand early childhood curriculum *Te Whāriki* (Ministry of Education, 1996), movement and play become embedded among a myriad of experiences, which occur in the early childhood environment. As outlined in the following exemplar under the strand of exploration (*mana aotūroa*):

> The child learns through active exploration of the environment. Children experience an environment where their play is valued as meaningful learning and the importance of spontaneous play is recognized; they gain confidence in and control of their bodies; they learn strategies for active exploration, thinking and reasoning; they develop working theories of making sense of the natural, social, physical, and material worlds. (Curtis & Carter, 2008, p. 225)

Other examples of involvement related to playing and being actively engaged can be found in the strand of well-being where "children develop an increasing ability to determine their own actions and make their own choices" or "a growing capacity to tolerate and enjoy a moderate degree of change, surprises, uncertainty, and puzzling events" (Ministry of Education, 1996, p. 50). On some occasions there are more specific correlations made to play and multi-modal styles of learning such as in the strand of contribution, where children develop "abilities and interests in a range of domains—spatial, visual, linguistic, physical, musical, logical or mathematical" (Ministry of Education, 1996, p. 68) or an "increasing confidence and a repertoire for symbolic, pretend, or dramatic play" (Ministry of Education, 1996, p. 84) under the strand of exploration.

The most obvious link to movement in the curriculum is also located in the strand of exploration where it is stated that "children develop locomotor skills, non-locomotor skills, manipulative skills and increasing agility, co-ordination, and balance" as well as "confidence with moving in space, moving to rhythm, and playing near and with others" (Ministry of Education, 1996, p. 86). References to playful and expressive approaches to learning and thus, the component of creativity can also be sourced under exploration with the learning outcome "children develop the knowledge that playing with ideas and materials, with no objective in mind, can be an enjoyable, creative, and valid approach to learning" (Ministry of Education, 1996, p. 84).

Dance: What Is It?

The questions "What is dance?" and "Why dance?" are often found in texts and articles about dance (for example: Blumenfeld-Jones, 2004; Hanna, 1999; Schiller & Meiners, 2003; Shapiro, 1998; 1999; 2008a; Stinson, 1988; 1990b; 1991c; 1998; 2002; 2005). As an early years dance educator concentrating on pre-service early childhood teaching and learning within a university teacher education program, these are two questions I often ask the student teachers in my classes. The responses include a myriad of viewpoints but generally incorporate the words 'movement to music' and 'fun'. In response to the suggestion that dance is 'movement' I hasten to add that whilst dance definitely involves movement, not all

movement is dance (Stinson, 1988). Consequently, I find this is an aspect of teaching dance that requires some unpacking. In addition, having fun or feeling good when dancing can be seen to detract from dance as a serious and well-regarded area of learning, which could place dance in even further jeopardy within education. Alternatively, fun can be a motivating factor to either inspire further participation in dance or offer a reason why dance is important as a way of connecting to humanity and the world. Despite these admirable aspirations for dance, I am astutely aware of the many and often troubling issues that surround dance education together with the sometimes negative perceptions students have about dance.

For much of my career I continually told myself how fortunate I was to be teaching in an area that felt enjoyable and a little different from other areas of learning. While doing so I was disassociating from the rather derogatory views surrounding the subject of dance. Upon reflection, nevertheless, I remember that there were many occasions when I encountered (or was reminded of) the dubious, as well as relatively fragile and marginal status dance was seen to have as a subject within educational environments including university settings.

I frequently felt that I had to stand up for dance, or explain to those in academia who ask me, "What kind of dance do you teach?" that dance education is actually something quite different from what people generally presume dance to be. Explaining what I do as a person who is responsible for teaching dance in teacher education often becomes complicated because there are few who have experienced dance education as part of their own schooling. If anything, most people see dance as an after-school or extra-curricular activity usually covering a specific style or genre of dance for either recreational or competitive purposes. The educational or even cultural component of dance is quite often disassociated with the reasons why we dance. Thus, trying to define dance is often a thorny topic.

Defining Dance

Within the field of dance education there have been several labels used to describe the type of dance being taught. These labels include free dance, creative movement and dance, modern

educational dance, movement education, dance movement, and music and movement (Barlin & Barlin, 1971; Barlin, 1979; Benzwie, 1987; Bolwell, Cossey, & Oliver, 1998; Boorman, 1969; Brehm & McNett, 2007; Farley, 1969; Green Gilbert, 1992; Griss, 1998; Harrison, 1990; Joyce, 1980; Krogh, 1990; Nicholson & Shipstead, 1994; Russell, 1975; Stinson, 1988; Weikart, 2004).

The question what is dance can be found in many different texts. Dissanayake (1992, p. 120) describes the nature of dance itself in the following way:

> Intrinsic to one's actual "being-in-the-world" is the fact of one's material body ... Of all of the arts, dance—whose instrument is the body—in particular manifests and celebrates our physical, corporeal reality.

Having said this, however, there is the question as to what makes dance different from the other forms of movement we, as humans, perform or express? Just as in other art forms, dance, too, is said to be expressive of how we feel about things. However, this often gives the impression that dance, or the movement of the body instigated by the stirring of emotions is somewhat an abandonment of control, or a letting loose. These movements of the body, although being expressive of how we feel, may not necessarily be dance. As Hong (2003, p. 148) elucidates:

> Dance as a medium of expression is not to be regarded as subjective self-expression but rather as objectively created expression. Expression in dance is not self-expression in the sense of indulging oneself in expressing emotions or feelings through movement. Self-expression in dance is artistically rendered recall that is given shape and form, and intentionally communicated to others.

> Such expression involves the purposeful manipulation of dance vocabulary, conventions and practices. Through this agency dance becomes a means of communication.

This statement links well with Stinson's (1988, p. 2) description of dance when she states that "dance is about—making movement *itself* significant" through an awareness of movement made possible by the kinesthetic sense. This "does not mean dance is always 'expressing your feelings,' but it is more than just exercise with physical awareness" (Stinson, 1988, p. 3). Stinson (1988, p. 2) refers to the kind of dance which is most suited to pre-schoolers "as *creative dance* or *creative movement*." Stinson (1988, p. 11) goes on

to say that "movement is the raw material out of which dance is made."

Another definition of dance proffered by Stinson (2002, p. 157) "is rhythmic movement, usually done to music." Stinson (2002), nevertheless, considers dance is more than rhythmic movement when she suggests that "dance is not what we do, but how we do it. It is a state of consciousness involving full engagement and awareness, attending to the inside" (p. 158). An aspect of this definition involves not only the body, but also the spirit and the mind, together with a deeper sensory or kinesthetic awareness of what movement feels like on the inside in order to transform everyday movement into dance (Stinson, 1988; 1991c; 2002). Stinson (1991c) equates the transformation of movement into dance to transcendence where there is total involvement and an experience of deep connection akin to the aesthetic.

We are all involved in a multitude of everyday movements such as walking, stretching, bending, and lifting, which are executed to service our daily needs. However, these movements are not dance because they are generally unconnected or fragmented. When it comes to dance, these ordinary everyday movements of the body are redefined and shaped through intentional patterning, which are enhanced, embellished, repeated, and coordinated with other movements in a cohesive assemble through using our kinesthetic sense (Stinson, 1991c). As Stinson (1991c, p. 135) expounds; "our kinesthetic awareness can help us find that kind of involvement in movement, because the *body* and *spirit* are not completely separate; they meet in that special place inside each of us" and collectively transform movement into dance.

The approach is intentional, where one learns to pay attention to each movement the body makes. This links to the perspectives presented by Stinson of what is seen as art, or artistic, when associated with dance. Stinson (1995, p. 43) refers to the common perception people apply when they think about the arts as forms of representation and "as something external, the product that results from the artistic process." However, Stinson continues to say:

> Artistic form is not only external but also internal. For example, when I teach children the concept of *shape* in dance, I tell them that most people think about shape as what something looks like on the outside—like a square or a circle. Dancers, however, know that *shape* is not only about

what something looks like on the outside, but what it feels like on the inside. We make shapes on the outside by what we do with our bones and muscles on the inside; internal forming creates the external form. It is this internal sensing of oneself in stillness and in motion that turns what would otherwise be standing or sitting, walking or running, into *dancing*.

This internal sensing has great significance not only for how one performs dance but for how we perceive the art. If we think about dance as an artistic object only to be looked at, it becomes little more than a moving picture. Certainly an audience does look at dance (and, if there is music, listen to it), but the visual and auditory senses return only a surface view. In order to understand dance, one must also use the kinesthetic sense. The kinesthetic sense allows us to go inside the dance, to feel ourselves as participants in it, not just as onlookers. (Stinson, 1995, p. 43)

Dance, therefore, is not just a particular physical language which is only seen on the outside as conveyed by the external body. Dance is something that also has its naissance from deep within, and is felt, as well as thought about, in and through the body.

Dance educator Purcell (1994) queries how one knows they are teaching dance and not just creative movement. Purcell differentiates between the terms 'dance' and 'creative movement'. Nonetheless, the names given to dance, which can be included in the school curriculum, do include both creative dance and creative movement. Purcell does postulate that dance is different from other movement taught in physical education programs. She sees the distinction between functional movement, i.e. learning to perform a specific skill, and the "innate need to express thoughts, feelings and ideas through movement" (Purcell, 1994, p. 4), which is regarded as dance. The skill movements, however, can be used in dance, but for a different purpose; to express an idea or emotion. Dance is a place where, in a sense, human beings become their own creations (Purcell, 1994). In a more recent article Purcell reflects on how children create dance and examines her own beliefs about pedagogical approaches to dance, where the teacher follows, rather than leads (Purcell Cone, 2009). As a consequence, the transition from movement into dance was entrusted to the children or dancers to render forth the creative and kinesthetic impulses to guide the dance-making process. As an example of an aesthetic experience the externalization of inner visions is manifested outwardly through the art form.

Benzwie is another author who talks about dance in education. Using the term 'creative movement', Benzwie (1987) states that "creative movement as a modality helps us gain knowledge through the body and grasp the essence of learning from within, connecting to ourselves in the deepest, most direct ways" (p. vi). Green Gilbert reiterates these viewpoints when discussing the meaning of creative dance. Green Gilbert (1992, p. 3) affirms; "creative dance combines the mastery of movement with the artistry of expression. It is this combination, rather than a separation of the two, that makes creative dance so powerful."

Koff (2000) offers a useful definition of dance in education, where she discriminates between dance training and dance education. In Koff's view, the main purpose of dance education, as opposed to dance training, is not as preparation for performance. As illuminated by Koff (2000, p. 27) dance training tends to indicate the learning of technicalities "with the aim of mastery and future performance." Alternatively, dance education can be seen as something that "seeks the development of self-expression and interpretation through motion, with self-knowledge as its aim." The basic elements of dance, such as time, space and energy provide the foundations of both dance education and dance training. The intention in dance education, nevertheless, is to continue to explore the creation of dance, which is derived from the learner/student in relation to self, others and the environment (Koff, 2000). In dance education there are no specified styles or codified forms of dance, except for those genres that are part of the learned or acquired integrated expression of the student.

For children, and especially the young child, movement is a fundamental form of expression (Koff, 2000). Koff believes that children learn to use this non-verbal expression to communicate how they feel and think. This ability to create and use movement evolves over time as the child learns the rudimentary language of dance through play and physical exploration. As noted by Hanlon Johnson (2009) the idea of harnessing the moving body in areas such as dance, especially in the early years, is not new. Hanlon Johnson emphasizes, "John Dewey, Rudolf Steiner and Maria Montessori are among the strong voices that have advocated a more intense focus on body movement, project learning, dance, art and music in the early years." Early childhood educators need to be

cognizant of how to better serve "the yearning and mobile students in their early grades" (Hanlon Johnson, 2009, p. 167).

Multiple Intelligences: A Cautionary Note

As one of the multiple intelligences proposed by Howard Gardner (1993; 1999) a feature that can be attributed to the nature of learning in and through dance is the concept of kinesthetic intelligence. However, as cautioned by Blumenfeld-Jones (2004) it is important to understand the problematic nature of providing an ideal or iconic referent by which to measure kinesthetic intelligence. For instance, by using, as an exemplar, the well-known name of the dancer and choreographer Martha Graham as a model for kinesthetic intelligence, Gardner has espoused primarily a Eurocentric view and also one of elitism and exclusiveness.

Blumenfeld-Jones (2004, p. 120) declares that the purpose of education is to focus "upon an holistic understanding of human beings and a concomitant education that would enable a flourishing of the many capacities which cultures, the world over and throughout history, have shown to be part of the human condition." It would be imperative, therefore, that everyone have the capacity or potential to learn in different or multiple ways and for that reason, have access to multivariate approaches.

While being appreciative of Gardner's work, as many tend to be in the dance world, Blumenfeld-Jones makes it clear that he has some difficulty with the way Gardner discusses or describes bodily-kinesthetic intelligence. If we hold to the idea posited by Gardner that one shows certain acuity for a kinesthetic approach to learning, we may be denying many who have not yet been identified as having this capacity.

Blumenfeld-Jones (2004) argues that the type of kinesthetic intelligence that is associated with Gardner's perspective has far more to do with being spectacular or outstanding when it comes to performing physical activities. However, the author continues to point out that it is not so much the spectacular nature of performing movement that indicates a kinesthetic intelligence, but rather an awareness or a knowing "in a thorough way, what you are doing with your body" (p. 122).

In addition, the description provided by Blumenfeld-Jones of what makes something dance links well with prior descriptions of dance. Blumenfeld-Jones asks:

> What is dance movement? All dance movement is based on ordinary, everyday movement. No matter how strange the dance movement may appear, it can never exceed either the natural capacities of the human body nor escape its ordinary origins. (2004, p. 123)

Further on, the author suggests that in this way dance is "no different from a casual stroll down the street" (Blumenfeld-Jones, 2004, p. 123). Then he asks:

> What transforms the stroll into dance? It is nothing else than the primary component of bodily-kinesthetic intelligence: attending to one's movement. But, in fact, more than simply attending to one's movement (casually strolling down the street, swinging one's arms), it is paying attention to all the connections between identifiable movements (steps and arm swing). (Blumenfeld-Jones, 2004, p. 123)

Blumenfeld-Jones refers to the idea that it is not about how spectacular or refined we might be with our movement, or where some people are considered to have a high level of kinesthetic intelligence and others are not. It is more about being viewed on a continuum of what is potentially likely. From this perspective, intelligence associated with dance "becomes more possible as well as more relevant" (Blumenfeld-Jones, 2004, p. 123) for many people and not for just a few. As the author points out, this view has a greater potential to become embraced by education when we know we can teach people this particular way of knowing (bodily-kinesthetic) where most people can, at least, have the chance to come to understand or know themselves bodily.

The "education for bodily-kinesthetic intelligence requires departing from taken-for-granted paths" (Blumenfeld-Jones, 2004, p. 130) so that it can be made accessible, and this particularly applies to dance education. Thus, as many of the above authors attest, we all have the potential to dance through having access to opportunities for dance. By paying attention to and understanding the movement or motion being performed when we dance our awareness of what makes movement dance is heightened. The skills learned in and through movement and dance can also be

transferred into other areas of learning whilst remembering to acknowledge dance as a way of learning in its own right.

Why Dance?

The reasons why we dance come in many forms and serve multiple purposes. Children can become exposed to dance in a variety of ways. A young child's entry into dance and subsequent involvement, nevertheless, would probably be because he or she found it a suitable medium to be expressive. Although young children learn dance from others, the creation of their own dance arises from the body, which is imbued with all the richness of their personal lived experience (Shapiro, 2008b; Stinson, 2002) and, is, therefore, an expression of their own lives.

Schiller & Meiners (2003, p. 91) identify that the purposes of dance are seen as an "important means of expressing inner feelings, experiences and cultural identity." From a holistic perspective dance

> satisfies the integrated physical, mental and emotional needs of body and mind. Dance passes on and celebrates traditions, values and beliefs. It creates new ways of perceiving and understanding oneself, other men and women, communities, society, cultures and the world. (Schiller & Meiners, 2003, p. 91)

These expressions about the purpose of dance align with descriptions of the arts found in the New Zealand curriculum where it is stated:

> The arts are powerful forms of personal, social, and cultural expression. They are unique "ways of knowing" that enable individuals and groups to create ideas and images that reflect, communicate, and change their views of the world. The arts stimulate imagination, thinking, and understanding. They challenge our perceptions, uplift and entertain us, and enrich our emotional and spiritual lives. As expressions of culture, the arts pass on and renew our heritage and traditions and help shape our sense of identity. (Ministry of Education, 2000, p. 9)

When referring to dance explicitly, dance is described as "expressive movement with intent, purpose and form ... All dance communication is transmitted through movement and mediated through the body and gestures of the dancer" (Ministry of Education 2000, p. 18). Additionally, dance is seen "as a vital and

integral part of human life" existing in many forms, in all cultures, and a range of contexts and

> is a significant way of knowing, with a distinctive body of knowledge to be experienced, investigated, valued, and shared. Students become increasingly literate in dance as they engage in practical and theoretical investigations and explore dance forms, develop dance ideas, and articulate artistic and aesthetic understandings about dance works in various contexts. (Ministry of Education, 2000, p. 19)

Furthermore, the statement related to dance proceeds to explain or define what learning in, through, and about dance means. The statement continues:

> Students learn *in* dance as they use its vocabularies and practices to interpret, communicate with, and respond to the world in their own ways. In learning *about* dance, students investigate the forms, purposes, and significance of dance in past and present times. Learning *through* dance enables them to appreciate that dance is a holistic experience that links the mind, body, and emotions. (Ministry of Education, 2000, p. 19)

Ways of knowing, or the educational value of dance, is expanded further when it is claimed "education in dance promotes personal and social well-being ... and aims to foster [student's] enthusiasm as participants, creators, viewers, and critical inquirers and to develop their lifelong interest in and appreciation of dance" (Ministry of Education, 2000, p. 19). An intention of dance in the New Zealand curriculum is to provide another form of discourse or literacy (Hong-Joe, 2002) to not only advance the notion of dance as a valuable tool of communication but also present alternative avenues to generate social commentary about the world in which we live.

The Forces of 'Fun' and 'Fear'

When reflecting on the views presented earlier by the student teachers, it appears more immediate emotive responses about why we dance come to the fore. Among the reasons why we dance is the word 'fun'. While indicating dance can be enjoyable, perceiving dance as fun, as alluded to earlier, tends to present a somewhat superficial view about the purpose of dance, especially when compared with the reasons expressed above. On the other hand, 'fun' or enjoyment does, I believe, have relevance in our lives,

particularly in education. Other authors (Anttila, 2007; Bond & Stinson, 2001; 2007; Stinson, 1995; 1997) have also referred to the word 'fun', when allied with dance and interrogated what this might mean. Bond & Stinson (2007) considered 'fun' was worthy of further investigation and following some comprehensive research with a range of young participants about why they chose to dance the authors produced some captivating reasons why having fun was important. When linking the concept of fun to the child and adolescent psychiatrist Hallowell's (2002) theoretical work pertaining to intrinsic motivation, the researchers were able to make correlations not only to the benefits of learning but also to the larger aspiration of 'happiness'. As Bond & Stinson (2007, p. 176) explicate:

> He [Hallowell] identifies two primary sources of individual happiness: the ability to create and sustain joy, and the ability to overcome diversity. Hallowell describes five steps to developing these abilities that speak directly to our study of young people's experiences of work in dance, as well as our larger study of engagement: 1) Connection (with parents and teachers, activities, the arts, and oneself); 2) Play (a requirement for ground-breaking in any field); 3) Practice (gives control of the environment and facilitates discipline; 4) Mastery (builds confidence to persist through obstacles); and 5) Recognition (the feeling of being valued by others).

Whilst offering such in-depth or meaningful theses of what dance might mean, dance practice within educational settings very rarely concerns itself with such elevated thinking or visions of what could be offered beyond the technicalities of doing dancing itself. As reflected earlier in Ashley's (2009) perceptive findings, the contextual as well as the meaningfulness of dance tend to be negated or relegated to minimal importance subsumed in the technical or codified language of dance education.

Although fun featured significantly in the students' responses about dance, many of the student teachers I encounter in my practice are generally more concerned about 'how' to 'do' dance, or in some cases, 'how' to 'get out of doing' dance. In a similar vein to other areas of learning within a generalist teacher education program the focus on the 'how to' is often sought over the 'why' or visionary purpose of education. This focus is perhaps even more astute in areas such as dance because, as a subject, dance was often missing, overlooked, or minimally applied within one's own

schooling. For this reason many student teachers feel dance has been absent from their own bodies for so long that they do not know where to begin to pull upon past knowledge or skills that are deeply buried within. To envisage why dance might be of fundamental importance not only in educational settings but in people's lives, is usually far removed from the reasons why they chose to teach.

There are students who are fearful of or, indeed, sometimes petrified to dance. Such resistances are often caught up in a thick web of societal messages that surround issues about the body; (for example body image), and ability; (a view that could be expounded by the exemplars Gardner (1993; 1999) presented as attested to earlier) especially when certain forms of dance stress technical expertise. A focus like this tends to lead to notions of dance as elitist, or only for a very few who can meet the exacting standards specified in particular areas of dance. In addition, there are also other areas that can detrimentally impact the practice of dance such as cultural expectations (Bolwell, 1998; Shapiro, 1998; 2008c; Walker, 2008), ability (Bond, 1994b; Matos, 2008), and dominant normalizing notions of gender encompassing sexual orientation (Risner, 2007a; 2007b; 2008).

Education, as a reflection of society, has also been influenced by what is considered academic and what is not. A large part of how we learn is omitted when the restrictive nature of acquiring knowledge is based purely on the powers of the rational mind. The Cartesian notion of the mind/body split, or the emphasis on reason and the suppression of the body's experiences (Shapiro, 1994), has affected those areas in education, for example dance, that are commonly seen to be driven by emotions. Little credence is placed on bodily sensations and emotions as applicable means of learning. The physical body knows how to act in an acceptable way based on societal norms, so much so that the practice of keeping the body motionless for lengthy periods of time has become a matter of habit. The customary behavior of stillness can be cultivated even within the confines of early childhood learning environments. To move the body, especially in an expressive way, gradually begins to feel somewhat strange. Alienation from the body has seeped in. As invoked by Shapiro (2002b, p. 343): "An excision of the flesh from educational discourse and practice means an excision of student experiences, emotions, passions, compassion, and meaning-making

from the ground of reason." The separation of mind and body becomes an act of dehumanization where students (and teachers) are disembodied (hooks, 1994; Shapiro & Shapiro, 2002b). The lives of both students and teachers are effectively left outside the institutes of education (Sapon-Shevin, 2009).

Nestled in-between these extremes of complete abandonment or emotional upheaval and rigid technically demanding requirements (both for and against dance), is dance that fulfills and expresses the cultural and societal existence of human beings. It is my belief that these cultural and societal aspects of dance, nevertheless, are still left on the outer edges of education where dance is seen as an extra-curricular activity. Unless dance is viewed as a viable process of learning within education (and not just to showcase events or socials), dance becomes doomed to live out an existence in the shadows. It is not surprising that so many people find dance daunting, threatening, and unachievable. The introduction of these factors here provides the platform to focus on each of these areas in more detail in the next chapters. At this juncture it suffices to say that the influences preventing or hindering dance in education act as provocations for further investigation.

The Body in Education

Dance and the Kinesthetic

This chapter is central to my practice as a dance educator because it focuses on the corporeal body and, correspondingly, being human. Given that the body is essential to dance (whether real or virtual), recognizing how bodies are viewed and treated in education from a historical, social, political, and cultural perspective is crucial. The aforesaid noticeable tendency in education or schooling to eliminate the body (and thus, the whole person) from the teaching and learning experience requires examination. As stated by Sapon-Shevin (2009, p. 168), educational institutions fail "to recognize the bodies of the students we teach", thereby creating a form of disembodied learning.

The all too prevalent separation of 'mind' and 'body' continues to perpetuate the belief that the mind or rationality is the only aspect worthy of educational attention, thus, leaving the body virtually outside the classroom or teaching and learning space. Such a focus dishonors bodily experiences or the personal lives of students. The corollary is that education or schooling can be seen as a form of dehumanization. Accordingly, as Sapon-Shevin (2009) surmises, bodies are treated as "irrelevant or dangerous" (p. 168). The privileging of academic performance that concentrates on mental acuities believed to exist only in the mind equates to learning which is devoid of affective ways of knowing, kinesthetic intelligence, and the significance of social interaction. Concomitantly, an exclusion of the body from education negates bodily approaches to learning. Subsequently, dance (together with other physicalized forms of pedagogy) is viewed as superfluous to the educational process.

Dance, nonetheless, is one of those ways of coming to know ourselves, (including our bodies), others, and the world. Such knowing is achieved not just through the process of doing it, or through clinical analysis and disconnected rationality, but also through how we feel or sense the world in which we live. This brings in the affective and visceral mode of experiencing and directly relates to our receptiveness to any given situation. I realize, however, that because the body has been effectively removed from the majority of educational experiences offered to students throughout their schooling, there is a form of resistance to anything bodily in education. As a dance educator I acknowledge that these aspects hold significant sway for the students I teach where some are, in fact, fearful of dance as an area of teaching and learning.

These resistances are not isolated to my situation alone. Canadian dance educator Kipling Brown (2008, p. 144) confirms these feelings as captured in the following narrative:

> I know that the dance experience I will facilitate will influence the students, particularly those who enter the space with reluctance and ask me in skeptical and challenging voices what we are going to do. They tell me they don't want to dance and describe it as "sissy" and "silly". How many times have I heard those comments and risen to the challenge to prove that dance is a worthwhile endeavor that can be part of their lives?

Just as in the same way these sentiments echo my own, I, as do others, continue to believe that positive dance experiences (especially in pre-service teacher education) can eventually result in the occurrence of worthwhile learning situations in early childhood and classroom settings.

Therefore, to ensure the learning is beneficial when it comes to experiencing dance, it is important that I consider the mood my students are in; the place (especially in the confines of a dance studio with mirrors); and the time (being a scheduled time within a timetable). I also know that the students do not make a choice to attend these classes. The classes are mandated as part of their teaching degree requirements. All of these influences have an effect on how something is received or perceived.

These issues, I maintain, make the teaching of dance somewhat difficult or complex. While the learning of dance involves a technical aspect and some form of knowledge base, dance, especially as an art form, also draws on and becomes an

individual experience based on personal preference and, therefore, emotion, which is shaped by context, society, class, and culture (Sturken & Cartwright, 2003). From a Western perspective, culture and society (and therefore education) are traditionally accustomed to using visual and aural senses as dominant ways to perceive the world. The senses of taste, touch, and smell, or the kinesthetic and proprioceptive (Stinson, 1995) senses tend to be overlooked. If educational experiences are limited to perception via only sight and sound, the wider array of sensing or somatic ways of knowing that are housed in the body can become null and void. This has repercussions because the sensory nature of movement (as well as stillness) of the body, or kinesthetic sensing that can stir an emotional response, may be less likely to occur and hinder the emergence of dance.

This does not mean that the reason for dance has no other purpose beyond that of stirring emotions. Dance expresses our thoughts or views of the world. The origination of the movement, however, comes from something deeper and, in a sense, is taken out of context where the movements might be used for some other purpose, for example, to perform a task. It is the combination of these movements, which become redefined, and, appositely, controlled, refined, reshaped, exaggerated, and reused in a completely different way that then becomes significant or central in the overall concept of making dance. Beyond the aesthetic component and artistic rendering there is also the intention of the creator of the dance work as well the interpretation of the receiver or audience. Each of these factors is important in the process of making meaning. Dance in education, therefore, requires nurturing and an understanding of the historical, cultural, and social (socio-cultural) backgrounds of the students so as to connect to their lives, as well as an understanding of the context from which the dance arose.

As a dance educator I strive to offer opportunities for multiple forms of engagement in the teaching/learning process to open up and enhance the depth and breadth of all possible avenues of acquiring knowledge. This type of pedagogical process involves me, as the teacher, and the learners in an active engagement of knowledge construction, involving constructive and co-constructive approaches, through drawing on social, cultural, historical, political, and individual lived experiences.

I would like to think that by offering an appreciation of creating artworks, from their origination through to some form of development, connections can be made to the human condition. Furthermore, the historical and cultural foundations that contribute to and validate the existence of dance yield new ways of conceptualizing being human. Our human natures would be revealed in the process of initiating and developing ideas, creating, thinking through, researching, and refining ideas, while also experiencing the trials and tribulations that this type of practice brings when working together with others. I also believe that there is a place for the language of dance to be known together with the development of multi-literacies so that a framework can be put in place, which allows for exploration and the possibility of discovery and experimentation. The language of the art form and all its nuances also allows for appreciation, as well as communication, because knowledge and, therefore, understanding has been increased. When coupled with contextual knowledge about the origins of dance there is the potential of being receptive to new ways of knowing.

At the same time, I am aware of the possibility that an experience that draws on the unfamiliar can also create resistance because the depth of knowledge associated with understanding the purpose of dance together with the feelings that are unearthed may be too difficult, painful, or scary to face. This can impede receptiveness to dance and effectively limit or hamper understanding or ability to communicate kinesthetically in or through dance.

Ideologically, as well as pedagogically, it is often a double-edged sword because, while I want to support the hopes or visions I hold for dance education, I also need to be suspicious of my myopic and very biased view of dance. Consideration must be given to those whose experiences of dance have been less valuable, or even worse, damaging or destructive. For some the kinesthetic nature of dance is very foreign territory and not conducive to the ways one can come to understand the world. In fact, the very opposite could happen, where dance as a learning experience can be counterproductive or even a destructive force. Perhaps one of the most important aspects in my teaching is to let go of my persistent belief that everyone should enjoy and appreciate dance and simply be willing to let moments of personal experience evolve in

whatever form this may take. There is the realization, nevertheless, that whilst I relinquish my tenacious grip on being resolute in my teaching objectives, I know I have a role to play in offering other ways to not only experience dance, but also illustrate how dance can provide a critical understanding of the world in which we live.

A Critical Approach to Dance

From an epistemological perspective, critical ways of knowing should be a process that moves us from what we think we know to new ways of knowing; shifting from the familiar to the unfamiliar. If to know in dance is one way to promote critical inquiry in order to affect change, as opposed to just reflecting the world in which we live, pedagogical practices in dance need to be addressed and clarified. To possess a critical approach to knowing is to be able to have the awareness of consciousness to deconstruct certain constructions of knowledge and ideologies brought about through power and domination. This way of looking at things requires an examination of issues of essentialism, normativity, universality, and hegemony. In practice this equates to looking at difference and other sources of information that have not been referred to previously. In a more concrete sense, the boundaries of teaching and learning are pushed and tested to enable new pedagogical approaches in dance to emerge, without feeling threatened by loss of control, or, perhaps even more so, with the awareness of losing face when encountering situations of uncertainty or challenge.

Through the process of creating dance students learn to initiate ideas, make choices, and look at things in different ways. As stated by Hong (2003, p. 150), students "develop perseverance and tolerance in the face of chaos and uncertainty" to not only negotiate personal meaning and the way they understand the world but also learn to interrogate, question, and challenge that world. This can be done through the development of critical analysis and interpretation in the process of creating and performing dance, as well as responding to dance. A critical analysis of this type, however, must be willing to examine those issues that go to tyrannize and oppress.

One way to expand our base of knowing and to open up those avenues of injustice is to draw from lived experiences, both ours

and others. This enables us to begin to see from others' perspectives and examine our own frames of reference. When one is engaged in the process of learning in dance, the practice of making dance through developing ideas, analyzing, and refining what happens next creates an environment of reflecting on the knowing that is involved. An approach such as this has the potential to help new knowledge emerge. Therefore, from a pedagogical perspective, strategies are created that facilitate a certain type of exploration where the students' and teachers' lives are invited into the learning process. The incorporation of students' lives can bring about the unknown and the uncertain whilst acting as a decentering process, destabilizing not only the practice of the teacher, but also interrupting views the students' hold. Similarly, the teacher's life becomes an equally pivotal part of unearthing undemocratic practices and injustice, which can be an unsettling experience for one who commonly holds the power and is usually less inclined to expose parts of self in the teaching and learning process.

When learning of this type occurs, there needs to be cognizance of the fact that dance is being presented in a particular way as a framework of knowing. The process of structuring the pedagogical approach from a critical perspective, in order to stir or disrupt certain points of view through other ways of seeing, means that dance or the messages conveyed in the dance process are not value-free. While the skills of creating and performing dance might be developed, thereby establishing and increasing self-confidence through the active engagement of performance, the "student's existing patterns of knowing" (Greenwood, 2003, p. 128) are either reinforced or disrupted by the choice of content or approach used in teaching. This does not mean that learning to understand the elements of dance, or dance technique and how to perform are eschewed in the process. But the content or the purpose of that performance also has a conscious raising impact upon the students, and the facilitator plays a significant part in the choice of that content.

Displacing Positions and Entering the Unknown

Whilst acknowledging the importance of applying a critical approach and my role in foregrounding explicit issues of contention

in the educative experience, a paradox becomes apparent as hinted at above. This is because criticalities require a multitude of different voices, and not just the teacher's alone. To engender a multiplicity of voices, one's positionality as the teacher is confronted by the prospect of relinquishing ultimate control. Consequently, the potential of role reversal or the process of 'letting go' as the teacher, is something that requires serious attention to uncover pedagogical issues of power and control in tandem with considering one's own role as the pedagogue and, thus, responsibility.

Throughout my career as a teacher of dance in the realm of pre-service teacher education I have been accustomed to creating the structure through which the students would learn dance. I was the one who chose the focus for the lesson, which element of dance we would explore, and the course of action that would take place. Admittedly, there was allowance for student input in developing their skills and ideas but, for the most part, I prescribed the framework. I spent endless hours planning how to teach a certain element of dance, always, I maintained, with the intent that I was being, at least, co-constructivist. However, in the truest sense of the word, I was the constructor of the material, concept, or topic that was going to be covered.

Because the subject is dance and, more specifically, dance education, which means that the learning is to be accessible to all children or students in the teaching and learning environment, one of the aims is to develop children's/students' problem-solving skills in order to create dance. For this reason, the lesson is designed to cover a range of approaches from imitating or receiving direct instruction related to the predetermined dance skills, to providing space for students to create their own material based on a prescribed problem related to the focus of the lesson.

I have no reservations in declaring that the subject matter pertaining to the basics of dance education needs to be taught. Without the basic foundation there would be very few chances that students would be able to develop dance works with a competent understanding or the skills and knowledge of performance needed to execute their ideas. What was less evident in my approach to teaching dance, however, was the opportunity for students to actually voice their thoughts and feelings about what ideas *they* would like to explore. The predominant voice in the class was

mine, even though the dances created belonged to the students. As a consequence, whatever I decided was the focus, or the concept of the lesson became the focus for everyone. My pedagogical approach, therefore, raised questions about the minimal presence of the students' voices and lived experiences, which were equally important in structuring the teaching and learning experience, especially if the experience was to be meaningful to the learner.

Brazilian educator Paulo Freire (1996, p. 112) stipulates that "there is no educational practice without content." Further to this, Anttila (2003, p. 197) states that Freire "emphasizes that no framework and no content is neutral, free of values and ideology. Thus, he cautions against imposing the teacher's reading of the world on pupils and holding content as property, or possessing content." Additionally, Freire (1998) contends that all pedagogical encounters should respect differences while acknowledging the coherences. As Freire (1998, p. 120) has repeatedly and emphatically stated pertaining to the act of teaching:

> There are some things I know and some things I do not know ... with this conviction it is more likely that I may come to know better what I already know and better learn what I do not yet know.

For this reason space needs to be made for student voices and stories, including the origination of ideas or topics that could be explored.

In her book *The Dialectic of Freedom,* Maxine Greene (1988) points out that there are multiple ways of seeing, and, therefore, knowing things and nothing can ever be complete, or discovered, without realizing that there is yet another way to see it. These thoughts align with Freire's (1998, p. 121) viewpoint that it is important to "have an open-ended curiosity toward life and its challenges" as an essential part of educational practice. Effectively, Freire and Greene are referring to a form of openness as part of pedagogical practice where dialogue plays a central role. This openness results, according to Freire (1998, p. 121), in "a dialogical relationship" where our state of 'unfinishedness' or becoming acts as the motivation for the continued quest for knowledge.

Pedagogically, the act of discovering new learning alongside others becomes "an ethical encounter" (Dahlberg & Moss, 2005, p. 99) of reciprocal engagement and shared understanding, which is an embodied and "active relationship that is dialogic and

interpretive" where I participate together *with* the students. My pedagogical agency becomes a process of negotiation where power shifts in relation to others, and where, as Foucault (1984) testifies, we become moral agents. In countering the Cartesian binaries that exist between human experience and subject matter St. Pierre (2001, p. 159) interpolates:

> I can no longer think of the human subject as prior to or separate from the physical environment any more than from its linguistic and cultural environment. The limits of that Cartesian dualism became evident during fieldwork in my study because I simply could not describe many things that happened to me if I thought of myself as a subject differentiated from space/time, the land, objects, and so on.

At the forefront of such an approach is a focus on relationships and communication thereby producing a "pedagogy of listening" (Dahlberg & Moss, 2005, p. 97; Rinaldi, 2006, p. 65). From a Māori world view the concept of being in a relational and constant state of learning and teaching is termed '*ako*', where one is both teacher and learner, whether young or old, child or adult (White, Ellis, O'Malley, Rockel, Stover, & Toso, 2009).

From a Freirean perspective differences between learners are also acknowledged where each student is seen as unique, with differing learning requirements. I attempt to re-enliven the students' own lived bodies so as to gain a sense of embodied knowing, whilst acknowledging each person's individuality and agency to choose how they participate and contribute. When there is the possibility of re-awakening bodily engagement and enhancement of a deeper understanding of the self, connecting to and respecting the lives of others may have more promise.

Respect for the student demands of the teacher, as Freire (1998) aptly persuades, "the cultivation of humility and tolerance" (p. 65). This enables openness to curiosity and the unknown, which can only be possible when one reveals their own ignorance and, thus, needs to know or find out. Beyond the desire to move past one's lack of knowledge is the growth of conscious awareness and criticality. A fundamental of critical educative practice is "the need for spontaneous curiosity to develop into epistemological curiosity" (Freire, 1998, p. 83). A conscious awareness, or as Freire terms it, 'conscientization' requires 'praxis' or the unity of theory and action to create agents of change directed toward an education for freedom (Freire, 1998; hooks, 1994). An education for freedom

must interconnect with the students' lives if the call for active citizenship and social change is to be realized. To enable a cross section of experiences, values, and ideologies to enter the teaching and learning space I face the challenge to release some of my control or authority so that the voices and lives of the students become more central.

Stirring Consciousness and Action

From an early childhood point of view I have always favored and, indeed, thought I practiced the philosophy of placing the student at the center. However, I noticed a radical shift in my pedagogical approach when I became involved in teaching dance for both early childhood and primary (elementary) education student teachers. Yet, in the same way as the young child brings their interest into the teaching and learning environment, the student teachers also bring in their understanding of the outside world, which adds another dimension to what we know and, consequently, share with others. It is my task as a teacher to utilize what shapes the students' understandings of the world and interface this with ways of providing other avenues of seeing that challenge the given or normative aspects that are taken as real. To do this I examine my own, as well as the students' values, cultural understandings, universal beliefs, and the very constructs that formulate the way we see the world. I endeavor to look beyond the obvious, familiar, and known, and enter a terrain of the unknown.

The practice of teaching from a critical perspective necessitates reflecting on actual past experiences that are both pivotal to my desire for dance as a transformational experience as well as those times when I experience something confrontational related to the very idea of dance. Critical reflection acts as a channel to invite the reality back into my life in order to deconstruct that reality. Only then am I able to face the issues that truly command my attention and make the changes that are imperative if one seeks ultimately for a critical pedagogy of liberation.

When the lived experiences of participants are drawn on it enables students to move beyond being passive agents upon which dance meanings are created to becoming active constructors of meaning. As stated by Hong (2003, p. 151), students "not only demonstrate the skills of critical thinkers but also engage in an act

of self-definition." Associations can be made here to a postmodern view of curriculum where, through reconceptualization of traditional approaches of modern ideology, work toward a "transformative pedagogy" (Slattery, 2006, p. 42) can evolve. As stated by Hanstein (1990, p. 57):

> A postmodern view of dance education calls for a curriculum that attends to in explicit ways, the perception, exploration, transformation, and discrimination of artistic conceptions while cultivating historical perspectives, developing discerning skills of the critic, and guiding our students as they seek answers to questions about the nature of dance as an art form. In each of these endeavors there are not single correct answers. Meaningful engagement with dance works, whether as a maker, or perceiver, requires a willingness to explore new territory, a tolerance for ambiguity, and a commitment to an active encounter rather than a passive encounter.

From a postmodern and feminist epistemological perspective this approach challenges dance educators to place the student at the center of the pedagogical process to draw upon the lived experiences of the students in order to expose different voices, (usually those of women and ethnic minorities; although ironically in dance, this could be the male voice). Such an approach facilitates personal agency. Teaching that invites the students' lived experiences links to issues of social justice. From a critical and moral point of view the responsibility is placed on the teacher to ensure that this possibility occurs.

Greene (1978; 1988; 1995) charges teachers with this responsibility through her emphasis on stirring "wide-awakeness" (Greene, 1988, p. 23) to activate the consciousness to a level of imaginative and social action. The term 'wide-awakeness' speaks about the potential of arts education, our connection to each other, and what it means to be human. Hong (2003, p. 140) reiterates this view when she states: "I contend that dance is potent in stirring to 'wide-awakedness' the dialogue and the imaginative action that brings to greater consciousness the multiple conceptions of what it means to be 'human and alive'." The kinesthetic or bodily engagement found in dance has the potential to reach yet another level of knowing through a deepened visceral engagement that connects to the senses and an inner understanding of the human condition. Slattery (1995, p. 183) expresses this perspective with reference to dance educator Susan Stinson stating: "Stinson uses

the metaphor of personal knowledge—of knowing something in our bones—that allows us to extend our boundaries and make important connections to the world." Knowing in our bones can come from the inner awareness of our bodies, which is diffused through dance; otherwise expressed as somatic knowing. As stated by Green (2007, p. 1120): "Somatics as a field of study generally views the body from a first-person perception."

Indeed, during my own experiences and studies of dance my encounter with somatic or body-mind centering phenomena has been a life-changing event, particularly during the time when I was facing a life-threatening illness. Because somatic practices lead you deep into an inner awareness of the body and all that the body and, thus, the self confronts, they have the capacity to educe mindful and astute awareness of what the body is both feeling and thinking. Somatic influences help you get in touch with holistic systems of healing and rejuvenating the body. The concept of somatics cannot be categorized into one monolithic understanding or approach. Somatics are a valuable addition to addressing the ways in which our bodies are objectified and socialized; something Green (2007) refers to as a way of providing "an emphasis on an awareness of the social construction of bodies" (p. 1128). The body as subject is viewed as connected to society and, as such, becomes a powerful agent of expression about social issues or the world in which we live.

To be able to express through the medium of the body requires another form of knowing, a connecting or re-connecting to the body and all its nuances, its inner workings as well as the outer structure. This type of bodily experience develops new knowledge in another way, which can be found in dance. As part of the bodily-kinesthetic experience, there is a sense of knowing the body from within in both a concentrated and contemplative manner, and, in so doing, understanding something of what it means to be human. Perhaps it is because of this reliance upon the body as the sole instrument in dance, (without negating the body-subject) that personal agency or empowerment can be realized in a pursuit toward freedom because the body is deemed as the deepest site of personal ownership. The body as crucial to a pedagogy of freedom is evidenced in this statement by Kipling Brown (2008, p. 154) working with students in an Arts Education Program in the Faculty of Education at the University of Regina:

I attempt to work with the dialectic of transformation, leading and following, control and freedom, and so on. I focus on dance as a tool the students can use to consciously connect with their bodies, to accept their bodies, and to creatively express their thoughts and feelings.

Although the focus here is on dance, this is not meant to repudiate other ways of knowing, which can also be pivotal for some in understanding ourselves and our roles for the purpose of working toward freedom from oppression.

Bodily Matters

Paradoxically, it is also the human body and things bodily that have created a counter discourse pertaining to the existence of dance in education. The body has been a locus of controversy and debate for an indeterminate period of time. Literature abounds covering contentious bodily topics related to body image, aesthetics, race, class, ethnicity, culture, age, ability, gender, and sexuality. Masculine and feminine constructs pertaining to the body pervade our lives and contribute to identities, performativity, and power (Villaverde, 2008). The existence of these all-pervasive constructs has necessitated feminist and postmodern scholarship aimed at the body (Shapiro, 1994; 1998; 2008b; Shapiro & Shapiro, 2002b). As Greene (1988, p. 85) pointedly remarks:

Mutuality and concern (linked to connectedness or relatedness signifying women's ways of knowing or lives), are not in themselves enough to change the world … Some believe it is at first necessary to replace language that denies body and feeling, as does the still dominant male discourse, with a new female expressiveness.

Matters pertaining to the human body cover a multitude of different concerns to deliberate related to dance education. The body acts as a significant factor in how dance is viewed as an art form, where societal views of the human body effectively subjugates dance as being seen as less worthy than other art forms. As referred to previously, the body is also often disregarded as a viable source of knowing in education, something that has been noticeable through either minimal existence in educational curricula, or through complete absence (which would appear to be a logistical impossibility). From this point of view, the body becomes the most vulnerable antagonist because, as described by

Shapiro & Shapiro (2002b, p. 31), "dance is patently about the body" and yet it appears to be the prime adversary that works against the existence of dance. Consequently, the body is placed as, maybe, the most precarious and volatile of all the provocations dance faces in education.

Perhaps one of the most contentious issues related to the body in dance education is body image. Issues vis-à-vis bodily image are exacerbated by societal concerns surrounding the body such as objectification and consumerism, as well as the continued enforced marginalization and absence of the body in education. The Cartesian notion of the mind/body split that favors the logical or rational mind, over the emotional or irrational body, remains a strong contender in education and fosters, in my estimation, static passivity as opposed to active or engaged participation. This, as Shapiro & Shapiro (2002b) identify, has been the challenge to education related to the historical resistance of the dualism of mind and body.

There are also other bodily connotations to consider such as the retaliatory way the body is treated, which includes bodily maltreatment or abuse, eating disorders such as anorexia and bulimia (disorders which are disproportionately evident in the field of dance), punitive or corrective measures applied to the body, as well as the highly disciplined approaches to training the body. These treatments of the body come about as a form of counter-discourse to historical and societal views of the body where, at the other end of the continuum, there are the sensuous or erotic and ecstatic aspects associated with the body to contend (Ehrenreich, 2007). Villaverde (2008, p. 89) considers the extremes of bodily fetishisms or obsessions in disquieting depth:

> The body has been a zone of contention in feminism for centuries, a source of love/hate relationships with both self and others ... In this zeroing in on the body, again we must look critically at aesthetics, its impact on how we distance ourselves from our bodies, how we connect to or live in them, what we do to them, and in the name of what ... The idea of rearticulating and recognizing various experiences and enactments of physicality ... seems to be a critical area of scholarship in terms of understanding the body (inclusive of the mind, of course) as a primary tool for interacting with the world. These areas of study would also extend our conceptions of desire, corporeality, movement, disability, health and well-being, visible inscriptions of ideology, work and labor, mutilation and torture, and numerous other issues situated in the body. Despite all that has been written on body studies, we vacillate between

treating our own bodies as estranged family members and as temples of reverence (extreme comparisons, I know), and we continue to have disconnected, objectified, or solely utilitarian dispositions to our physicality.

Moreover, the social constructions of gender (Bond, 1994a; Risner, 2008), sexual orientation (Risner, 2007a; 2007b; 2008), race (Henry, 2001; McLaren, 1999), and age and ability (Bond, 1994b; Matos, 2008) compound the situatedness and functionality of dance within the domains of education. In a seminal article "*How 'Wild Things' Tamed Gender Distinctions*" written by Karen Bond (1994a), it is clear that oppositional behaviors can also be present related to gender practices in dance. For example, in the project leading up to a performance at a primary school in Melbourne, Australia, it was noted that the boys repeatedly demonstrated fast stampeding runs, falls, jumps, and explosive actions. The girls exhibited more individuality in their movements using skipping, hopping, and running with arm gestures and rhythmic synchronicity. However, there was less evidence of changes in energy, use of space, and tempo in the girls' actions compared to the boys. The gendered differences were clearly defined between the qualities shown. The girls displayed lightness, delicacy, and softness, whereas the boys created a cacophony of sounds using pounding feet and bodies frequently coming in contact with the ground. The concept of boys being seen as effeminate dancers seemed to be strongly affiliated with same-sex peer acknowledgment, which was tied in more with individual prowess rather than classroom cohesiveness. A cue, however, for the possible disintegration of sexual divisions was found in the collaborative project of working together to create a performance. Gendered distinctions became less significant in roles where identities were embodied in non-gendered characters and shared performatively as a collective whole. The boys were less likely to egg on and copy each other, as were the girls whose acquired female traits in dance were neutralized in accordance with the roles being enacted in dance.

As Risner (2008, p. 94) points out: "Girls often grow up with dance as a taken-for-granted activity of childhood", thereby adopting certain genres of dance and associated styles of movement. By comparison boys can become disassociated with the gentler components of dance preferring instead to assert their

masculinity through strong, hard-edged movements perceived to be more male. Societal constructs, therefore, effectively genderize dance from a heterogeneous vantage point. Under this hegemonic regime of what constitutes dance, a 'skip' becomes an action a girl does, whereas a 'karate kick' is an acceptable action for a boy. It is well noted "that peer pressure plays a strong role in children's constructions of masculine and feminine stereotypes" (Bond, 1994a, p. 30) and gendered connotations associated with certain movements become perpetuated. It is important to unpack the perpetuating and dehumanizing discourses that surround dance and, in particular, affirm "individual differences to reduce cultural emphasis on gender" (Bond, 1994a, p. 32).

Again, in acknowledgment of the gendered and marginalized status of dance, Risner (2008, p. 107) alerts us to the fact that dance

> remains widely misunderstood by the general public. Due in large part to dualistic thinking that separates mind from body and intellectual activity from physical labor, and due to dance's close association with girls and women, dance is often perceived as part of the women's domain, whereby its denigration for its dense female population is possible. Historial notions about the body often linked the feminine with intuition, nature, the body and evil; conversely, intellect, culture, the mind, and good have been perceived as masculine.

At the same time, those involved in dance may have, albeit unwittingly, engaged in sustaining these societal constructions and marginalization "through silence or consent" (Risner, 2008, p. 112). Powerful constructs do not exist by themselves; they become entrenched through coercion to dominating asymmetrical power relationships. Exposing and disrupting these hegemonic approaches requires both imaginative pedagogical strategies and critical interrogation of the structures that contribute to their continued existence.

Equally, the constructs of race, age, and ability require confrontation, something that the following statement from a young dancer testifies to on the subject of the color of her skin.

> In *Sugar in the Raw: Voices of Black Girls in America,* ... Jaminica, age fourteen, remembers how she got an ulcer at seven years old, citing as a cause "my racist ballet teacher who was loathe to remember my name and felt that if she kept ignoring me, I would disappear—which I did." (Henry, 2001, p. 176)

This type of message delivered frequently can affect one's self-identity and self-efficacy to the detriment.

McLaren (1999) also points out "the importance of understanding the body as the site of embodiment of racist discourses" where "specific forms of subjectivities and otherness are produced through discourses of the body", which are reflected in the way people classify themselves "by hierarchical orders of purity" (pp. 277–278). What is needed, therefore, is a critical pedagogy that not only recognizes "the way in which racist discourses are produced by the body as well as the manner in which they have become conjoined with discourses of class, gender, and nation" but also examines the influence of history that has created these discourses and move "into the arena of a transformative social practice through the struggle against multiple forms of oppression and multiple determinations of racial discourse" (McLaren, 1999, p. 278).

Yet another litigious area related to the body is the compulsion of certain sectors toward prohibiting touching or bodily contact in education, a concern I will specifically return to when addressing aspects with regard to early childhood education. All of these concerns have a bearing on how the body is viewed and used in dance education, including early childhood settings.

The Contested Body: A Prime Source of Opposition

Because not everyone favors or values the body, especially in education, but also in society at large, the dilemma of establishing dance as an art form within education, and as an accepted subject of the curriculum has been fraught with complications. Coupled with this, there is also the difficulty of teaching dance to generalist teachers who are not comfortable with bodily activity and do not consider themselves dancers or artists. Considering that dance is reliant on the body for its existence, this factor immediately presents a quandary for it is the movement of the body that is the material of dance. In addition, the place of the body as central to learning in the early years comes into question, which is of particular concern to me as a dance lecturer working with early childhood education student teachers.

The body, and all it stands for, is a contested area of education, and not just beyond the gates and playgrounds of early childhood

environments. What happens with regards to bodily related activities within school grounds trickles down to the early childhood sector. Throughout my career in teaching the body has long held a primary role in the acquisition and transmission of knowledge. My career in early childhood education taught me well about the vital role the body played in learning. I became readily engaged in the pedagogical practice of the pursuit of inquiry and discovery through active exploration. It took very little to convince me that effective learning was actively engaged in, rather than passively received, as the young children demonstrated.

I now find, however, that what I thought was basically acceptable in early childhood education is sometimes seen as inappropriate methodology in not only other areas of education that the young child enters after leaving early childhood settings but also in early childhood environments themselves. Within these educational environs the body is prone to being controlled and constrained so much so that it gradually becomes a non-essential item in the process of learning. It appears that the body or anything bodily, is not seen as fit or proper in education, even with children as young as one or two years of age. As a result, the body is sidelined to suffer second-rate treatment while the mind is saturated with knowledge that requires little bodily engagement. It is considered better to remove any bodily emotional responses or uncontrollable physical urges from learning as they are seen to interfere with the serious undertaking of head-stuff rational knowledge acquisition.

Within the institutes of schooling, playing, moving, dancing, or any other physical activity is often ostracized, or kept contained and controlled in designated areas called physical education, cultural or recreational activities, and recess. There are even attempts to do away with anything physical altogether in these socially institutionalized settings. The rationale is, or at least it is offered as a reason, that if one combines feelings with thought, brought about by bodily engagement, all sorts of unwanted behaviors might be unleashed. It is better not to risk upheaval, not to invite the creative spirit or the imagination, because this would challenge the control mechanism in the classroom and upset the status quo. From a Western perspective the shaping of how one performs and thinks is mistakenly understood as taking place "primarily through language, rules, punishment and reward"

(Hanlon Johnson, 2009, p. 160). Furthermore, as Hanlon Johnson continues:

> This is a major problem of pedagogy in the modern Western world with its Cartesian heritage: ideas and rules by themselves are helpless if they are disconnected from the organic foundations of our being. Insisting that young, protean, highly mobile children sit still in desks, that they be punished for giggling and squirming, sets up an atmosphere of resentment and hatred of school as an institution of dissociated discipline, not of vibrant evolution of sensitive intelligence and imaginative craft.

Movement and other physical requirements are restricted within a structure where routines and rules dominate to construct a compliant body that learns to remain still and obey instructions. Because dance relies upon the human body for its existence, matters regarding the body become pertinent to my area of teaching. The concept of the body as knowledgeable, let alone as a free agent with its own volition, are important components in my attempt to place the physicalizing of learning at the heart of education and pedagogical practice, particularly as it relates to the early years. Dance has an immense body of knowledge in itself, but also requires the physical body to become central to the acquisition of that knowledge, to be the creator of new knowledge, as well as the performer or presenter of thoughts or ideas. In order for this to happen the whole body needs to be involved, that is, all that the body possesses, the thinking, the feeling, the doing aspects of the body. This means that the holistic body must be present as a vital part of the process of learning in, through, and about dance as well as the manifold areas of learning the young child will encounter.

The removal of the body from education was a strategic move, and one that society has suffered and paid a high price for ever since. Such a stance continues to support the maintenance of the mind/body split in education and, although it may appear that this ideology is slowly being eradicated, the opportunity given to invite the body into the teaching and learning environment is still limited. As evidenced in the work of Sapon-Shevin (2009) the disregarding of the body in education can have devastating effects, including aspects such as low self-esteem, lack of empathy, and an inability to develop and maintain relationships.

Conversely, as identified by Sapon-Shevin (2009, p. 177):

If bodies were fully integrated, accepted and valued in education, then students would be taught the language of bodies. They would be encouraged to move their bodies during the day in a variety of settings. They would be taught to talk about their feelings, paying careful attention to what was happening for them internally and externally as well. Bodies would be respected as an important source of information and knowledge.

To know the joy of moving and sensing the body is the inalienable right of every child, whether or not each child chooses to continue to focus on the body as an integral part of their everyday life. To deny this possibility is to detach or disconnect the child from his or her self. Sitting in the confines of hard chairs and desks is not always the most conducive approach to learning for every child, whereas, a physically moving body or alternative bodily positions (e.g. lying or sitting on the floor) can provide different and more acceptable ways to become engaged in learning. Such approaches may be expected to be normal practice in early childhood education, yet, even with our very youngest children, expectations for standardized practices of sitting still and listening to the teacher can all too readily be found. By the time the young child enters school, access to different bodily positions pertaining to learning is less evident, favoring instead the use of chairs and tables or desks for the purposes of learning. Elementary or primary school teachers can sometimes marvel at children's readiness to learn when the location of learning is shifted from tables to floors. Children can recline on comfortable cushions or mats on the floor while fully immersed in the learning experience. Interactions between the children and the teacher are increased (as long as the teacher is positioned at the same physical level as the children), because the status of power is changed between the adult and children to a more equitable footing. Such a positioning invites a focus on bodily engagement in the learning process where teaching can come from an embodied place.

Acknowledging our own bodies as teachers could alter the way our student's bodies are appreciated in the learning process, something that is inevitable when teaching dance or engaged in movement or dance education experiences. When I hear that teachers discover movement as an approach to teaching, I am both heartened at this discovery and also saddened or dismayed that such a discovery is outside what is normally occurring in teaching and learning spaces. There are added bonuses when teaching

becomes a corporeal endeavor as Sapon-Shevin (2009, p. 181) espouses:

> I have learned that, while I am very practiced in talking about social justice issues (oppression, solidarity, resistance, voice, visibility, marginality and inclusion), I have been able to teach these ideas far better through the body. This teaching has shifted my students' learning but also altered my relationships with my students. By my being an embodied teacher, they have become embodied students.

Finding that teaching about social justice, humanity, and peace are more readily attainable through the body, or the holistic self, makes sense. An embodied understanding envelops mind and body, feelings, and spirituality, and encapsulates an ethical and moral engagement with matters regarding the human condition. The disconnect between our lives and the lives of others can so very readily be manifested when we increasingly distance ourselves from our bodies and the sensations contained therein. If we lose an awareness of how our bodies feel and, consequently think, the desire to care about and save the lives of others is diminished. For this reason, I wholeheartedly concur with Sapon-Shevin (2009, p. 183) with regard to why the inclusion of the body in education cannot be overlooked. The author states:

> What if we connected what we know and feel about our own bodies and the bodies of those we love with all the other bodies in the world, knowing that the nations being bombed far away were populated by real people with real bodies, a lot like ours?

And while I am buoyed by these insightful words:

> Every child who is touched lovingly, kindly, safely and respectfully carries that memory in her body. Every teacher who is allowed to teach from an embodied position brings that sensation to his future teaching as well. And every classroom in which children and teachers are allowed to be fully and completely human—embodied—allowed to cry, hug, dance, move, touch, connect, brings us closer to a world in which all humans are connected and peaceful as well. Let's keep moving our bodies in that direction. (Sapon-Shevin, 2009, p. 183)

I believe there is yet a long way to go in reinserting the body, and thus being fully human, into education. The body as the conveyor, as well as the receiver of knowledge and life, must start during the formative years of learning because this area is equally at risk for

the eradication of the body. Dance, which fortuitously supports the involvement of the whole body in education, provides another possibility to otherwise overlooked or dismissed areas of learning. With this in mind, I now re-enter the world of early childhood and the landscapes of movement, play, and exploration in association with dance.

Movement and Dance in the Early Years

From Movement to Dance

In this chapter I address how dance education intersects with early childhood and consider what an interrelationship between dance and the early years of learning means for both children and teachers. Although, as purported earlier, there is a noticeable propensity for young children to move, even in an early childhood program where there is a professed emphasis on bodily awareness including learning through physical exploration and play, dance is frequently still seen as a marginal component of the curriculum. Therefore, if the body is to be acknowledged, especially from a holistic perspective as proposed in *Te Whāriki* (Ministry of Education, 1996), the stage needs to be set for the promotion of the whole body in learning. An awareness of and active engagement with the young child's bodily capabilities has implications for dance as well as for early childhood educators.

In the profession of early childhood education there are certain emphases placed on what is considered appropriate learning during the early years, which tend to influence what is included in the curriculum of early childhood and what is not. Curriculum content is often based on the values and beliefs early childhood educators hold and affects not only what is incorporated, but also how the learning experiences are facilitated. Factors such as these can encroach greatly upon the possible inclusion of certain kinds of knowledge, particularly if these areas have been either limited or omitted altogether from prior educational and life experiences.

From my point of view the early years of education have the possibility to open doors to new ways of knowing that can go beyond the traditionalist aspects considered as being curriculum,

as well as what teachers perceive to be priorities in young children's lives. In the New Zealand early childhood curriculum, *Te Whāriki* (Ministry of Education, 1996), (as referred to in Chapter Two) the principles of holistic development and empowerment, relationships, and family and community, are interwoven with the strands of well-being, belonging, contribution, communication, and exploration. These form the basis for a holistic early childhood curriculum where the children as well as the teachers are seen as possessing agency. Such a probability attests to not only the idea of the child as a contributing agent to the teaching and learning process, but also seeing teachers as intellectuals (Giroux, 1988) and, thus, establishing contextually specific programs that meet the interests and needs of the child, family, and community.

According to Miller (2009, pp. 124–125) a holistic pedagogy is concerned with

the highest and noblest qualities of our existence, such as our aspirations toward … wisdom, compassion and love. These ultimate expressions of our humanity are inherent in our nature; they emanate from within the person, not from the authority of society. As human beings, we carry the seeds of our highest aspirations and potential evolution within our own hearts. …

Each person possesses both the capacity and the spiritual imperative to fashion a personality, an individuality, that will experience and live in the world in ways that no other does, and we require autonomy and security in order to fully achieve this potential. Because this individuality begins in childhood, young people are entitled to the educational and existential freedom necessary for them to accomplish their task of building a mature individual.

Hence, the potential in early childhood for pushing boundaries and offering a respectful pedagogy that values human rights and individual autonomy has great promise. Nevertheless, there is still the dilemma concerning what to emphasize in the overall curriculum related to the world the child will encounter. The choice is to either replicate the world through providing conformist areas of learning, or to produce opportunities to develop other ways of being and thinking in order to imagine what could be for the possibility of change (Greene, 1988).

It is this belief in bringing about change and incorporating disparate and wide-ranging ways of knowing that challenges what a curriculum might look like in early childhood education. To

honor the competent and confident child (Ministry of Education, 1996) pedagogical practices need to embrace the whole child and assume an embodied way of knowing. As testified to by Leavitt & Power (1997, p. 42): "Embodiment is the basis of human intersubjectivity and fundamental to the processes of reciprocity." Consequently, it is through relationships with the world and other people that children learn about their bodies and selves, and, subsequently, their identities and emerging agency. This practical engagement leads to competence and a sense of physical and social well-being, fulfilling the principles and aims of *Te Whāriki* (Ministry of Education, 1996) and ultimately contributing toward their roles as citizens of the world.

As one of the ways to satisfy a sense of physical and social well-being it is conceivable that dance would be a paramount area to invest into young children's lives. In spite of this likelihood, however, I contend, as indicated in the previous chapters, that dance education is an area of learning that is either neglected, or misunderstood, within the sphere of early childhood education. I do not believe this is because early childhood educators or program creators consider dance to be irrelevant to young children's learning. Rather, there is a misconception of what dance education is in the early childhood context and an implicit form of power that is exercised by teachers, which lessens bodily experiences. As expounded by Leavitt & Power (1997, p. 67):

> There may be less malice than mindlessness on the part of teachers. They may or may not be fully aware of the implications of their power over the materiality of children's bodies, but most teachers claim explicit and sole authority over the activities of the classroom.

Also, if dance is considered, the dilemma then becomes a question of appropriateness as it relates to the young child.

For this reason, dance as an art form, and as a way of knowing for young children, needs to be both demystified and reconceptualized to enable integration as a relevant area of learning during the early years of childhood. In order to do so, it is important for teachers to be cognizant of the significance of the body so as not to eliminate the more bodily pursuits from the child's daily experiences in an early childhood setting. Serious consideration needs to be given to how often opportunities are provided for children to move so as to become actively engaged and

aware of their bodies. It is also vital to take into account how children can be guided through a process of a deeper, inner sensing of their bodies' capabilities. This inner sensing of the body's capabilities or body knowledge gives rise to dance. To this end, the various practices and attitudes, which can be seen to detract from the inclusion of dance in early childhood settings, need to be interrogated. Alternatively, other kinds of thinking about dance as an art form and as a way of knowing during the early years require re-evaluation to work toward the cultivation of an interrelationship between dance and the young child.

The Body in Early Childhood

In the realm of early childhood I argue that the body is often prone to questionable, as well as contradictory and exclusionary attitudes and practices. Some of the doubts that come to mind when I think about the vulnerable status of the body during the formative years of learning pertain to how early childhood education is viewed and how the body fits into this perspective. I am concerned that with the cry for 'back to basics' in education, especially with the recent re-emphasis on literacy and numeracy, the body gradually becomes subject to being lessened or even removed as a conduit for learning within early childhood environments.

The body has proven to be essential in foundational areas of learning in early childhood, such as play and movement exploration (Koff, 2000; Wood, 2009) yet the body appears to continue to become endangered within early childhood educational settings (Leavitt & Power, 1997; Hanlon Johnson, 2009; Sapon-Shevin, 2009; Tobin, 2004). As Tobin (2004, p. 111) emphatically states: "The body is disappearing in early childhood education." By association, physical exploration and play are also under threat as attested to in this statement by Leavitt & Power (1997, pp. 63–64): "The oft-stated belief of early childhood educators that play is fundamental to children's lives … is practiced with ambiguity as the parameters of children's play are tightly circumscribed." Teachers are disposed to limiting or constraining children's bodies in ways that are seen as 'normal' or in the interest of safety, therein denying children the right to express themselves bodily or enjoy the pleasures of physical play. This has immense

ramifications for early childhood education where young children's bodies are deemed to be their most personal sites of knowing or knowledge making (Davidson, 2004; Schiller & Meiners, 2003).

From a traditional or modernistic perspective the body in education is often viewed as being of lesser importance as it is required to be kept still (for example, so as not to annoy others, or as part of acceptable group behavior), or to become a passive entity in other areas of learning that are seen as requiring rational thinking or 'head' knowledge. For this reason areas of learning such as physical education and dance become subject to teacher control where discipline and skill development are seen as more important than freedom of expression. The body becomes subjected to corrective or punitive measures rather than pleasurable experiences of creative exploration.

Even from a very early age there is a form of distancing from the body. Babies are all too quickly shaped and controlled by being placed in containers or carriers to 'keep them safe', but in so doing, they lose contact with those essential sensory (proprioceptor) elements that help them connect to themselves, as well as to the world around them. The young child's body is also separated from others and therefore devoid of any physical contact in a relational sense. Babies' small bodies are subjected to rigid patterning and conditioning (Hanlon Johnson, 1992; 2009; Kálló & Balog, 2005), through being bodily positioned and re-positioned and placed in particular constraints or items of furniture and play equipment, which allows for very little freedom of choice and exploration. The seemingly incessant need to habitually shape and re-shape the body of the young child is exacerbated by the ingrained routines the young child is constantly subjected to, especially within early childhood settings. The ubiquitous omnipresence regarding the control and development of young children's bodies, coupled with the anxiety surrounding the taboo of touching have, at times, reached epidemic proportions. This has been especially so in early childhood environments where rules are put in place to maintain "appropriate or acceptable touching" (Jones, 2003, p. 23). Accordingly, a form of nervousness begins to pervade the early childhood sector and creates further suppression of the body.

A quashing of the body also transfers to a lack of recognition of what the body is 'saying' because there is minimal acknowledgment of the body as a legitimate site of communication

(Tobin, 2004). The child's non-verbal bodily expression goes unnoticed. Because of the sensory nature of the body, a denial of the body as a channel for communication is "inevitably, to suppress bodily expression of feeling" (Tobin, 2004, p. 118). Our relationships, especially with the very young child, require a cautionary and mindful vigilance of the ways in which contact is made with the flesh and bodily matters are attended to.

Movement for the very young child is about establishing one's intersubjective relationship with the world, where one's social, emotional, and cognitive development is enveloped in the process. These natural movement tendencies evident in the very young child deserve our utmost respect and trust to enable "the child to be an explorer and self-learner" (Perry & Rockel, 2007, p. 3). The young child has, in a sense, a unique rhythm, which, when given free reign has a chance to evolve and flourish in its own special way. Close observations of babies reveal the concentrated effort they invest in the discovery of what they can do with their bodies. When an infant focuses intently on the intricacies of the movements of fingers, hands, wrists, and arms and visually traces these actions, a link is established between the experience of moving and the experience of looking (Kálló & Balog, 2005), a link that is later instantiated in the deeper consciousness of dance.

The freedom for young children, and, in particular, babies, to move as they wish has a positive influence on their learning because the very young child problem-solves through her/his own perseverance and persistence in learning how to move the body. Not only are ways to move learned, but learning how to learn and do things are also achieved whilst experiencing the joy and satisfaction success brings when the child experiences the learning as her/his own. It is these early investigations of movement exploration that act as a source of kinesthetic knowing, which further enhances the growing links between dance and the young child. Subsequently, if the body is restricted, the potentiality for physicalized understandings of self, others, and the world will be seriously immobilized.

The Dilemma of the Body in Dance

When it comes to issues of dance, there are further concerns to consider. Some of these concerns surround how dance is perceived

in early childhood education, and how dance as a way of learning occurs in the early years. From my own experience of observing dance within early childhood settings, I have often seen movement activities offered using musical recordings where the actions are stipulated and, thus, directed by rote instruction. An example of these are action songs where the movements are modeled by the adult and copied by the children, as well as prescribed folk dances, or dance ideas found in books, which are often followed like a recipe. Whilst, the resultant learning from some of these experiences may offer rudimentary movement vocabularies, the essence of the child's own dance is often sorely missing. As a result the outcome is a diminished form of dance with little input from the child.

Observations such as these indicate that the dance experience is seen as neither aligned to nor reflective of the child's lived experience. Under these circumstances, the body is placed in a precarious position because it becomes either objectified, or null and void. This is in opposition to acknowledging the place of both the subjective and the objective, which, when engaged through the kinesthetic sense, brings about a heightened awareness of what the body is saying, doing, and feeling. Within the context of early childhood education, therefore, it is important to support and pay attention to the young children's modes of expression using the language of the body, which can then contribute to their own unique creation of dance.

The body, as I have said before, is elemental to teaching and learning in dance, as well as in early childhood, and for this reason, constructs regarding the human body are crucial areas to examine during the formative years. Something that many dance educators face, and, I also suggest, early childhood educators encounter, is a constant battle with the notion of the Cartesian mind-body split. As with many dance educators there is a desperate need to prove that the Cartesian dualism of body and mind is wrong and that the body has a knowledge, which involves *all* of the body. This affects how dance educators think and teach. The same sorts of views could similarly apply to early childhood educators where there is an emphasis placed on the holistic nature of learning in the early years, which involves the whole body. The physical aspect of learning, however, can sometimes be somewhat happenstance when, what is viewed as the child's natural

approach to exploring the world is overlooked and left to its own devices. Body awareness and body knowledge (including skills) need to be nurtured. Certain aspects of body sensing associated with dance require specified circumstances to be learned. This also means that early childhood educators need to learn what constitutes dance education so as to implement appropriate learning experiences that incorporate and promote an awareness of the body through dance.

Young children do not automatically continue to appreciate the capabilities of their bodies unless they are promoted through well-thought-out teaching and learning experiences and encouraged in a variety of ways. Thus, as in all art forms, to use the body as a medium for artistic expression, children have to learn how to use the body just as they learn how to use paintbrushes, create a sketch, play an instrument, use the voice to sing, or learn the skills of acting. Whereas many of the aforementioned areas may have other tools to utilize and, therefore, need to be practiced as extensions to the body, dance, together with singing and acting, requires a concentration on attributes the body itself houses.

Accordingly, the corporeal body needs to be paid attention to in a way that values its bodily acuities. If our bodies are used or treated in less than positive ways, either through punitive or highly disciplined and corrective measures, or through dismissal and the complete ignoring of the body, we soon ascertain how to adopt the less than healthy or wholesome behaviors we receive in these messages about the body. Thus, we learn to regulate our bodies to fit certain norms of acceptability or, alternatively, disregard and mistreat our bodies altogether. In deference to the earlier examples of what might be considered dance for young children, I put forward that full regard be given to the body as an all-knowing, all-sensing phenomenon, which has status and is capable of creating dance from an authentic place of being—the self. When the body is afforded full regard, the resultant expression of the body is immeasurable.

Movement, Play, and Dance: Crossing the Divide

A distinct, and yet surprisingly less conspicuous factor to consider is the somewhat prevalent divide between the activities young children engage in, namely movement and play, and dance, despite

the seemingly obvious link between these areas. Tautologically movement and dance seem to be one and the same, however, as previously referred to, not all movement is dance. Nonetheless, there is definitely a connection, which Stinson (1988; 1991c) qualifies when referring to "finding the magic in movement" to transform movement into dance. Stinson (1991c) expands upon this concept of 'magic' by placing the emphasis on the actual movement and what it means in *itself* in contrast to executing a movement to achieve another end, e.g. pointing to something across the room. If the action of 'pointing' focuses on the actual parts of the body engaged in the process (shoulder, arm, finger, upper body), the transformation between 'pointing' to show someone where something is and the intentional focus on the movement (shoulder, arm and finger movement, body position) makes the *movement significant* because attention is paid to the movement rather than the extraneous object of pointing.

Thus, noticing, recognizing, and responding to movement as a form of expression enables transference from movement into dance. Regardless of the inextricable bond between movement and dance, there appears to be a lack of understanding of the ways in which young children's expressive movement can lead to dance. There is a distinct difference between applying the codified language of dance to any movement a child does, e.g. as an action to a song, and recognizing an expressive movement that comes from the child pregnant with some form of intent or kinesthetic awareness. This is dance!

In a similar vein to Dunn's (2003) stance about the divide between dramatic play and drama, a division not only between movement and dance, but also between play and dance invites equal scrutiny. From Dunn's perspective the divide between children's play and drama is more pronounced following the pre-primary (pre-elementary) years, where during the formal years of schooling play is banished to the playground and, thus, devalued as an ally of drama or an approach to learning. In contrast, however, different areas for play can be found in almost every early childhood center both inside and out. A statement such as this indicates that play is valued in the early years of learning, yet, together with movement exploration, neither is significantly apparent as a precursor to, or an initiator of dance in early childhood settings. Perhaps this is because movement and play are

seen as part of the child's world, and therefore, construction, whereas dance is viewed as a subject to be taught and thus, disconnected from the child's world or culture. I posit, however, that the relationship between the child's world of movement and play, and the construct of dance can be linked together.

In addition to the earlier concerns regarding curriculum and what young children can or should learn, there is also the matter to consider how children learn about the less than desirable realities of the world while continuing to sustain the imagined and inquisitive state of childhood. Despite the type of protection put in place to keep children safe and secure the other aspects of life are also evident in children's lives and cannot be avoided. I submit that one of the avenues available for exploring life during the early years that make it possible to face reality, still enjoy childhood and imagine possibilities, is through play. Because of the inextricable link between play and the creative use of the imagination, alliances can be established between play and dance. The possibility to imagine can be brought to fruition through play and dance, because both link to the human condition and, thus, engender the ability to imagine other realities for the world in which we live.

Play in a young child's life is a fluid entity often shifting indiscernibly between real life and an imagined life that comes from within. Play manifests a deepened sense of motivation as the drive of inquiry and accomplishment through play is experienced by the child (Brooker, 2008; Crain, 2003; Egan, 1999; Elkind, 2007; Lindqvist, 2001; Paley, 2004; Slade, 1954; Wood, 2009). Through these avenues young children have the opportunity to see themselves as agents of change, where via play and creating dance they come to know that their actions can affect the world, which must surely contribute to the well-being of children. As Anttila (2003, p. 9) states, with reference to her commitment to the arts, and, in particular, to dance as a way of authenticating the well-being of children:

> I cannot think of any other validation to my decision than my deep, inherent interest in the well-being of children, and my curiosity about the role that artistic experiences, especially in dance, play in that well-being. This interest traces back to my personal experiences in dance, how dance has changed my life, and my background in humanistic education and the idea of self-actualization.

These words echo mine related to dance and early childhood, as well as the role dance has played in my own life. Because of my experience as a dancer and love of dance, I danced frequently with the children at the kindergartens where I taught during my career as an early childhood educator. The continuing process of sharing dance experiences revealed a multitude of different personalities, a high level of engagement, and, from my perspective, great potential for learning and establishing long-lasting relationships. All of these factors are inextricably interwoven with the child's world of movement and play. As a result, the correlations between dance and the child's world of movement and play prompt further investigation.

Dance Pedagogy in the Early Years

Two important questions arise for consideration when it comes to facilitating learning experiences in any area of the curriculum, (including early childhood), especially if the intentions are to honor the learner, offer meaningful experiences as well as engendering the prospect of creating change. These questions are: "Why has this learning experience come about?" and "What is its purpose?" Furthermore, there are other questions to ponder such as "What is the role of the educator?", "What methodology or language should be adopted?" and "What or whose theories should be used?" Additionally, if the intention is to be contextual in nature and, therefore, meaningful so as to work or play with the children in a particular context or location (country, nationality, culture), what pedagogical practices should be considered? It is important to ask these questions as they pertain to dance because this is an area of learning that draws on certain codified language or techniques (Laban, 1947; Ministry of Education, 2000). In their original form these languages or approaches may not be the most appropriate, especially for the very young child or a particular cultural group (Anttila, 2003; Lindqvist, 2001).

Lindqvist (2001) maintains that the influence of Rudolf Laban's theory of movement on dance education relies heavily on how the authenticity of movement feels and conceptualizations of this nature "may not be meaningful for the child" (Lindqvist, 2001, p. 48). Indeed, certain practices are culturally insensitive when viewed as abstract movement explorations and for some children

the approaches that are asked of them related to creative dance are far from meaningful. Moreover, as Anttila (2003) affirms, dance education is not only "too separate from play [the child], but also from drama and other art forms" (p. 53). As Lindqvist (2001) verifies; dance for young children should be linked to their play. The synchronicity between the movement of the body and creative behaviors are inevitable in young children's spontaneous play. Children's thinking and imagination "come into being through the expressive acts of the body in play" (Lindqvist, 2001, p. 50) yet the connections between dance and the child's world of movement and play often appear to be diametrically opposed.

This oppositional concept requires some serious attention in education, particularly during the early years because, as Lindqvist (2001) continues to elucidate, "dance education for young children needs to be creative and productive and to originate in children's play" (p. 49). An opinion such as this has implications for teachers because it indicates that one of the reasons why dance is often less prevalent as an area of learning in early childhood education is because it is seen as disconnected from what is known about young children's learning, and, consequently, from young children's own movement exploration and play. Common misconceptions of dance, especially from a Westernized or Eurocentric point of view, are that dance is too abstract, sophisticated, elitist, overly specialized, or extremely technical (Bresler, 2004b; Stinson, 1988; 2002) and, therefore, unsuitable for the young child. These views come from prior conventional conceptions of what dance is, and not from what is known about dance from an educational or cultural standpoint. Hence, dance as a curriculum area may not be seen as relevant in early childhood education.

Stinson (2002) talks about what is considered apposite as forms of engagement in dance within early childhood settings. Young children, as well as babies and toddlers, may often be witnessed moving to the rhythm of music. From a developmentally appropriate perspective this appears to be an excellent beginning to a young child's entry into dance. However, dance is more than just moving to music because it requires attentiveness or awareness of what the body is doing both inside and out. Stinson (1988) reminds us that young children seem to have, what she terms, special access to another reality. This other reality is

something I would call the imagined world often found during moments of physical exploration and play. For this reason, in order to provide young children with appropriate ways to sense moving in a meaningful manner, it is useful to connect to the "real or imaginary world of young children" (Stinson, 2002, p. 159). In other words, dance must have significance for children and relate to their ideas and concrete experiences, experiences found in daily life and play (Stinson, 1988; 2002).

Equally, children need time and space to develop and sustain their own interests in both dance and play (Stinson, 2002; Purcell Cone, 2009). When intimately linked with the child's lived experiences, exploration of these worlds can be promoted through understanding basic movement skills and by paying attention to the source of the movement, which emanates from the child and her/his creativity and play. The young child often creates a fictitious situation to promote the development of movement into dance. Thus, in a sense, the child becomes 'other' or someone else, which sustains the performative component of the dance whilst acting on and extending the initial impulse that gave rise to the creation of the dance.

Schiller & Meiners (2003) agree with these ideas when referring to dance for young children. They suggest that because the body is a sensory site for learning during the early years, young children learn about themselves, others, and the world through the kinesthetic acquisition of knowledge, values, and attitudes. This early awareness of the moving body reflects the things children encounter during physical exploration and play. When stimulated by the world around them, young children "are inspired to make movement responses" as well as responding to the inner world of thought, imagination, and feeling (Schiller & Meiners, 2003, p. 92). It is salient to remember however, as the authors identify, that pleasurable or disagreeable engagement with dance shapes our attitude and the value we attach to both dance and associated stimuli, such as bodily involvement, physical experimentation, and play.

In my role as a lecturer in teacher education, and specifically in the area of dance and drama, I am constantly alerted to the importance of play and a physical approach to learning. The attributes of physicality and playfulness are indispensable in my field of teaching, just as they should be non-negotiable in the

young child's world. I have witnessed the propensity young children have for moving and playing on many occasions during my years as an early childhood educator. The times I can recall most vividly are those where I have both observed and been invited into young children's self-directed dance experiences and play. During these moments children are engaged in deeply meaningful episodes pertaining to their lives where they take ownership of what is happening, often creating their own fictional or imagined world in the process. As wisely observed by Hanlon Johnson (2002, p. 105):

> Preschool educators and theorists are fully aware of the crucial role of the body in learning: playful and imaginative movement, flexibility, and sensory enrichment. Encouraging the native liveliness, endless experiment and discovery in children's bodies is a commonly held principle for organzing learning at these ages. At that age, the brilliant meaningfulness of preverbal expression is still a palpable reality. Those close to it take it into account.

Despite such accolades and the support of substantive academic research and theoretical knowledge both play and dance can be seen as inconsequential areas within learning environments. They become excess to requirements within a curriculum program already overcrowded with other demands related to teaching and learning (Hanlon Johnson, 2002; Koff, 2000; Wood, 2009; Wright, 2003b). As reminded by Egan (1999, p. 88) education has "largely ignored those things that children do best intellectually ... those imaginative skills attached to metaphor and image generation" that often arise in the arts and children's play. Anttila (2003; 2007) also questions the status of play in teaching where play or playfulness is not viewed as true education.

The concept of the link between dance and play is not new. In the 1980s dance educator and author Diane Lynch-Fraser wrote *Danceplay* (1982) which was followed by *PlayDancing* (1991). These two titles on, 'play' and 'dance', however, tend to reveal a paradox because of the impression that dance is seen as an area requiring discipline and play is viewed as time to 'muck about' and have fun. The idea of dance as fun as opposed to being a serious discipline reflects the marginalized status dance is inclined to have in education. Playing or having fun as a component of dance can be dismissed by educators to ensure that dance is viewed as a bona fide area of learning. Hence, when it comes to dance, the concept of

playing, or having fun can have a compounded negativity. In accordance with other authors (for example Anttila, 2003; Bond & Stinson, 2001; 2007; Lindqvist, 2001; Stinson, 2002; 2005) I believe, however, that dance and play can augment each other, especially during the early years.

Akin to Lindqvist's (2001, p. 43) belief that "play ought to be considered as an interpretation of children's experience in order to create meaning", Lynch-Fraser (1982; 1991) also noted that movement or dance has immense meaning in young children's lives, and play, as an outlet for children's thinking and feelings, reinforces what she defines as the magical link between movement and creativity. Drawing on the work of Liljan Espenak, Lynch-Fraser aims at nurturing the whole child enabling dance, like play, to arise and be recognized as spontaneous and in the moment. Otherwise, if these dancing moments go unnoticed and are not reciprocated, the dance dissolves. As reasserted by Lindqvist (2001, p. 42): "Play forms an early basis for children's creativity ... The child does not separate singing from dancing, or the story from the drama ... Whatever they create, they do it more or less spontaneously." Play, together with physical movement deserves recognition as a relevant form of expression about the child's world. If the young child's bodily movement and play are not responded to or validated, these essential forms of existence can become relegated to minimal moments in a young child's life or dismissed entirely. When the connections between play and the child's expressive movement are not recognized as contributors to the origins of dance, dance as a way of knowing will have less significance for young children. Hence, valuing young children's movement exploration and play as valid sources for dance requires some serious re-consideration, especially within early childhood educational settings.

Indeed, the idea of play and dance, and specifically play in relation to dance education, has been given special attention by a number of dance educators and researchers interested in the correlation between these two areas (see, Anttila, 2007; Bond & Deans, 1997; Bond & Stinson, 2001; 2007; Hanna, 1982; 1986; 1988; 2006; Lindqvist, 2001; Schiller & Meiners, 2003; Stinson, 1997; 2005; Wu, 2005). For Bond & Stinson (2001; 2007) the concept of play became a source of in-depth examination because they discovered the word fun was frequently aligned with dance. In

a study of dance with a selection of students from different countries, Bond & Stinson (2001; 2007) found that a highly motivating factor for engagement in dance was having fun. At first, this finding does not appear to be surprising given that dance in schools could offer an alternative approach to learning for some children. However, the question arose that if dance was only seen as 'fun', there was also the concern that dance as an area of learning becomes devalued.

Whilst the study conducted by Bond & Stinson (2001; 2007) covered a range of age groups from early childhood to adolescents, the significance of having fun was still important across the different levels and indicated that having fun, or being playful, provided a well-needed injection of motivation. Motivation produces serious intent and actually promotes more effort or a form of work ethic. This effort or hard work is clearly signaled in a young child's persistence to achieve a certain outcome or skill and to know the pleasure of sharing that accomplishment with an interested other. The resounding cries in young children's playgrounds of; 'Look at me! Look at me! Look what I can do!' act as testimony to the perseverance and sheer hard work that has gone into such an achievement, an achievement that has often been born from playfulness and fun. As noted by the authors, the line between play and work became blurred. However, the qualities of "self-discipline, inexhaustible curiosity, challenge seeking, and commitment" (Bond & Stinson, 2007, p. 156) encapsulate both work and play, or the attitude of playfulness (Parker-Rees, 1999). And although play may be seen as a form of recreation as a release from work, the disposition of playfulness can unite the attributes of both work and play. Such a finding offers promise for both the status of dance and play, not just in the young child's life, but also throughout our lives. As Parker-Rees (1999, p. 61) indicates:

> Adults who work with young children are particularly well equipped to appreciate the value of playfulness, not only in children's early exploration of cultural systems but also in their own efforts to cope with the pressures of externally imposed constraints. We can learn about playfulness from young children and we may find that we can find opportunities to be playful in our work but we also have a responsibility to share our understanding with a wider audience beyond the world of early years education.

Hanna (1982; 1986; 1988; 2006) also refers to the concept of play in relation to dance and addresses the culture of play as part of the social construction of the child's world. Hanna (1988; 2006) sees dance as a form of play. Just as in young children's dramatic play, the creative ideas expressed in dance, and the opportunity to try things out, have no impact on real life and the possibility of failure. This is because if things do not work out, another dance work can be created. Hanna perceives that these attributes of play can benefit our lives, where dance as an activity of creation can contribute to the alleviation or even prevention of stress. Opportunities to 'play' with ideas in dance can "contribute to positive self-perception, body image, and esteem" (Hanna, 1988, p. 19), as well as enhancing health and holistic well-being.

As Anttila (2007) aptly points out; the expressive content of dance is unquestionably different when connected to children's play and, by association, movement exploration. Anttila suggests that in order to elevate the significance of play in dance education, the children's participation is fundamental, which, in turn, is dependent on the child's background, culture, and her/his opportunities to take part in play. In other words, play is practiced spontaneity and important in its own right in the same way that dance can be seen as significant in and of itself (Stinson, 1988; 2002). As Anttila (2007, p. 876) further elucidates: "This kind of reasoning could perhaps help dance educators [*or early childhood educators*] in their efforts to appreciate the child as a subject; reversing the rationale of dance education from predefined aims and contents to something that Bond & Deans (1997) refer to as emergent curriculum" *(authors comment italicized in brackets)*.

The significance of play as an area of exploration, where negotiation and communication is essential, becomes related, not only to a physicalized understanding of the world and others, but also to the concept of dialogue (Anttila, 2003; 2007). Anttila (2007, p. 876) posits "that dance education could be more closely connected to play", by the very nature of play being dialogical. Our ability to make meaning, imagine, and express ways of seeing the world links to the arts as well as our relationships with each other. With reference to this perspective, Dissanayake (1992, p. 44) also talks about the ties between play and the arts as evident in the following quote:

It is that sense of discovery, of finding out, of creating, of fiddling about, of wonderment, of sense of joy, exhilaration, it is also the root of drama in the sense of dramatic play, and form of rehearsal for life, and therefore for one's survival in this world, making sense of the world.

Play is often about those things that puzzle or confront children in their daily lives as well as presenting ways of working out how we can live together. Dissanayake (1992, p. 44) further states:

With regard to play, the young are practicing skills that eventually enable them to exist in this world. Also, importantly, in play, they learn how to get along with others. Individuals who play, and thereby learn practical and social skills, survive better than individuals who are not inclined to play or who are deprived of play and therefore lack practice with these essential things.

Although play is something that children, in particular, are seen to have a propensity for (not unlike movement), it also requires the cultural support in order for play to become a practiced activity (Fleer, 2010; Paley, 2004; Wood, 2009). Depending on the circumstances, not all children have this luxury, which is also something to be mindful of and, thus, sensitive to. In addition, some cultures do not value the place of play over other necessary skills such as literacy and numeracy, which are deemed important for a successful and profitable life (Brooker, 2008; Cannella & Viruru, 2004; Noddings, 2003; Stinson, 2005; Wood, 2009). As certified by Brooker (2008) when viewing play from a multi-cultural perspective, not everyone is convinced about the effectiveness of play as a tool for learning. Favorable views of play are also often inculcated into the lives of those who already feel they are disadvantaged within a particular culture or society. These idealistic notions of play are reified as an all-encompassing Eurocentric construction (Cannella & Viruru, 2004).

Despite these conflicting viewpoints, it is upheld that through opportunities for play the young child negotiates and navigates with others (or with their environment) a form of shared understanding of what the world is all about. This is done through talking to and interacting with each other. Whatever occurs, or what meaning is established, it is done so in the space between those who are doing the talking and playing (Winnicott, 1999; Wood, 2009). Play, as stated earlier, and as I have often heard said, is the child's rehearsal for life (Dissanayake, 1992; Paley,

2004). Play is an important component in a young child's life and should, therefore, be viewed as integral to other named areas of learning, including dance.

On the other hand, as Anttila (2003) so rightly points out, the word play also has many interpretations depending upon the context in which it is used such as playing games, playing a part, (play-acting), playing an instrument, as well as the different nuances culture and language bring to bear. The notion of play can sometimes be set up in opposition to work-related activities, which creates a binary. In this way play is perceived as a social or recreational past time, such as sport, or as an alternative to work where play is used to intervene in the everyday work-like events such as schoolwork or proper learning. This view effectively limits the potential of play and the possibility play has to create another reality and, therefore, a different way of knowing.

Whilst the world of play and everyday reality are often interrelated, they are also independent from each other. Children are well aware of this distinction and can enter the play or fictional world with ease, yet treat it as if it were real. Hence, young children are quite capable of keeping everyday reality and play reality separate (Anttila, 2003). The imaginary world of children's play is also akin to dance and drama because, while we bring the reality of the world to both dance and drama and treat it as if it *were* real, it is fictional and, therefore, separate from the living reality. Yet, in the same way, both these art forms are connected to life and express what it means to be human.

For this reason, play is not only important in the field of dance education as well as other art forms such as drama, but also in the field of early childhood education and, consequently, life because it helps us imagine beyond the constraints of everyday reality. Play or imaginative experiences in the teaching and learning process can lead into the creation of dance. Thus, the special nature of play in the early years of learning needs to be preserved and honored as an integral contributor to the genesis of dance.

Fun and Playfulness: Being on the Edge

Apropos of the aforementioned noteworthy considerations attached to play and fun, suspicions still remain. Skepticism haunts the functionality of play and fun (or playfulness) in academia in spite

of the robust justifications proffered as to their usefulness not only in education, but also in life. In her study *A Question of Fun*, Stinson (1997) questions how adults consider play and having fun as something childish and only reserved for young children. Noddings (2003) also queries the function of education in her work about happiness in education, which equates to the concepts of pleasure, play, and fun. Noddings (2003, p. 200) reminds us that "given the state of the world and the documented loss of happiness among individuals, perhaps we should be more concerned with understanding and preventing violence, offering more courses in peace education ... encouraging lasting pleasure in the arts." If what we do is guided by enjoyment and the intrinsic rewards this creates, education has the possibility to address the learning needs of many rather than a selected few. By the same token if we only focus on a narrow approach to learning and decide that it is more important to work toward extrinsic outcomes, e.g. making money, then the pleasurable things in life will be overlooked or discarded. Noddings (2007) adds further to this somewhat bleak outlook for education and life advising that as educators we

> have to ask ourselves whether we are contributing to the boredom syndrome by putting such great emphasis on the economic benefits of schooling. Is financial success the only desirable end for their daily drudgery? We engage students too seldom in discussion of the sources of happiness. The boredom that so often accompanies schooling threatens to stretch out to span a lifetime.

Even in the early years the views associated with being playful and having fun affect how early childhood educators may perceive play and *how* they include it in their programs. Pressures from pre-school parents can effectively dictate what gets focused on and what does not, yet the power of play in learning is incalculable. Consequently, both play and fun deserve serious consideration as a valid part of a holistic education and as a way of life.

It is the perception of fun and play as frivolous and trivial that I find I am constantly coming up against, not just in the field of early childhood but also in education in general. I know that having fun, or as it is sometimes translated into, playing, is not seen as necessarily fruitful in a world where there is so much at stake, such as tyranny and oppression. It often appears that the only way to consider the world is to take it seriously. The outcome of which sometimes actually means to be fearful of, or to take on a

deterministic attitude that allows little space for the creative or imaginative spirit. I surmise that when we view the world and, consequently, our action in it from one perspective only, our worldview becomes limited. I wholeheartedly adhere to the idea that if fun and play are permitted into our lives, we can open up new horizons brought about by the power of the imagination, which has been allowed to flourish. If our imaginations are stunted, the creative ways in which the world can be influenced and changed will be restricted.

While I am well aware that there are situations where play and having fun are not appropriate, I find that these misguided dismissive attitudes about play are a slight against the inextricable value both play and fun can have in our society and, consequently, education system. Play, it seems, is all too readily eradicated from the young child's world. As a result the body and all its nuances are also removed, especially the emotional and physical behaviors, because they are essential components of play. These attributes, however, are seen to interfere with the more considered and serious transmission of disembodied rational head knowledge.

I agree with Stinson (1997) that the 'question of fun' needs to be seriously reconfigured if we are to not only capture the interest and, hence, intrinsic motivation of those we teach, but also open up avenues to find alternative ways to live our lives. In this way there is yet another modality, and this includes dance, through which we can work toward freeing the world from oppression because we know something of how freedom or joy may feel in our bodies and in our bones through the experiences of playing and having fun. Play and other embodied forms of engagement enable us to empathize with one another and to also engage with more serious matters through the medium of make-believe and the power of imagination.

Because play, or our memories of play, has relevance to the ways we work through the less than desirable aspects of our lives, play has the potential to help us remember what it feels like to experience through both collaboration and confrontation, not only the excitement and fun, but also the anguish and pain. These elements of play, and how they contribute to our relationships with others, can provide access to other ways of understanding the world and work toward change for a life free from oppression.

Indeed, the very fact that both dance and play can be seen as trivial and therefore on the edge of what might be considered curriculum opens the doors to enable new forms of freedom to emerge. McArdle (2008, p. 365) announces that "there is something to be said for staying on the margins, away from the centre" of mainstream to provoke alternative ways of seeing. Such a position can be powerful, particularly when aligned with humanistic concerns that go beyond the stipulated curriculum of 'core' subjects and required learning. And whilst there is acknowledgment that moving and playing appear to be natural territories for young children, those areas that are highly likely to give children 'voice', such as dance still require the skills and techniques to nurture that 'voice'. Dance on the edge can be a place to access and foster these skills and honor 'why' we dance as opposed to dancing to attain certain normalized standards or levels of achievement.

Perhaps it is timely here to be reminded of Maxine Greene's (1988) belief that when the pursuit of something meaningful is to occur in the practice of education "it must happen on the verge" (p. 23). Eventually, however, dance, as for other areas on the margins such as the arts or physical education, can inveigle its way into the dominant domains of learning whilst still retaining its integrity and authenticity as an art form. In dance, as in all the arts, children's thinking, and thus voices, can be made visible. And as McArdle (2008, p. 372) suggests; "the children's voices can contribute to our efforts to improve our ways of working with children" and challenge the way teachers teach.

Looking at Ourselves and How We Teach

The pedagogical approaches articulated here place the onus on the teacher to provide meaningful and appropriate learning experiences. Contrary to the popular belief that all young children have short attention spans, as Stinson (2002) points out "my experiences with young children have taught me that sometimes their attention span far exceeds that of an adult" (p. 161). I can verify Stinson's viewpoint through my own experiences as an early childhood educator when I have witnessed young children maintaining an interest for sustained periods of time. I have specifically seen situations of prolonged involvement when young children have been dancing and, because they have chosen, and

thus, created the experience, they become fully immersed in the occasion. Children's engagement, and therefore, staying power, is guided far more by their interest in something, which is often imbued with the aesthetics of play (Alcock, 2008; 2009; Lindqvist, 2001). Hence, as Stinson (2002) continues, "we need to follow as much as lead, help them discover their interests, appreciate their creations, and give them the respect of our full attention" (p. 161). It is in these moments of mutual exchange that new imaginings and understandings can be realized if we pay attention and listen to the child who is in our midst (Fels, 2010).

Such ideas confirm giving children a voice and choices in a child-centered curriculum (Cannella, 2002; Dewey, 1959) and, with dance in mind, to provide opportunities for children to move and dance as and when they choose to. These are the times when teachers can become attentive to what the young child is engaged in and support the process as appropriate (Schiller & Meiners, 2003; Stinson, 2002). As professed by Leavitt & Power (1997, p. 71):

> Caregivers can become more comfortable with their own and the children's embodiedness and can learn to restrain their panoptic urge to control everything that goes on in the classroom. In so doing, they free themselves and win back children's—as well as their own—rights to their bodies and desires. When caregivers attend to and respect children's embodied experience, they—we—embrace, validate, and empower the body and the child.

At the same time, those aspects, which the child has not yet experienced or accomplished, need not be neglected. Rather, it is because of our attentiveness as early childhood educators, coupled with knowledge of the children, that meaningful learning experiences can be established for each child.

As I have already alluded to, something that is central to the philosophy of early childhood education is a child-centered approach. The rhetoric of being child-centered often presents teachers with some dilemmas. Teaching generally occurs in institutions, whether in early childhood or other sectors of education, which are governed by larger factors such as time and specific structures. When these factors enter the equation, educators become accountable to more than just the learners. Even in early childhood learning environments, where there is the possibility to be different, there is a tendency to create routines

that can restrict how things are done because of this accountability to a higher or more authorized power.

Being child-centered also relates to how dance experiences can be facilitated in an early childhood setting. Something that is special to dance, as prior to suggested, is the significance of movement itself and an inner sensing or awareness of what the body is doing and feeling (Stinson, 1988; 1998; 2002). As previously stated, in order for this aspect of learning in dance to be achieved it is important to make available both the opportunity and time for this type of experiencing to occur. If given the time and the place to explore, through a guided kinesthetic awareness, the young child can begin to develop a deeper inner sensing of the body beyond that of identifying parts of the body and what skills the body can perform. Experiencing dance using a heightened kinesthetic attentiveness provides the prospect for discerning or sensing something of being whole or in touch with one's self at a deeper or more aesthetic level; something that is often disregarded in young children's encounters (Anttila, 2003).

As part of the kinesthetic experience there is a sense of knowing the body from within in a concentrated way (Bresler, 2004b; Schiller & Meiners, 2003; Stinson, 1988; 1998; 2002) and, in so doing, understanding something of the wholeness of being human. Schiller & Meiners (2003) affirm that: "Children are much more attuned to their body through their senses and have sensitivity of the body ... Moving naturally and using the body as a sensory site of knowing, dance has considerable potential to enrich young children's lives" (p. 94). Leavitt & Power (1997) also make the point that "alternative constructions of the child with respect to his or her embodied experience are possible. These can rescue the child-body and recognize it as a corporeal, intentional, active, feeling reflective subject" (p. 71). From this perspective, therefore, the child can come to know her or his body from the inside out and, as such, become the creator of the movement that the body is to perform. Thus the child literally becomes the center of the action (Anttila, 2003; 2007).

If there is the belief that the child *is* the center of the action, which is not just the action that the adult/teacher decides should occur, but action which the child initiates, then genuine consideration must be given to this process for it to be realized. When the obligation is on the child, the teacher is then placed in a

different position. A reversal of position enables children to experience the freedom to choose how to use the time and, thereby, the opportunity to explore the way their bodies move with more awareness. A correlation can be made here to Hanna's (1999) assertion that attention needs to be given to children's spontaneous and creative dance, thereby reversing the role of the teacher-child relationship where the content is only reliant on the teacher. From this perspective there is more recognition of the child's kinesthetic voice (Hanna, 1999); what I might call the child's agency, or the child "as an agent in dance" (Anttila, 2007, p. 865) where the child's body expresses her or his knowledge of the world.

For many teachers, however, their understanding of the body as a 'voice' or as a conduit of expression is not all that prevalent. This is especially so for those who have received the majority of their education devoid of any form of bodily engagement or sensing through being the center of the action, or the initiator of the experience. It is more likely that the majority have become alerted to their bodies through being forcibly corrected rather than being allowed to develop an awareness of their own bodies through sensitive pedagogical instruction within a framework of freedom (Anttila, 2003; 2004). As explained by Anttila (2003, p. 145): "Freedom is an essential concept in critical pedagogy, as well as in dialogical philosophy ... However, freedom ... is always joined with responsibility." Under this guise, the practice of freedom engenders a heightened consciousness where there is the opportunity to go beyond preordained constraints or limitations and find one's personal agency or, from a Māori perspective, *rangatiratanga* (self-determination). In order for the children to experience this state of concentration and bodily agency it would be desirable for teachers to have some understanding of their own bodily sensing and efficacy. In addition to this, the teacher needs to know how much to guide the child as well as to what extent the child can initiate her or his own bodily experiencing.

Teachers who hold fast to the philosophy of a child-centered approach often face the quandary of whether to influence the learning through direct instruction or to allow the experience to be freely discovered (Bresler, 2004b; Wright, 2003c). A directive methodology eliminates a child-inclusive approach where the learner is left to discover the bodily experience through

exploration, but minimal guidance may result in no experience at all. The desire to help others experience or learn something one cares about tends to go against the notion of learners initiating their learning experiences. Yet teaching occurs because there is a belief in certain aspects and these beliefs cannot be abandoned just because others have not been exposed to particular areas of knowledge and experience (Fleer, 2010; Greenwood, 2003; Kipling Brown, 2008; Shapiro, 1998; 2008b). In dance, therefore, "we have to choose not whether to teach children skills but what and how we will teach them" (Stinson, 2002, p. 163).

Thus, discovery or re-discovery of the adult's bodily engagement through becoming attuned to what the moving body does and feels can heighten the presence and meaningfulness of dance within an educational setting. When coupled with providing time and space for young children to move, as well as support to allow for self-initiated exploration, children are able to experience something which then becomes uniquely theirs as well as expanding their parameters of knowledge.

Multiple and Emergent Approaches

If giving children the freedom to choose to make decisions is truly valued, it is necessary to provide them with the opportunities to explore and experiment with their own ideas and to share and develop ideas with others. Also, the ability of children to use time to explore their own interests needs to be offered and fostered in education and modeled in our pedagogical practices. Alternately, educators can adopt diverse methodologies that result in a fusion of possibilities "that integrates both teacher and student perspectives" (Purcell Cone, 2009, p. 81). When the possibility of different and multiple ways of learning are present, the potential of discovery and inquiry in the learning process is amplified (Bresler, 2004b; Gardner, 1993; 1999; Schiller & Meiners, 2003; Wright, 2003b). Multiple approaches to learning connect to the concept of the emergent curriculum (Jones & Nimmo, 1994), which is a mainstay in many early childhood programs. In this scenario learning is no longer viewed as linear related to "predefined aims and content" (Anttila, 2007, p. 876) but as something that evolves and redefines itself transpiring from the participants within the learning process. Harkening back to the child's 'voice', Purcell

Cone (2009) ascertains that when we pay attention and listen to what the students are doing and saying "we gain insights about what is important in and to their lives" (p. 89).

Apropos of these perspectives, however, there is also a need to be cognizant of the different ways children learn so as not to perpetuate the hierarchies or disadvantages that can exist. For example, when referring to a child-centered approach Cannella (1998, p. 166) forewarns:

> Child-centered, play-based instruction is rooted in the work of Rousseau, Pestalozzi, and Froebel, and is based on the interests, needs, and development of children. A cautionary note however is to be aware of romanticizing this notion of child-centered instruction, which tends to allude to individualism, exploration and discovery. What is often not considered is that one cannot universalize and assume that each child is capable of making choices based on their interests because this presumes that each child has a shared value and experience base.

Consideration of these factors is also important when taking into account those who have experience, or favor the body as a mode of learning, and are, therefore, more comfortable with their bodies, over those who do not favor or have experience with using their bodies. In addition, how we come to know and use our bodies is also dependent on, and influenced by, the lives we live and thus the way our bodies are inscribed (McLaren, 1999; Shapiro, 1994; 1998; 1999; Tobin, 2004). As Cannella (2002) opines, there are people who have a "societal fear of the body" (p. 160) which can be manifested in the curriculum. The construct of the body is an important factor to consider when promoting multiple approaches to learning, because different socio-cultural and historical backgrounds have an effect on our perception of the world and also shape the distinguishing features we bring to the teaching and learning environment (Fleer, Anning, & Cullen, 2009). The transition from one mode of teaching to another, whether it be in dance or in other areas, is not necessarily easy because prior practices have become ingrained. To consider new approaches, particularly within a socio-cultural and historical framework, requires acute sensitivity and a culturally responsive pedagogy. This also means there has to be a focus on critically reflective teaching and thus the role of the adult, which is of special relevance when adopting multiple or divergent approaches to teaching dance that differ from conventional methodologies.

Discussions about the emergent curriculum or multiple and child-centered approaches, or even a postmodern approach to teaching and learning, often result in an accepted belief that this is where nothing appears to be defined. According to Anttila, (2003) this can be translated into anything goes or a 'laissez faire' attitude. It is perceived that freedom, coupled with a lack of authority or discipline, equates to the removal of any real responsibility by the teacher for the children's learning above and beyond the safety and care of the children, especially in early childhood education. I have often encountered such views but see them as misconstrued conceptions of what is meant by any of the above terms. If anything, the role of an early childhood educator, or any educator who believes in following a multi-faceted student-centered and emergent approach to learning, becomes more complex. As reiterated by Anttila (2003, p. 149); "the teacher's freedom, thus tied with responsibility, makes the job of teaching more complex [when] it entails awareness and follow-up of the students' multiple meaning making processes." Greene (1995, p. 57) supports this view stating:

> To understand how children themselves reach out for meanings, go beyond conventional limits (once the doors are ajar), seek coherence and explanations is to be better able to provoke and release rather than impose and control.

The young child is very capable of sourcing multiple ways of knowing as further indicated by Greene (1995) when she states: "Young persons have the capacity to construct multiple realities once they have begun to name their worlds" (p. 57). Moreover, as Greene continues to illuminate:

> The young can be empowered to view themselves as conscious, reflective namers and speakers if their particular standpoints are acknowledged, if interpretive dialogues are encouraged, if interrogation is kept alive ... It becomes all the more important that they tap the full range of human intelligence and that as part of our pedagogy, we enable them to have a number of languages to hand and not verbal or mathematical languages alone. (Greene, 1995, p. 57)

For me, this is a reminder of the excitement found in teaching and learning where the process becomes a reciprocal affair and inclusive and authentic relationships have a chance to develop, thereby opening up avenues for "the hundred languages of

children" (Edwards, Gandini, & Forman, 1998, p. 12). It is also a learned process as the practices we have been taught or trained to follow need to be unlearned, in order to re-educate ourselves to relinquish authority and offer choice. In these moments of relinquishing control and going with the flow to follow the emergent instances learning becomes more meaningful, or more authentic, not only for the learner but also for the teacher because there is an absolute commitment to what *is* happening then and there.

Relinquishing the Self and Going with the Flow

The notion of going with the flow is not necessarily as effortless as it sounds, and is, therefore, an area that requires examining. Such an examination correlates with the idea of being unafraid of revealing the self (Pinar, 1994) or, as Anttila (2003) refers to, "sharing the self" and "letting go" (p. 144). An inability to go with the flow links to being prepared, being in control and, consequently, to issues of power. It is also recognized that power is not fixed, although it seems to be constructed by the particular situation or context one is in (Foucault, 1978). As stated by Pinar (1994, p. 213), "power becomes form through discourse and language" and is not separated from time, place, or thought.

Consequently, it is how that context is challenged or deconstructed and the traditional modes of operation and discourse are usurped that requires the utmost attention. For this reason I ask the following questions. Can educators shift their positions of power within a situation where they are charged with the responsibility to fulfill a particular role of authority? If the teacher (who has the professional background and skills in teaching) switches the roles of authority, or gives more responsibility to the student, will such an action be seen as relinquishing responsibility and making way for the possibility of chaos, or a lack of direction and purposefulness? Or is it simply the way these practices are seen because other approaches have never really been experienced? In addition to these questions, I concur with the questions Anttila (2003, p. 270) asks related to trying to connect to her students and being reflective and dialogic in her approach. She asks: "How do they experience this? Is it important? Does the activity always have to be directed?"

Similarly, Purcell Cone (2009) ponders her pedagogical methods. Reflecting on her lessons, she asks critical questions concerned with, for example, overshadowing the students' creative input, or dismissing ideas that did not fit with her own thinking of what constituted dance. As Purcell Cone (2009, p. 82) explains; "stepping aside and letting the children make the topical decisions was challenging, especially when I did not agree with the meaningfulness of what the children want to dance about." Ultimately, however, when teachers relinquish their overall control and encourage children's (students') initiatives and ideas, children are honored for their capabilities, thoughts, and decisions in a more dialogical, powerful, and authentic liaison with expert others.

The transformation into a reciprocal and dialogical approach through critical reflection is a slow process, but the prolonged process also brings about a more intense understanding of "what it means to be a teacher" (Anttila, 2003, p. 275). Ultimately, this is the intention and the challenge. Provocations such as these compel educators to push the boundaries and find new ways through the process of introspective critical reflection (Ellis & Bochner, 2000; Ronai, 1992) in order to become more authentic in their teaching, and thereby, more fully human in their pedagogical intentions. In turn, there are connections made to teaching for the purpose of developing a viable artistic, educational, and liberating pedagogy in dance (Anttila, 2004; Shapiro, 1994; 1998; 1999) where one is not afraid to embrace risk and uncertainty as well as new possibilities of culturally democratic practice.

At the same time, there is a heightened awareness of alternative ways of knowing, which, for some children, may be neither child-centered nor self-directed. Recognizing "the relationship with the Other and how that relationship can avoid violating the alterity of the Other" (Dahlberg & Moss, p. 65, 2005) means being alert to dominant discourses in the teaching and learning space. When thinking democratically about teaching differently, Cowhey (2006) highlights that "teaching critically listens to and affirms a minority voice that challenges the status quo. Instead of forcing assimilation and acceptance of dominant culture, it reexamines cultural assumptions and values and considers their larger ramifications" (p. 13). Within this type of

scenario the locus of power has shifted and become a fluid entity where multiple ways of knowing and being can exist together.

I contend that when educators are able to let go of control, or relinquish authority, the desire to shift the seat of power in any teaching and learning situation can be like lifting a heavy burden or mantle from one's shoulders. From my experience it certainly creates a space for a more reciprocal and dialogical approach. In a way senses can be heightened when becoming more involved and present in the moment because the concern of the future has been discarded, which would be otherwise designated by our control of the situation. For this reason it can actually be a relief, but the outcome certainly will not be able to be predetermined and that can be both daunting and exciting. When there is complete presence or attentiveness, the relationship with another will become further intensified and what happens in that encounter is the only thing that matters. It is in moments like these that there can truly be an experience of complete embodiment for both the learner and the teacher because when one is fully attentive to another, there can be dialogue (as well as disruption) where uniqueness and difference can be both honored and respected.

The teacher plays an important role (without denying the agency of the child) in establishing a challenging, provocative, and liberating pedagogical environment for the purpose of envisaging change and creating meaningful teaching and learning experiences that connect to the lives of young children. As Greene (1995, p. 42) suggests with reference to our relationships with others, so does play, arts, and the imagination:

> Through proffering experiences of the arts and storytelling, teachers can keep seeking connection points among their personal histories and the histories of those they teach. Students can be offered more and more time for telling their stories, or dancing or singing them ...

> Not only do teachers and learners together need to tell and choose; they need to look toward untapped possibility—to light the fuse, to explore what it might mean to transform that possibility.

It is because of these beliefs in other ways of knowing and of authentic relationships that I see what is possible for dance as it intersects with early childhood education and life.

Dance is integral to a holistic quest for knowledge about the world in which we live, as well as about ourselves and others. A

legitimate education cannot exist if parts of the whole are missing; the interconnecting links that connect us all to being human are crucial in an authentic and holistic education. Dance as a human activity is a necessity in early childhood education, particularly when associated with culture, the body, movement exploration, play, and the promotion of imagination. Dance connects not only to ourselves, but to others, and helps in some way to establish relationships through an understanding of who we are as people living together whilst, in turn, providing a platform for appreciating difference and prompting the possibility for change.

I believe that finding avenues that help children explore, create, and understand the complexities of relationships is essential. Dance is definitely one of those avenues, but dance in the sense that goes beyond simply moving because we feel like it. It is when attention is paid to what the body is doing that, as Schiller & Meiners (2003) posit, "[d]ancing combines technical skill with physical awareness and aesthetic and artistic understandings. [Accordingly it] provides a unique way of knowing about oneself, other people and the world" (p. 91) all of which commences during the formative years of life.

Dance and Culture

Cultural Matters, Practices, and Meanings

Like many of the countries of the South Pacific, Aotearoa New Zealand has a colonial history. As a component of that history the Treaty of Waitangi (*Te Tiriti o Waitangi*) as referred to in Chapter Two sets out a mandate to ensure the nation aspires to work toward bi-cultural relationships between the indigenous people, the Māori, and other (predominantly Pākehā). This also means that by virtue of its political positioning the Treaty underscores education in Aotearoa New Zealand. Accordingly, Māori values inform the shape of curriculum as found, for example, in *Te Whāriki: He Whāriki Mātauranga mō ngā Mokopuna o Aotearoa: Early Childhood Curriculum* (Ministry of Education, 1996), which obligates reviewing pedagogical practices.

Educators are faced in teaching with complex multi-faceted people shaped by traditions of history, culture, and environment (Cannella, 2002; Dahlberg, Moss, & Pence, 1999; Fleer & Richardson, 2009; Kincheloe, 1993; MacNaughton, 2005; 2009; Steinberg, 1996; Steinberg & Kincheloe, 2004). Consequently, any epistemological situation cannot be taken for granted through believing that it is the teachers alone who possess not only subject knowledge but also in-depth cultural understanding and are, therefore, the sole people capable of imparting wisdom. Such a viewpoint can shatter the assumption of hegemonic authority (Cannella, 2002; Kincheloe & Steinberg, 1999) because there is a definitive shift of power. The control or agency becomes transferred from what is normally seen as the one who holds the dominant position to the less competent participant in the learning process (the child) or minority (the 'other'). Thus, as already indicated in the previous chapter, a situation is created where the teachers take "risks alongside the children" (Fraser, Price, &

Aitken, 2007, p. 43) and, therefore, knowing others. Educators relinquish their own positions of authority in order to embark on a new journey of discovery as a co-creator of learning with the child and their family (*whānau*) (Anttila, 2007; Bond & Deans, 1997; Hanna, 1999; Ministry of Education, 1996; Pere, 1994). Congruently, the children and their *whānau* also take chances in their roles as initiators of new learning alongside the adult/teacher. Such a position, nevertheless, ultimately engenders children and *whānau* the opportunity to "exercise their *tino rangatiratanga*" (self-determination) (Ritchie, 2008, p. 206) as active collaborators and co-constructors of *mātauranga* (knowledge).

What is more, a change in positions of authority and the acquisition of knowledge challenges what is taught and how it is taught (Webber, 2008), especially from a cultural perspective. If educators are not attentive to the children they are teaching, as well as the knowledge which is embedded in the cultural inheritance of each child, the reciprocal nature of teaching will cease to exist and the relationship will be ineffectual. Perhaps this is where, as Anttila (2003, p. 94) states, "the teacher needs some magic, being like a magician, to spread something extraordinary, something different from everyday" in order to connect to the children and their backgrounds to establish a meaningful learning environment. I would also equate this 'magic' to something akin to bearing one's soul, or, as Ritchie (2008, p. 204) prophesizes, "embracing intuitive holistic ways of (un)knowing that transcend concretised representations and categorizations" which renders new learning to emerge. In this way it becomes more than just the specific subject knowledge that is being imparted and shared, but also our own lives and our own stories. This occasions the provision of what Bhabba (1994) refers to as the third space, thus opening up another place to re-conceptualize knowledge creation or produce meaning.

Te Whāriki as an Empowering Curriculum for Dance

For early childhood services in Aotearoa New Zealand the cultural underpinning of Māori values embedded in *Te Whāriki* (Ministry of Education, 1996) offer the prospect of subverting prescriptive methodologies and creating an opening to embrace inclusive

practices. Some examples of all-encompassing and alternative practices from a cultural perspective can be found in the ritual of welcoming (*powhiri*) or the sharing of food (*kai*), which attends to people's spiritual well-being (*mana atua*) (Ritchie, 2008). The provision of culturally meaningful activities, which are learned and shared alongside one another in the spirit of *ako*; the Māori concept for reciprocity between the learner and teacher (Pere, 1994), reflects "the Māori value of *manaakitanga*, the obligation to care for others" (Ritchie, 2008, p. 205). These cultural practices honor the presence of the child, which contributes to a deeper understanding of what it means to receive the children among us (Fels, 2010).

By the same token, if, as Duhn (2006) suggests, aspirations related to not only cultural, but democratic ideals of social justice are paramount in our outlook for children, educators need to become critically reflective and engage in a praxis of change. "The desire for social change, embedded in liberal aspirations such as equality and empowerment, can only be achieved if citizens involve themselves in democracy" (Duhn, 2006, p. 197). A proclaimed progressive curriculum such as *Te Whāriki* requires teachers to critically analyze their own pedagogy and normalizing views of the child in order to fully realize the true essence of the awesome challenge put forward by Māori in the formulation of the curriculum.

Because who we are as people is embedded in our socio-cultural histories and integral to our practice as educators, the process of reflection is a key component (Ellis & Bochner, 2000; Schon, 1987). We share ourselves in the act of teaching, which relate to these words by Stinson (2002): "What we teach is who we are: the stories of our lives" (p. 157). There is much to reflect on related to who we are as people, and therefore, as teachers, that makes the process of critical reflection essential. Consequently, the views educators hold about those they teach invite critical examination.

From a Eurocentric or Westernized perspective the field of early childhood education is (or has been) directed by developmentally appropriate practice and therefore what is deemed needed or required because it is found wanting or missing. Thus, those things that are perceived as a lack of competencies, often guide educators in their work with children (Anning, 2009; Anttila, 2007; Bresler & Thompson, 2002b; Cannella, 2002; Carr,

2001; Woodson, 2007). Children, nevertheless, do not enter the realms of early childhood or classrooms as blank slates onto which to etch knowledge, values, and beliefs. They come equipped with incredible achievements and qualities that should be cherished and expanded upon, rather than subsumed into a hegemonic culture based on normative standards and restrictive views of what constitutes education (Kincheloe, 1993) or the image of the child (Cannella, 2002; Dahlberg & Moss, 2005; Duhn, 2006; Rinaldi, 2006).

Coming from a Māori standpoint learning is deeply embedded in the life world of Māori *kaupapa* (cultural customs and protocol) and Māori *tikanga* (cultural values and beliefs) (Pere, 1994; 1995; Reedy, 2003; Ritchie, 2008; 2010), which offers a very different type of engagement with the world. As Reedy (2003, p. 55) elucidates: "Māori tradition identified the Māori child as a valued member of the Māori world—before conception, before birth, before time." All children were seen as precious and inculcated with an understanding of the importance of their own heritage and stories.

Despite the pertinence of indigenous knowledge to the Māori people, earlier renditions pertaining to schooling in Aotearoa New Zealand were angled from a dominant (Eurocentric) perspective only. Because 'other' did not possess the cultural capital of the dominant Pākehā society, Māori children within the education system became associated with something referred to as the "deficit theory" (Simon & Tuhiwai Smith, 2001, p. 116). This deficit marker has continued to reign and influence how knowledge is acquired within the dominant Eurocentric discourse (Simon & Tuhiwai Smith, 2001) leaving little room for indigenous or other ways of knowing. This was, and still is, based mostly on the acquisition of the English language with its reliance on the written word. Such a position effectively negates a more holistic oral and corporeal tradition of knowledge transition favored by Māori, including the use of *te reo Māori* (the Māori language) and *te reo kori/tinana* (the movement and language of the body).

A challenge such as this raises questions about the construction of learning within early childhood settings and how the decisions related to curriculum are made. To address not only cultural aspirations, but also issues of equality and empowerment for the purpose of working toward social justice, necessitates a shift in cemented pedagogical and epistemological inheritances.

Such a transition has implications for dance in the early childhood curriculum where cultural traditions and contemporary views of transmission interface. The boundaries between different methodologies raise the potentiality for uneasiness. Even under the auspices of a national curriculum that espouses equality and empowerment, there is a danger as Pinar (2010, p. 5) points out, for nationalism (or nationalized approaches to curriculum development) "to destroy specificity, most prominently the indigenous." Because, as Pinar continues to elucidate: "The personification of specificity is the individual; the 'subject' is the lived site of remembrance and reconstruction ... the individual personifies ... history and ... circumstances." The privileging of white or Eurocentric modes of transmission continues to reify the status of one dominant way of knowing, which overrides and discredits other ethnic or cultural practices. One prevailing approach raises risks or challenges for teachers as well as children above and beyond the already stated demands corporeal enterprises such as dance present.

Intercultural Connections: Crossing Borders

Perhaps one of the ways to illustrate the concept of domination related to the world of dance is to provide an anecdotal account of an event where intercultural connections are fostered. Personal narrations enable the interstices between power and cultural constructions to be critically examined.

Since 1978 I have been a member of an international dance community that aims to recognize and develop dance for children and young people, "with respect for the ethnic, gender and cultural identities of each young person within a spirit of international understanding" (11th Dance and the Child International Conference, *Cultures Flex: Unearthing Expressions of the Dancing Child* Programme Guide, 2009, p. 12). Dance and the Child International (daCi) is an association that promotes the development of dance for children and young people on an international basis. As further stated:

> daCi strives to promote all that can benefit dance and the child and young people, irrespective of race, colour, sex, religion, national or social origin. The right of every child and young person to dance and the preservation of the cultural heritage of all forms of dance for children

and young people are recognized. In creating opportunities for children and young people to experience dance as performers, creators and spectators their views and interests are of primary importance. The inclusion of dance in general education and community programmes and the research into all aspects of dance for children and young people are encouraged. (11th Dance and the Child International Conference, *Cultures Flex: Unearthing Expressions of the Dancing Child*, Programme Guide, 2009, p. 12)

In this global nation each of us has the potential to be in contact with others from many places around the world. As an organization, Dance and the Child International reflects increased mobility of international traffic where people of the world have become far less isolated as they gather and form new transnational communities every three years in different parts of the world.

At a Dance and the Child International conference I attended some years ago in Regina, Saskatchewan, Canada, the keynote speech was presented by dance educator and researcher, Karen Bond. Her speech, entitled "Revisioning Purpose: Children, Dance and the Culture of Caring" (Bond, 2000, p. 3) was presented with the intention of visualizing fresh hopes or possibilities in a new millennium for children and dance across cultures and nations. While espousing a positive, affirming, and hopeful message about the role dance could play in the lives of the future generation, Bond also shared her views about the oppression many children of the world face. Bond soberly reminds the audience that there are children worldwide who presently suffer from lack of food, shelter, medical care, and basic education. Consequently, while dance for children is promoted, a more global view of the world's children needs to be considered.

People have danced since the beginning of humankind as discovered in Stone Age caves where there was evidence of early dance (Bond, 2000). Children dance; it is said that dance is more universal and older than education as children instinctively know (Espenak, 1981) and, as Bond (2000, p. 6) points out; "children were probably the first dancers of our species." Thus, as an aspiration of Dance and the Child International (daCi), it would appear that dance should be a part of all children's experiences socially, culturally, and educationally.

Despite these aspirations, Bond (2000) laments that many of the world's children do not have access to a basic education or

experience fundamental human rights. For many children dance is the least likely possibility in their lives. If there is to be a re-visioning of dance for the future, as well as a revision of children's lives, it has to be one that aspires for the eradication of any form of oppression and strives for the rights of *all* children. It is through the children that this awesome task or undertaking gets passed on. Today's educators, and this includes those who teach dance, need to be cognizant of the messages being transmitted to children. Is it a message that we care about all people beyond our own walls, neighborhoods, or borders to honor the diversity different cultures bring to the world of dance and, thus, to our societies? Or is there an air of ambivalence about such aspirations?

Dance is one avenue that can be used to make significant strides in intercultural and transnational relationships. In the process of doing this, however, a critically conscious awareness or conscientization (Freire, 1998) of how and why things come to be in the world, including dance education, needs to be applied. If, as Bond (2000) asserts, children know more about dance than we give them credit, we need to listen to what children have to say about dance to begin to understand how dance is meaningful from a child's perspective. A myriad of viewpoints may be revealed in the process giving better access to what dance really means and how such understandings are constructed.

As Bond continued to express, she noted that in past times there was a reason why people danced. Dance had cultural meaning and was also often intergenerational where all people danced, sometimes for joy, sometimes for releasing woe, or expressing the uncertainties or the unknowns of life. These are all cultural connotations that are important to consider, because, while being culturally significant as well as intergenerational, dance can also be intercultural and allow "expression of both difference and unity in a web of life that connects us all" (Bond, 2000, p. 12). When the doors are open to multiple ways of experiencing dance, dance has the potential to change people's views about living together, especially if there is a willingness to acknowledge difference.

While attending this inspiring keynote address, I listened intently to the wise, passionate, and thought-provoking words wondering what this really meant to dance teachers and to those who danced, including the children and young people in the

audience. As this speech spoke to the younger people in the audience with regard to their futures and the roles they could play in shaping that future, I was curious about their reception or interpretation of the message. Did a vision of this nature change their views about who they were as dancers, as well as citizens in a global and international community?

In order to satisfy my curiosity further I began observing the children in various venues; as audience members at dance concerts, as participants in the dance events, and their interactions with others within an international village. I noticed that certain groups of children appeared to exhibit less than favorable traits when it came to responding to other children's dance performances. I overheard some children sitting in the audience who appeared to have little to say that was complimentary about the dance groups performing, especially those dance groups that were from countries other than their own. Was this because of a cultural divide? Or was it because the construct of dance taught them well about competition, about seeing themselves as better than others? These questions led to further queries about respect for diversity and understanding difference. Where was the sense of community? Where was the extended hand of friendship that this conference so earnestly wanted to foster and yet still appeared to be somewhat disingenuous when cloaked under the capriciousness of dance?

Admittedly, these types of behaviors were generally exceptions to the rule. I consider these attitudes are probably in the minority rather than the majority. There was definitely evidence to show children engaging with others from different nations. Children forged friendships and danced together in a show of unity. It still concerned me, however, that some of these ingrained attitudes existed among children and youth who had been given a chance to share their lives and their dance with others from around the world. A wonderful opportunity had been offered to cross the bridges and to broaden horizons. The construction, nevertheless, of some specific Westernized approaches to dance is, seemingly, strong competition to these ideals.

My recall of this experience leads me to question why there is antagonism against coalition with others who are different from ourselves, or, as in this case, the disparaging of people whose dance is perceived of a lesser standard or less worthy. This

recollection is a reminder that there is still a long way to go and dance is no more innocent in the construction of these attitudes than other areas of learning. In a way, this is an example of the continuing subjugation of certain populations where power is held and used by far more powerful factions to maintain the status quo. That power could be held by a nation, or by a particular group of student dancers. Ultimately, however, that power can be destructive, or can shift depending on one's situation or position. As noted by Villaverde (2008, p. 123) "the existence of power is not the issue ... rather, [it is] how power is exercised and experienced" that matters. Creating a democratic and socially just environment where there is affirmation of difference for all students of all backgrounds, "linguistic, cultural, socioeconomic, among others" (Nieto, 2002, p. 221), including ethnicity, race, religion, gender, age, and ability, is paramount. Thus, recognizing the functionality of dance as a border crosser needs careful consideration to ensure equality and justice for all people becomes a human right not just in temporarily constructed international villages but also on the global stage.

Dance and Difference: Cultural Borderlands

As a dance educator I am aware of the multifaceted nature of dance. Because of this pluralistic reality, the importance of considering multiple pedagogical perspectives within the frame of multi-culturalism is essential. For that reason the monolithic European or 'white' Western mode that often predominates in the process of teaching dance needs to be problematized (Bolwell, 1998; Churchill, 1996; Shapiro, 1998; 2008c; Walker, 2008).

If, for example, dance is only seen in one way, with one language and pedagogical process to draw on, namely a Westernized discourse, how are the multi-cultural, multi-national, multi-ethnic, or global aspects of dance addressed? How do ethnic dance forms maintain their ancestral heritage born of resistance to colonized domination where oppression and subjugation was wrought upon nations such as cultural denigration, appropriation, assimilation, forced migrations, and enslavement (Walker, 2008)? As Shapiro (2008c) deplores, the cultural narratives of dance are prone to become disconnected from the historical-cultural intent of the dance. Furthermore, "in a global society in which cultures

become more fluid, commodification and fusion are inevitable, and the function of dance as a record of, and a modality for the hope, dreams, and struggles of, a culture can easily get lost" (Shapiro, 2008c, p. 67). And whilst a search for our commonalities may be laudable, the annihilation of difference that results in a demise of a culture or race cannot be tolerated. Hence, it is necessary to present alternative approaches to learning dance from both an indigenous and multi-cultural perspective. If, as Churchill (1996) induces, there is a belief in a united nation and world of humanity, those committed to liberatory education must make every endeavor to critically scrutinize dominant hegemonic pedagogical methodologies and epistemologies, something that applies equally to dance.

A strategy such as this calls for a wider view of education where, within the domains of predominant Eurocentric approaches, a new paradigm needs to be introduced. As Churchill (1996) continues to stress, the Eurocentric view of education can no longer rely on its supremacist dominant perspective of knowledge and learning "to the ultimate exclusion of all others" (p. 280). Nor, I suggest, can it exude tokenism in its approach to other cultures, by acknowledging and including them in the curriculum without any alteration to how these new knowledges are perceived. By disregarding the dominant cultural application of learning, the process implicitly conveys that the Eurocentric approach is really the right approach. In agreement, Ashley (2009) adds to this argument recommending that pedagogical approaches to dance need to be re-developed in response to the multi-ethnicities encountered in today's teaching spaces.

From a bi-cultural perspective the mindful consideration of indigenous ways of knowing in Aotearoa New Zealand is imperative. As stated earlier, Aotearoa New Zealand is a country that is in the process of working toward the aspiration of equal partnership between Māori (or indigenous people of Aotearoa) and Pākehā (white colonial settlers) to honor a treaty that has historical significance. This significance is indicated in the following quote by Greenwood (2001, p. 197):

> Perhaps the key issue in New Zealand today [in this post-colonial time] is the public relationship between Māori, the indigenous people, and Pākehā, the immigrants to the land. The debate today is about the

extent and form of Māori self-determination and about Pākehā relation to that self-determination.

The people of Aotearoa New Zealand need to be fully committed to redress the injustices the Māori people underwent during the process of colonization in order to achieve this form of self-determination. In addition, a promise of this magnitude must be supported by educational initiatives that both honor and promote Māori values and beliefs. From a bi-cultural and bi-lingual perspective, therefore, a continued emphasis on equal partnership is crucial, together with the acknowledgment of an increasingly multi-cultural and multi-national society, which incorporates a range of South Pacific Island and Asian nations and, more recently, from countries further afield such as India, Africa, South America, and Eastern Europe.

With this said, however, it is often difficult to navigate the dominant rhetoric inherited historically and internationally in order to find the language to describe or conceptualize a specific location. Likewise, to include the Māori language within the global framework of rhetoric requires a form of explanation beyond the basic acceptance of terminology. This is aptly stated by Greenwood (2001, p. 196) in the following way: "Even the name *New Zealand* carries a positioning—it names the country after its colonial history. *Aotearoa* avoids that particular problem, but requires other explanations in the same way as *poi* and *haka* require explanation, whereas *ballet* doesn't."

Correspondingly, there are the many languages of personal narratives so vital to critical pedagogy that need to be drawn on, so voices, which are normally silenced, begin to be heard. Dance is one place where a diverse group of students can find their 'voice' or '*mana*' (personal agency or self-determination) through a form of expression that is, or could be, very much a part of their embodied life-worlds. With the reinstatement of the multitude of different voices in the learning process, coupled with the engagement of the body, which incorporates students' lived experiences, the possibility for multiple approaches, languages, and vitally pertinent issues is more likely to occur. This, in turn, can disrupt the dominant and introduce a critical component learning in, through, and about dance from many different perspectives. Such a process promotes intercultural connections and helps to traverse cultural borderlands.

The multiplicity in today's society cannot be ignored or simply seen from one perspective, i.e., the dominant perspective. When looking at the issue of multi-cultural perspectives, McLaren (1992) cautions that notions of multi-culturalism and diversity as affable and harmless need to be discarded because such forms of thinking tend to subvert how knowledge of cultures are often founded in histories of social hostilities and hatred.

The word diversity conjures up the inclusion of a wide range of learning styles to encompass the multiple life experiences with the proviso that it does not subsume or assume the knowledge of the other, or ignore the history that carved out the characteristics of that culture. The arts can have a role to play in encountering and coming to know different cultures, as well as understanding how cultural identities are shaped. By critically examining and altering the terrain, the arts can go beyond simply including quaint customs of other cultures within a dominant and immoveable framework. As Greenwood (2001, p. 199) posits with specific reference to bi-culturalism within the context of Aotearoa New Zealand:

> Today monoculturalism is no longer an option, nor would many New Zealanders, Pākehā or Māori, want it to be. However, we are still struggling with individual and systemic understandings of how a two-cultural society might be structured, what it would be like to live in, and what kind of roles we can take. For the most part the debate about culture and identity tends to take place in a political forum, at the level of economic and legal analysis or at the level of grassroots reactions.
>
> And therefore it remains a debate—from relatively fixed postions. If we turn to the arts, it is as cultural products, as icons of various understandings of identity.

As part of humanities, dance, as well as other art forms, provides an avenue to embody a diverse range of learning styles so that the lived experiences of students can become central to a critical pedagogy of difference or coalition (Sasaki, 2002). As Sasaki (2002, p. 35) expands; a pedagogy of coalition "addresses the ways in which knowledges are dynamically produced in the multiple, intersecting, and often competing narratives of the personal, apolitical, and social." What is called for is a reframing of the notion of difference via the self or the interrogation of one's subjectivity. Through the creative process of the arts there is a

"means of exploring, and of reshaping, who we are and how we live together" (Greenwood, 2001, p. 199). In this union of difference new meanings can be found; meanings that emerge from an alliance, albeit sometimes a less than comfortable alliance, which produces profoundly deeper and more enriching understanding.

Creating a dance curriculum that comprises the diverse cultures and ethnicities of Aotearoa New Zealand as well as honoring a true partnership with the indigenous people, the Māori needs to be done in collaboration with both Māori arts educators and the Pacific Island communities. Bolwell (1998, p. 81) substantiates this perspective adding: "In Polynesian cultures ... the arts are regarded holistically" and "it is inconceivable in most contexts for Māori and Pacific Islanders to sing without also expressing themselves bodily" which, for example, alters the way music and dance are taught. She goes on to say "competency in these art forms also means acquiring language skills, with the centrality of language in the dance form (through chant or song)— a direct contrast to the non-verbal traditions in Western dance." Additionally, Bolwell (1998) suggests that the genesis of dance evolves from the act of identifying oneself, one's *iwi* or tribal base, and one's family or *whanau*. Together with acknowledging the origins of dance forms from other cultures, this view indicates the importance of creating not only an interdisciplinary approach to learning in the arts, but an integrated approach to learning in relation to many other curriculum areas guided by a strong contextual, historical, cultural, and social base.

However, as pointed out by Hong (2003) Western approaches to learning and teaching dance need not be relinquished. As Hong (2003, p. 153) stipulates:

> The dominant canons of Western dance forms and Western civilizations are still important, just as those other civilizations are. What is necessary is a more complex and diverse version of culture taught in schools so that Western dance forms are taught in context, like dance from many cultures.

Having said this, it is also important to remember that every possible cultural style of dance cannot be incorporated without considering the context or backgrounds of the students being taught. Simply including every nation devoid of any necessary understanding of the customs, practices, and traditions encompassing each nation or culture, or a "culturally myopic

approach" (Hong, 2003, p. 153) would be tokenism of the worst kind. Any form of multi-cultural incorporation must be contextually appropriate, preferably involving the different cultural communities and resources, in order to be meaningful, as well as being steeped in the *kaupapa* (foundations or guiding principles) of the culture (Ashley, 2009). In fact, it would be imperative to acknowledge the lived experiences of students as an act of liberation to eschew cultural appropriation and destruction (Ashley, 2009). For example, when expressing the cultural significance of Māori dance, the life world of being Māori is explained eloquently by Māori arts educator Keri Kaa (1999, p. 8) in the following passage:

> Everything is intertwined. The *tinana* (body), the *hinengaro* (mind) and the *wairua* (spirit) are joined as one. If you don't understand what you are singing and dancing about, your peformance has no integrity. The *ihi* (energy force) or the *wana* (quality of performance) are missing.

From an educational perspective the role of cultural knowledge must be acknowledged, and this includes all forms of dance that are imbued with cultural meaning and represent the cultural identity and heritage of students (Ashley, 2009).

Cultural Interfacing: A Pedagogical Approach

One of the ways to achieve a deeper and more holistic understanding of a culture is to live and learn within a culture and to take it on firsthand. From a bi-cultural perspective within the context of Aotearoa New Zealand this means that the space where the learning and teaching occurs is decidedly "visibly and functionally Māori" (Greenwood, 2001, p. 197). The participants in the learning process (students, educators, artists, Māori elders) learn together through sharing their collective resources, knowledge, and life experiences within the context of a living and breathing culture. In this way the history, protocols, and values embedded in the culture become an integral part of the process and are engaged in through creating the art work. Together, both Māori and Pākehā alike begin to identify with the other without necessarily either needing to have to take on the role of the all-knowing. This means that as a Pākehā one need not be proficiently conversant with the Māori language (*te reo Māori*) and for the

Māori one does not need to be the all-knowing from a Māori perspective and fear appropriation by the more dominant other. It is about taking risks on both sides and enabling new knowledge to emerge.

From a bi-cultural aspect this has to be one of the ways to approach shared understanding, because until the dominant are prepared to step over the *whare* (Māori meeting house) entrance-way or "physically cross the threshold into a Māori world" (Greenwood, 2001, p. 198), the only people who will uphold the bi-cultural aspiration will be the Māori, or the minority who have no choice because they are forced to live in two cultures. A form of cross-cultural experience will help develop "a dynamic bi-culturalism" (Greenwood, 2001, p. 197) where there is the chance for the voiceless other to be heard through an artistic venture that both acknowledges and honors Māori values and opens up possibilities of what could be (Greene, 1978; 1988; 1995; Slattery, 1995; 2006).

As a consequence, a form of dislocation as well as relocation is enacted. In this type of situation one can encounter the concept of "making the familiar strange" (Kincheloe & McLaren, 2000, p. 286) where what is normally at the center or mainstream becomes decentered. There is a sense of working against the grain in an environment that appears to be familiar, yet unfamiliar because one is now in the "world of the 'Other' and, at least temporarily and partially ... experience it as their own" (Greenwood, 2001, p. 203). A re-location and, thus, location of oneself physically and emotionally into another space where intercultural explorations can occur and new understandings and relationships develop helps contribute to a re-vision of living together. An inter-cultural or inter-disciplinary approach also contributes to a re-visioning of dance education particularly when it comes to issues of multi-culturalism. In today's society multi-cultural issues are already central to a contemporary view of the world and, as pertinently reminded by Bolwell (1998, p. 84), unless "dance educators grasp the issues and enter into the fray ... we will simply be further marginalized within the larger education arena."

The inclusion of the subaltern (Spivak, 1992) or the voice of the other in conjunction with the dominant culture both have the opportunity to contribute to the creation of knowledge and, in so doing, crack the veneer of what is normally accepted as the

mainstream approach. Transgressing whatever the prevailing mode of transmission might be is necessary to find new ways of understanding each other as well as deconstructing what is given or taken for granted. The door becomes open to completely different ways of knowing when indigenous or other cultural approaches to understanding the world become part of learning and teaching. As stated by hooks (1994, p. 44):

> Multiculturalism compels educators to recognize the narrow boundaries that have shaped the way knowledge is shared in the classroom. It forces us all to recognize our complicity in accepting and perpetuating biases of any kind. Students are eager to break through barriers to knowing. They are willing to surrender to the wonder of re-learning and learning ways of knowing that go against the grain. When we, as educators, allow our pedagogy to be radically changed by our recognition of a multicultural world, we can give students the education they desire and deserve. We can teach in ways that transform consciousness, creating a climate of free expression that is the essence of a truly liberatory liberal arts education.

If education *is* based on "what we know" then there should be a place for other knowledge, which provides us with alternative ways of looking at and interpreting reality. Thus, it is incumbent upon both educators and students alike to enter new spaces to experience the other whilst embracing a culturally responsive pedagogy (Melchior, 2009).

Culturally Responsive Pedagogy in the Early Years

From an early childhood point of view and with special consideration given to *Te Whāriki* (Ministry of Education, 1996) both bi-cultural and multi-cultural subjectivities call for a more enriched understanding of what it means to address cultural inequities. The extent of how advantageous these possibilities might be is dependent on the volition of all engaged in the early childhood sector to counter the dominant discourse of colonialism and presumed mantle of power (Ritchie, 2008; 2010). In dance, therefore, it is about deeply engaging with the origins of *tikanga Māori* (Māori culture, beliefs, and values) to render problematic the tokenistic appropriation of Māori dance forms that do not possess the heart (*manawa*), spirit (*wairua*), or energy (*ihi*) so integral to Māori dance. Or, in the case of Pasifika dance, to honor

the offerings of young Polynesian children as they share their traditional dances in the generosity of spirit given. The 'learning' of dance for both Māori and Pacific Island children is not separated from learning about life but comes about as part of being immersed in their culture alongside adults. There is an indefinable need to honor this traditional mode of passing on knowledge, which has existed for a very long time within these cultures. This is evident in learning traditional Māori dance as indicated by Keri Kaa (1993) in the following passage from an interview sourced by Bolwell (1998, p. 82):

> We sing and dance because we must ... and you learn because your granny teaches you, or your grandad, and you soon learn to keep the beat when the old lady pinches your leg and says "E tu (stand), dance now." You don't get told anything; you get signaled to and you stand up and you copy what your elder's doing so that the music and dance is not seen as a separate part of your life—it's just there all the time ... Who taught me? Nobody taught me; I just listened and watched by being part of the scenery. There is no provision for that kind of learning anywhere. The whole thing now is that you go to classes and you parrot off. It's the new way—teach it as a skill, but then it just becomes a technical matter without knowledge behind it.

When 'teaching' dance as a subject becomes disconnected from its cultural purpose or intended narrative, there is a danger of losing the culture and, thus, all the dreams, hopes, fears, struggles, and resistances embedded within. Simply translating a codified, Westernized dance vocabulary into, for example, *te reo Māori*, does not do justice to the eons of history and ancestry that have created the dance. Our very young children receive this dance with a wisdom and openness that far exceeds fragmented or contrived renditions of dance devoid of cultural meaning. As testified by Kuini Moehau Reedy (2007, p. 14) regarding her passion for *te reo Māori* (Māori language) and *haka* (dance): "It is the dance form that is connecting us with the environment: it is trying to keep in sync with everything that's been created. It's that kind of relationship. So we learn through that." Learning to dance, together with other cultural inheritances, was instilled by being present among experienced or expert others. Knowledge grows and remains within each child waiting to be rekindled. The teacher's responsibility is to nurture what already exists (White et al., 2009).

I uphold that when dance is steeped in authentic cultural roots, and there is a belief in the powerful child, the principles and strands of *Te Whāriki* so boldly emblazoned across many early childhood centers' walls can become realized. Implementation of the promises, extracted from The Treaty of Waitangi (*Te Tiriti o Waitangi*), requires a vision that transcends mere rhetoric to ensure they become active occurrences. As persuasively asserted by O'Loughlin (pp. 144–145):

> Teachers need to be taught how to go beyond imparting inert, dominant culture cognitive knowledge, and should be prepared to engage children in emotionally and imaginatively liberatory pedagogy rooted in ancestral lore but widening to a future of healing and possibility.

> I envisage a curriculum that will allow children to locate themselves critically within their own ancestral histories and memories. The curriculum that will emerge from such a venture is what I refer to as *small-h history*—a curriculum that implies a readiness to accept the wisdom of elders, and the power of myth, storytelling, folk art, performance, and other forms of knowing that bend, stretch, and even transcend *logos*.

A curriculum that reclaims the embedded memories "to engage children's minds, hearts, bodies, and souls" unearths "embodied histories" (O'Loughlin, 2009, p. 147), which simultaneously liberates and renews connections to other cultural or indigenous ways of knowing. When educators become committed to engagement with other without applying assimilationist tactics or exhibiting a concern for reciprocity, they become moral agents in the act of 'ethical encounters' with others (Dahlberg & Moss, 2005). The transference of these ideologies into pedagogical practice is the challenge that educators face.

Dance as a Moving Experience

Concretizing Dance Through *Currere*

In this chapter I proffer a different perception of dance and the young child within the setting of early childhood education using Pinar's (1975; 1978; 2004; 2006) notion of *currere* as a living, breathing curriculum of humanity. By interlacing past and present through the theory of regressing, progressing, analyzing, and synthesizing, a reconceptualization of dance as a moving curriculum and the child's place within that curriculum is offered as another way to consider teaching and learning in, through, and about dance. In the process of concretizing dance through *currere* I address what it means to include the whole self (the body and mind) as a way of reconceptualizing not only the body, but also the holistic image of the young child. It is my belief that through this reconceptualization there is the possibility of recovering the myriad of ways the young child learns and is present in the world.

I am coaxed in this endeavor by the words of Cannella (2002, p. 17) when she states:

> I propose that we begin a new journey, an educational course of critique and possibility, an excursion that acknowledges the ever-present existence of human bias and the never ending struggle to conceptualize how we live together and respect each other.

For this reason I suggest an alternative approach through *currere* for movement and dance in the young child's life. In so doing there is the potential to seek and discover new possibilities of existence.

To help explain the purpose of using *currere* as a conduit for dance Springgay & Freedman (2007, p. xxi) provide an insightful definition of *currere* in the following quote:

Pinar (1975/2004), proposes an understanding of curriculum through "currere," which is defined as "to run the course, or the running of the course" (p. 35). Currere, argues Pinar (1975/2004), provides students and teachers with an embodied understanding of the interrelations between knowledge, life experiences, and social reconstruction. Currere, like its counterpart self-reflexivity, "is an intensified engagement with daily life" (Pinar, 2004, p. 37), in which conceptions of self-knowledge are always understood in relation to others.

Hence, *currere* is used as a way to explore movement or the language of the body as the genesis for deepening understanding of self and others. This is made possible through a form of contemplative receivership and the development of reciprocal interrelationships. Ultimately, a transformative pedagogy through dance is sought where children and adults work collaboratively toward a more just and equitable society.

Currere as a Moving Curriculum

Pinar's notion of *currere*, as it relates to any form of curriculum, is "an autobiographical method ... to remember ... and enter the past, and to meditatively imagine the future" (2004, p. 5). This enables us to slow down, to analyze our own lived experiences, and to become more consciously submerged in the present. When applying this notion of *currere* to an early childhood setting, I am paying attention to the young child's holistic presence for the purpose of becoming more attentive to the everyday experiences presented as moments of interrelationship. From the bodily perspective this requires a radical shift in thinking, from the overall manipulation of young children's bodies, and, therefore, powerful and authoritarian strategies demonstrated by adults, to an ultimate freedom of physical engagement and self-understanding, where choices and risks are made by the child and the adult within the teaching and learning environment.

The acknowledgment of noticing children's embodied participation within the early childhood setting links with the concept of *currere*. It is a process of interactive participation by all involved in the educational environment brought about through interpersonal, reflective, and contemplative relationships. Because very young children both participate and show their understanding through the body often more than words, recognition and awareness of bodily engagement and expression is

crucial. Such an awareness aids the development of an embodied understanding of themselves, as well as their interrelationships with others and life experiences.

In order to advocate for the acknowledgment and re-assertion of the body in education, I suggest that through corporeal areas of learning such as movement and dance, there might be the possibility of a new perspective of, not only the body, but the self. Thus, to become more aware of ourselves, I focus on the concept of *currere* as a conduit to achieve this understanding. As stated by Kincheloe & Steinberg (1999, p. 64):

> Pinar's notion of *currere* ... allows us to move to our own inner world of psychological experience. The effort involves our ability to bring to conscious view our culturally created, and therefore limited, concept of both self and reality, thus revealing portions of ourselves previously hidden (Pinar, 1975).

Accordingly, the memories, thoughts, and emotions the body houses can be brought to the surface and validated through becoming receptive to what the body is both saying and feeling.

Correspondingly, dance, as referred to earlier, can be related to an inside awareness of movement (Stinson 1988; 1998), which, when given time to emerge and evolve, becomes a powerful form of pre-verbal expression for the young child. Given that young children concentrate deliberately and often inwardly on each action or movement they execute, the opportunity to pay attention to the movement is inextricably enhanced. Coupled with space and time, the young child is able to contemplatively experience these inner as well as outer sensations of moving. When attention is paid to how we feel on the inside, this type of concentration places us in the position of knowing ourselves in a different way as well as how we relate to others (Stinson, 2004).

For this reason, I maintain that if the notion of *currere* is adopted as curriculum, who we are humanly would be imperative to address as part of the curriculum. For the young child this could be translated into her/his connection with the body, the living, breathing self, who occupies the world and feels the world through every core of being. If one is not yet able to be fully understood using the spoken or written word, the body can become that manifestation of expression, the mirror of experiences in the world, and the physicalization of understanding self. This is in the full

capabilities of the young child, who is purportedly bodily, sensing her/his presence in the world somatically through movement, touch, smell, taste, sight, and sound (Anttila, 2007; Green, 2004; 2007; Schiller & Meiners, 2003). These are physical or bodily attributes, which cannot be denied or diminished if the role of the child and her/his contribution to the world is to be honored. Conscious sensing of the body can be found through experiences in creative movement and dance where children can get in touch with all the nuances "of their own bodies" (Pinar, Reynolds, Slattery & Taubman, 2008, p. 590).

Children often imitate the world around them and the actions of others. They then begin to transform what they have seen and interpreted into their own actions or movements (Schiller & Meiners, 2003; Woodson, 2007; Wright, 2003b). The process of receiving information via the body in relationship with others assists young children to become engaged in an understanding not only of the self, but also of others. This opens up avenues to connect to and engage in others' perspectives and intentions while enabling them to see their own influence on others. They come to know that their actions can effect change. Early childhood practitioners can become reciprocal and supportive partners in the child's bodily participation (learning) through responding to and engaging in what the child is doing and offering. The child's world will "become revealed and negotiated through a reciprocal process where the children would be active participants and creators" (Anttila, 2007, p. 877). Here the body is seen in a holistic way as a site of knowing and exercises agency as the creator of the action the body performs and, thus, expresses.

The messages children display through their expressed bodily movements can be received by an attentive adult (early childhood practitioner) in a way that both acknowledges the child's expression and shares in it through a form of movement response. For example, mirroring the child's bodily actions, or copying some of the movements and re-creating them in a dialogic way with the child reflects appreciation of the other and, in so doing, not only affirms the other, but also pays regard to the underlying ideology of *currere*. This type of interrelationship could be seen as a form of movement conversation brought about through spontaneous and improvisational exchanges in response to the child's body language. Responding to the young child's dance fosters

recognition and acknowledgment of the child's identity, background, culture, and lived experience, which is manifested through the expressive movement of the body. The young child becomes a co-creator of the curriculum or content (Bond & Deans, 1997), which correlates with what Hanna (1999) terms paying attention to children's messages so that children become active agents in the creation of their movement or dance as forms of expression about their lives.

An interchange of this nature requires time as receivership of the child's movement takes place through mutual engagement in the giving and receiving of bodily expression. There are parallels here with the socio-cultural practice of scaffolding children's learning but also differences because of the degree of reciprocity engaged in by the child and the adult. Through *currere* the adult is placed in an equal or mutual position with the child, which deepens potential for engaging and understanding the other, while also contemplating and discovering or re-discovering the moving and sensing self.

The importance of being able to understand the self in relationship to others and to see oneself as an agent of change is imperative to avoid succumbing to what is in order to imagine what could be (Greene, 1978; 1988; 1995; Slattery, 1995; 2006). Children should be encouraged to engage in this type of pursuit, where the awesomeness of the world is a wonder to behold. They should be able to explore with the belief that one's bodily presence in the world has an important role to play. This is made possible when they are not restricted by a static unrelenting curriculum but supported by a living, breathing, forever fluid and changing curriculum; a curriculum, which is constantly created by its participants and grounded in the lived experiences of all who enter (Pinar, 1975; 1978; 2004).

As a consequence, there is an appreciation and comprehension of the entire body as knowledgeable (Bresler, 2004b). Grumet (1978, p. 305) evocates:

> If *currere* was to reveal our conceptual inclinations, intellectual and emotional habits, mime *[or movement and dance]* would reveal the knowledge that we have in our hands, in our feet, in our backs, in our eyes. It is knowledge gathered from our preconceptual dialogue with the world, knowledge that precedes our utterances and our stories. *(emphasis added by author)*

It is this closeness to body knowledge or the important and undeniable place of movement in the young child's life that is integral to making sense of who we are and how we live in the world. A curriculum that legitimates the moving body, and adapts in relation to the participants (learners) in a process of giving and receiving, is a curriculum that lives, breathes, and cares because everyone is involved in its creation (Pinar, 2004). Thus, curriculum as *currere* is grounded in the learner's experience to create new ways of being, knowing, and acting; action that will "heal the wound that naming creates between what is and what might be" (Grumet, 1978, p. 290).

The material reality of the body as an actor in what could be can be neglected when there is a strong emphasis on a linguistic discourse. The substance of the body gives form to ideas or thoughts not otherwise expressed through verbal language or the written word, especially in the young child's world. As Olsson (2010, p. 350) contends: "There are non–linguistic materiality, contents, and expressions that are equally worth paying attention to" which is relevant to the corporeal material or body language of dance thus debunking the imperialism of spoken and written language. An examination of the construction of self formed through a dominant linguistic discourse invites critical scrutiny. If people are predominantly perceived through linguistic language, the language of the human body is effectively shunned and becomes invalid. Thus, the important aspect is to reconsider how 'language' is perceived, i.e. "turned around" (Olsson, 2010, p. 351) to focus on the material language of the body and take into account how meaning is constructed and communicated through other avenues beyond the verbal or written word.

As those involved in dance know only too well "there had been too much focus on only one dimension of language; the spoken and written alphabetical code—rather than engaging in all of the other possible languages" (Olsson, 2010, p. 346). Beyond the confines of written and spoken language there are languages such as body and sign language that add another dimension to the semiotic and symbol system. These corporeal and creative languages also disrupt the idea of thought that is seen to only progress in a linear way, and challenges the hierarchical structure of linearity and cause/effect (Olsson, 2010). When alternative discourses are invited into the teaching and learning space, the possibility for a

more just and equitable society is made more feasible. A focus on *currere* as a 'moving' and embodied curriculum offers hope for a re-emphasis on the 'language' of the body as an equally valid avenue of communication and commentary, especially in young children's lives.

Dance as *Currere* and Critical Praxis

As *currere* suggests, regressive and progressive recollection and retrospective reflection implies a form of looking into the past. The purpose is to bring that past into the present, in order to look toward the future and effect change. Change, or perhaps, more pertinently, emancipation or liberation, especially for the emergence of social democracy and justice in the lives of young children, creates a new space for a re-visioned pedagogy of dance within early childhood settings. The question is how this might look when seen through the lens of *currere*?

In conjunction with the earlier examples of suggested engagement between adults and young children through curriculum as *currere* the following synopses offer exemplars of empowering dance experiences for young children that, I believe, capture the essence of *currere* and the stages of regression, progression, analysis, and synthesis. These vignettes are drawn from my own experiences and observations in early childhood settings in Aotearoa New Zealand, as well as descriptions of children's dance from other countries with programs not dissimilar to the underpinning principles of the early childhood curriculum of Aotearoa New Zealand.

Within early childhood environments I have witnessed young children's dance creations that are rich with intriguing movement patterns, abundant and compelling energy, as well as eloquent interpretation which attract a commanding presence. Some of my observations have revealed the choreographic skills young children possess when they are conversant with a range of dance vocabulary and able to re-create dances they have learned or inherited. One such instance comes to mind when I watched (because I was requested as a spectator) several young children develop and re-develop a well-known folk dance. The resulting outcome was a complex display of relationships (partnerships, trios, small groups) and dance motions, all embossed by an

interesting array of entrances and exits. From a dispositional stance, the children displayed true agency in the choice of decisions undertaken to shape the dance. They exhibited an in-depth awareness of themselves and others, as well as heightened performance skills when presenting to an audience. The children were very readily able to enter their created world of dance, whilst acknowledging the outer world that existed as witness to their dance making. The setting where the children performed was chosen by them, together with the decision to present their dances informally to others.

On another occasion I became an unwittingly invited participant in a spontaneous Polynesian dance event where the young children, mostly of Pacific Island heritage, performed elegant Niuean and Tongan dances and strong, yet gentle Māori dances such as haka and poi, as well as the Samoan sasa. I participated as one of the musicians who, along with other young children, attempted to play the beat of the drum for the Samoan sasa. During these incidences the children had the freedom to choose their own spaces to dance, their choice of music for the dance, as well as additional technology such as digital cameras to record the dances. With the use of this technology they were able to transfer photographs onto a computer as a form of documentation to be viewed and re-visited. The children's involvement in these self-created and directed dance experiences captured the energy, vitality, and confidence of children who knew their cultural inheritance as well as possessing a developing understanding of self.

In the above examples the children are engaged bodily in "an embodied awareness between inside and outside, and amongst bodies" (Springgay & Freedman, 2007, p. xxi). Together with others they share their innermost feelings and thoughts drawn from outside influences. The past hovers above them and within them as the children capture what has been in their lives, in their parents' lives, and in their ancestors' lives. From these memories the children create new possibilities, (the not yet), through imagining what could be and manifest those imaginings in their dancing thus bringing the past and future back into the present (Pinar et al., 2008). In these moments there is a form of acute consciousness of self that young children possess when they are authentically present with others. These experiences encapsulate

the essence of *currere* and are analogous with a living curriculum that is created by the participants, together with reflecting the underlying principles of an empowering curriculum as evident in *Te Whāriki* (Ministry of Education, 1996).

When compared with other visions of early childhood education, it is clear that parallels can be drawn between the New Zealand early childhood curriculum *Te Whāriki* and programs such as Reggio Emilia (schools in Northern Italy for children aged 3–6 years) with their complimentary views of children as capable and central to the learning and teaching process. Because *Te Whāriki* is distinct with its own specific values, rather than being prescriptively constructed around subject areas, it offers a principled approach to learning embedded within the historical and social constructs of culture. The Reggio Emilia approach also comes from an informed base of principles, where, in a similar way to *Te Whāriki*, learning arises from multiple sources and is historically and culturally grounded. The Reggio Emilia curriculum, as described by Rinaldi (1998, p. 119) "is at once defined and undefined, structured and unstructured, based more on flexible strategies than rigid plans", which provides evidence of clear allegiances to the concept of *currere*. In addition, parental and family involvement is strongly encouraged in the New Zealand early childhood curriculum. Equally, alliance with community is promoted with invited involvement of parents in the Reggio Emilia schools.

Both curricula grew out of a germane understanding of the past born from the strength and courage of people who believed in the civic rights of *all* people, including children. These beliefs and values evolve from historical experiences of oppression; Fascism and the war for the Italians and British Colonial domination and violation for Māori. Liberation and emancipation from past atrocities set the scene for regenerative initiatives designed to honor the newest and youngest members of society. The citizens of Reggio Emilia recognized the right of the child as a protagonist capable of curiosity and sustaining inquiry (Gandini & Malaguzzi, 1998). Māori people believe in their connections to a long line of ancestry and both honor and value children as integral to the survival of who they are as a people (Reedy, 2003). Thus, the ideologies that gave birth to Reggio Emilia and the early childhood curriculum of Aotearoa New Zealand, *Te Whāriki,* pass through

the lens of liberation and emancipation as a remembrance of the past, with a view toward the future. As the Māori proverb (*whakatauki*) wisely reminds us; "*kia whakatōmuri te haere whakamua.* My past is my present is my future. I walk backwards into the future with my eyes fixed on my past." Thus the past informs the future whilst being evident in the present.

Accordingly, these two visions of early childhood education hold great promise for dance. For example, in a project designed by Reggio Emilia to capture places and spaces within the township through a range of artistic enterprises the children gifted their art work to the new Malaguzzi International Center as a form of dialogue between past and present, with a view to the future. The dialogue acted as a type of analysis through the "communicative structures", whilst conceptually synthesizing beyond what is visible and being "captivated by the emotion that is always stirred when we get a glimpse of the identity of children in order to grasp the mirrored complexity of the adults who stand by their side" (Trancossi, 2008, p. 8). Such an instance can be found in an account of Running: Notes for a Choreography in *Dialogues with Places* (Filippini, Giudici, & Vecchi, 2008). The children of the municipality of Reggio Emilia discover the beauty of running in spaces where there are empty rooms and columns through which "you can run in a wave" or do different types of running with shapes like a dance. The children's experience of running reflects "all the power, energy, sense of freedom, and the emotion of running, but also their competence and ability to interpret the perceptual and imaginative evocations" (Filippini, Giudici, & Vecchi, 2008, p. 71).

Here we see an example of a pedagogy of listening (Dahlberg & Moss, 2005; Rinaldi, 2006) as children and teachers share in the exploration of movement and stillness, pathways and directions, sequences and forms of coordinated movement, which become part of a choreographic composition. As three of the children describe:

> Choreography is a kind of dance where we put together all the ways of running, but different from before, even some new ways to run and a little bit mixed ... We have to think about it, we have to concentrate so we get some ideas ... When we find them we show them to our friends, and if they like them, then we can all do them together. (Filippini, Giudici, & Vecchi, 2008, p. 77)

Thus, a dance is produced from children with the opportunity to explore and experiment, to share and develop ideas in the company of receptive and attentive adults. Such an experience mirrors what could happen in an empowering curriculum informed by *currere* when children bring their bodies and energy, their minds and spirits, and their lives, into a place and space that enables them to create dance. In *Dialogues with Places* the engagement of the body and the emergence of dance making or choreography are influenced by the actual places being occupied. Children mark the spaces with multiple senses; physically finding different ways of walking, running, and jumping; or sitting, lying, and placing their bodies in the space. They talk, laugh, touch, and match the imagery of the spaces with the shapes of their bodies or by making different body shapes to fit or complement the places. This corporeal acquaintance with the space enhances the making of dance.

Equally, young children within early childhood environments in Aotearoa New Zealand become acquainted with their cultural heritage and knowledge of self through the freedom to create their own dances. These dance moments may emerge slowly over time, or spontaneously blossom as children discover their own abilities to transform movement into dance in an environment that engenders these precious discoveries. The emergence of these moments can give rise to previously unforeseen traits, knowledge, penchants, and passions the young child possesses. In a notated learning story (Jovanovic, 2008) chronicling a young child's emergent interest in dance, new-found discoveries were being unearthed not just about dance but also about the child's background and culture. These discoveries led to more than just dance but also about relationships; child-self, child-child, child-adult, and adult-self. The teacher expresses her own discovery of becoming more comfortable in herself and her dance guided by the self-directed dancing of a young two-year-old boy from India. For this young child the significance of familiar Indian music gave impetus to the creation of dance and reminded the teachers that the links between the center and the child's home and culture were truly important. There was a shift from simply using the rhetoric of socio-cultural responsive practice to democratized reality.

As noted by White et al. (2009, pp. 30–31) with further reference to acknowledging the cultural inheritance of each child;

"children in the Māori immersion service had regular opportunities to join adults in rehearsing for cultural events ... an example was the learning of the poi movements for Hinewairua during adult Kapa haka practice." The learning had special intent and purpose alongside experienced others who share their cultural *taonga* (treasures) with the inheritors of these precious gifts, the *tamariki* (children). Even more so, the young child is honored for her/his interests, achievements, and talents.

This reminds me of the acumen of Rangimarie Rose Pere (1995) when she advises; listen to children and give them the space to move around and explore, with the additional maxim that children should be treated as total beings and acknowledged with having wisdom and power. It is these beliefs upon which the foundations of *Te Whāriki* are laid, that, I uphold, echo *currere* as a 'living, breathing curriculum of humanity' rooted in historical, cultural, and social contexts.

The dance events described in this chapter grew from the lived experiences of the children and told the stories of their lives. These stories were steeped in histories and rich heritages that reveal lives lived long ago and places and spaces ringing with struggles and triumphs. They also hold promise for what is yet to be, whilst reflecting on what has been. The children's own ideas became the central material for the dances being made as they negotiated with others in pairs or small groups in the overall process of making dance. The springboards for these dances came from various sources, including the sharing of personal stories or life-worlds as well as popular culture. The young children supplemented or complemented their dances with additional materials such as props and costumes, along with historical and cultural mementos and artifacts that connect to their own lives and identities.

Because the source or origin for the dance making is drawn from the children's lived experiences, those important questions about what it means to be human and how to live together become discernible in the process. To facilitate the creation of an environment to share their dances, a supportive framework is provided that enables the children to explore what dance means to them. The children experiment with gesture and a variety of traveling actions, plus multi-various ways of using space using the fundamental language of dance. When each of these movements, or components of what the body can do, is brought together, they

can be transformed into dance that tells something about their lives. From these rudimentary beginnings the children can reproduce further movement including those drawn from cultural origins and gradually gain the confidence to begin to think and question what this means in their lives, the lives of others, and the world in which they live. The children's discoveries of the source of their gestures, actions, or movement motifs, arise from things that are important to them, which they can imagine and share with others. The children have the opportunity to show how they see themselves in the world, which can be made visible in and through the tacit knowledge of the body.

As a reflection of the New Zealand early childhood curriculum *Te Whāriki* dance as *currere* mirrors the concept of *whakamana* (empowerment or agency), and *tino rangatiratanga* (self-determination), thereby signifying the rights of children by honoring their dignity, identity, cultural heritage, and citizenship. Ultimately, however, the early childhood setting becomes a place where our youngest citizens have the chance to find their voices and their bodies as they move and feel the intensity and release of the inherent knowledge stored within. Those who are normally viewed as powerless now have the opportunity to share and express their thoughts and feelings through the profundity and universality of dance, which, as Espenak (1981) points out, all young children instinctively know.

A Vision for Dance

The Body, Dance, and Life

Throughout the preceding chapters a raft of concerns have arisen, which could be categorized into three main areas. These three areas are the body, dance, and life or life-world (Greene, 1995; Shapiro, 2002b), particularly the world of young children. Each one of these areas is, I believe, important in a world where rationality tends to dominate, and feelings, or the sensate of the body, are subsumed among the bodiless acquisition of knowledge devoid of emotional or visceral engagement. This is especially poignant when considering the life of the young child.

As noted previously, dance is often relegated to the background of curricula or placed on the fringe of education. Sometimes dance is completely off the edge, out of sight, or entirely absent. The positioning of dance links intimately to the presence (or absence) of the human body in education, as well as how the body is treated, included or excluded. Subsequently, life or humanity itself is affected, which seems to be, in this day and time, the most precarious thing of all.

The preciousness of life and respect for existence are being threatened from almost every quarter of humanity as alienation from ourselves, others, and from the world appears to become more apparent. Each of the aforementioned areas, while seemingly necessary for the sustenance of human welfare (yes, even dance!), often tends to be the last aspects considered important, especially in education. Yet, these areas must be central for the purpose of a critically conscious or responsive and liberatory pedagogy (Shapiro, 1998; 2008b). As Shapiro (2008b, p. 254) outlines:

> Dance ... offers a unique and powerful form of human expression. It allows us to speak in a language that is visceral and far less mediated by our thoughts and abstract conceptualizations. It provides, at times, a

raw, embodied way of capturing human experience. It allows free reign to the sensual and the sentient—things that elsewhere are often circumscribed by custom and convention.

Drawing on the sentiments expressed above the final chapter focuses on a vision for dance pertinent to education, especially during the early years, whilst extrapolating interpretive meaning from the previous chapters to derive inferences about what has been and what might be. The aim is to contribute to a reconceptualization of dance, not only as it relates to educational practice but also as a way to think critically about the world in which we live. In addition, consideration is given to what this means for young children and their teachers. Although, as already stated, I am not proposing any universal answers, I conclude with some specific thoughts to open up potential for further dialogue and possible debate.

Reconceptualizing Dance Education: A Reawakening

Strategic to the development of the arts curriculum and the inclusion and credibility of dance within the context of education in Aotearoa New Zealand was consideration of the aspirations espoused as part of a newly desired approach to teaching and learning in dance education. Two of the initial claims were the predilection to promote dance from an academic perspective through the development and emergence of dance literacy, and secondly, to relocate dance within the arts thus, acknowledging dance as a justifiable art form.

In deference to the first claim, the emergence of dance literacy in *The Arts in the New Zealand Curriculum* (Ministry of Education, 2000) aligns with more recent calls for broader understandings of the meaning of literacy (Hong, 2003; Thwaites, 2008). From this standpoint literacy can be seen as a social and cultural practice, which includes a myriad of semiotic sources or multi-literacies; verbal, visual, aural or auditory, and physical or bodily. Multi-literacies encompass, among others, arts literacy (Ministry of Education, 2000) and critical literacy (Freire, 1970; 1996; Giroux, 1988; 2001; 2006), challenging traditionally based literacies such as spoken and written language. As an embodied literacy, dance endorses other ways to communicate through

gestures, actions, or motion. As Thwaites (2008, p. 85) illuminates: "Becoming more literate in the arts has the potential to develop the mind and expand the ways in which we can express our ideas, feelings, beliefs, and values to better understand those of others."

Dance is, oftentimes, a group activity where participants learn from one another, and thus share their understandings of the world in which they live. This brings in a multitude of different perspectives about dance, depending upon one's cultural and social environment. The very fact that dance is, and has been, imbued with certain views of society requires a form of critical deconstruction in order to provide an environment, which is conducive to both the reconstruction of dance as a group activity, as well as participation for everyone. As stated by Hong (2003, p. 140), dance "is a social and evolving set of practices, so the process of developing dance literacy involves both teachers and learners engaging actively in the construction of individual and social group meaning, in, through, and about dance."

As stated in *The Arts in the New Zealand Curriculum* (Ministry of Education, 2000, p. 10) where literacies in all the arts is presented as a central and unifying agent:

> Literacies in the arts involve the ability to communicate and interpret meaning in the arts disciplines ... [as students] acquire skills, knowledge, attitudes, and understanding in the disciplines and use their particular visual, auditory, and kinaesthetic signs and symbols to convey and receive meaning.

Students are occupied in the exploration and use of elements, conventions and techniques, developing ideas, making art works, presenting, responding, conveying and interpreting meaning, and investigating art in relation to their social and cultural contexts (Ministry of Education, 2000; 2007). Therefore, literacy, as it relates to dance, pertains to the development of literacy *in* and *about* dance, which is learning the language of dance education as well as understanding the context and purpose of dance. In addition, literacy refers to learning *through* dance, where dance may be used as a vehicle to enhance learning in other areas and ways. As Kipling Brown (2008, p. 154) affirms:

> I use dance language to teach about membership, the importance of context, the dynamic of identity, and the role of those on the margins ... Finding ways in which the content of dance connects with student's lives

and enables the students to make sense of what is happening in their world has powerful results.

Coming to know in, through, and about dance, therefore, involves learning to create and share dance, as well as to interpret, develop, and receive meaning from dance works. As Hong (2003, p. 142) attests: "The study of dance cultivates kinaesthetic sensibility and elicits a range of cognitive, artistic, aesthetic and emotional understandings in ways that are very different to other scientific or theoretical constructs." Knowing in, through, and about dance provides other ways of seeing, different ways of thinking, and new ways of knowing the world because it draws on particular acuities or insights that may not be drawn on in other subject areas or practices.

Dance as an art form adds another dimension to consider. Whether or not dance as art raises the perception of dance as an accepted way of knowing beyond being seen as a component of physical education, I maintain it is important to be cognizant of both the artistic and aesthetic facets of dance. As stated by Thwaites (2008, p. 86):

> Aesthetic ways of knowing encompass personal, cultural and societal values, sensory perception, imagination, analysis and evaluation; they make us more acutely aware of our self, often through our body's responses, and are a form of embodied knowing and understanding.

The connection between our aesthetic sensibilities and the art of dance can transfer into the kinesthetic sense, which engenders engagement in dance rather than simply receiving dance as spectators (Stinson, 1995). To become involved in dance as art alters perceptions about dance by facilitating participation in, and learning through dance. Greene (1995, p. 125) reiterates this perspective in the following passage:

> Aesthetic experiences require conscious participation in a work, a going out of energy, an ability to notice what is there to be noticed in the play, the poem, the quartet. Knowing "about," even in the most formal academic manner, is entirely different from constituting a fictive world imaginatively and entering it perceptually, affectively, and cognitively. To introduce students to the manner of such engagement is to strike a delicate balance between helping learners to pay heed—to attend to shapes, patterns, sounds, rhythms, figures of speech, contours, and

lines—and helping liberate them to achieve particular works as meaningful.

And as Kipling Brown (2008, p. 152) stresses with regard to the arts education program at the University of Regina:

> We strive to foster critical and reflective thought, aesthetic sensibilities, an understanding of how knowledge is socially constructed, an appreciation of the diversity of human experience and expression, and an understanding of the importance of creativity and lifelong learning.

In wrestling with this concept of the aesthetic, and thus the kinesthetic, particularly as it is found in dance, I am aware that for some the kinesthetic nature of dance is an alien landscape and, thus, not the best way for everyone to learn. Subsequently, it is less about dance per se and more about the learner and the different ways we learn. Accordingly, there are multiple levels of meaning making occurring, from that of the teacher and her/his knowledge of the subject matter, to the students/learners and their understanding arising from their lived experiences. In addition, there is the sharing of ideas for the wider purpose of disrupting established ways of knowing so that new meaning is created for everyone involved in the process. It is when meaning can be found in the art form through some form of connectedness to our own lives and to the lives of others that a new way of knowing or making sense of the world can emerge. Greene (1995, p. 149) encapsulates stating:

> If we can enable more young persons to arouse themselves in this way, to make sense of what they see and hear, and to attend to works in their particularity, they may begin to experience art as a way of understanding. While we distinguish between the analytic, abstract rationality we often associate with knowing and the peculiar relational activity that brings us personally in touch with works of art, we may nevertheless well call art a way of knowing. The experience and knowledge gained by this way of knowing opens new modalities for us in the lived world; it brings us in touch with our primordial landscapes, our original acts of perceiving.

In the evolution of Aotearoa New Zealand's early childhood curriculum *Te Whāriki* (Ministry of Education, 1996) dance, the arts, and aesthetics are less visible as noteworthy avenues to find new ways to live in the world. Whilst *Te Whāriki* heralds a new era for innovative early childhood practices within Aotearoa New

Zealand, particularly from an indigenous standpoint, the idea of the broader philosophies of aesthetics tied up with ethical and political allegiances is, perhaps, more obfuscated. Yet, as reminded by Dahlberg & Moss (2005), the possibility for new ways of seeing and change are noticeably appealing for the field of early childhood education especially as part of a global society.

Rather than acting as a technology for neoliberalism, or constructing the neoliberal child (Duhn, 2006), the early childhood curriculum *Te Whāriki* has the potential to engage in the acts of border crossing (Giroux, 2006) through "valuing the provocation of difference" (Dahlberg & Moss, 2005, p. 186). Alternative discourses and beliefs have the power to unseat the dominant and attendant rhetoric of early childhood services to ensure both difference and commonalities are valued and respected. As components of a transformative and emancipatory pedagogy, dance and aesthetics have the possibility to reconstruct discourse in places such as early childhood settings because of their sensual, experiential, and experimental qualities rather than relying on purely rationalized verbal or written modes of learning. However, whilst the presence of the arts is implied in the early childhood curriculum, their transformational possibilities are less visibly distinguishable. Thus, the intent of the arts, such as dance, may lack the potential to fulfill an emancipatory or liberatory pedagogical ambition (Hanlon Johnson, 2002; Shapiro & Shapiro, 2002b) so wanting in all sectors of education, but, above all, during the early years of life.

The Body, Culture, and Criticality

When looking at the subsequent areas pertaining to the body, culture, and critical matters, especially related to movement and dance in the early years, I consider how the learning and teaching of dance is presented and used in education. It is important to see if there is space for other epistemological approaches, for example, the inclusion of multiple social and cultural perspectives or ways of understanding the world. Additionally, there needs to be a critical discourse of the body related to how the body is included (or excluded) in the pedagogical practice of dance education.

Because dance is very much about the body, it is not surprising that there are many factors to address from a bodily perspective.

An aspect that was, initially, less on the horizon, is the idea of the fragmented, or floating and drifting body (Shapiro, 2002a). While wanting to firmly establish the body as central to pedagogy in both dance and education, I find myself facing a counter-discourse of the body as ephemeral and forever changing. The fluid and flexible concept of the body connects with a postmodern view of the self, and the embodiment of multiple selves. Concurrently, this enforces a recognition or acknowledgment of the many 'voices' of those from different cultural backgrounds. As Shapiro (2008b, p. 256) soberly alerts:

> Our discomfort with those who are different from us provides a challenge to dance within the complexity of achieving diversity within unity. The task is in finding ways that accept the particular and at the same time transcend the differences. What isn't answered is, Why is this important to dance?

As a dance educator in teacher education, it is imperative that I examine encounters with the body, culture, and criticality. Misconceptions and uncertainties pertaining to the human body (especially with regard to body image and ability), together with the culturally and socially situated lived experiences we all embody, require confrontation and critical analysis; an autobiographics of alterity (Pinar, 1994; Villaverde, 2008; Villaverde & Pinar, 1999). In other words, not only is it important to get inside my own body (feelings and thoughts), but it is also crucial to step into the shoes (lived experiences) of others. This enables, as much as it is possible, a sense of how others perceive their bodies and lives and, subsequently, how these perceptions could be manifested through dance education, or a pedagogy of the body.

In relation to the body, I am also heedful of the way in which my own experiences of moving and playing (both in my childhood as well as in my profession as an early childhood educator) lead to my extreme interest in the place of the body and physicalization in education, especially during the early years. Alternatively, I also note how readily the body is removed from education and the influence this has on our views of the body. The removal of the body is inextricably linked to the concept of physical exploration found in play and illustrates why the value of play has been undermined because of a focus on work-related outcomes in

education (Noddings, 2003; Stinson, 2005; Wood, 2009). When play is connected to dance, however, there are further complications to consider as attested to in Chapter Five. I find it comforting, nevertheless, to note the opinions of other dance educators who advocate for the place of play, or playfulness in dance, e.g. Anttila, 2003; 2007; Bond, 1994a; Bond & Deans, 1997; Bond & Stinson, 2001; 2007; Hanna, 1986; 1999; Lindqvist, 2001; Stinson, 1997. As Shapiro (2008b, p. 254) summarizes, dance

> manifests that form of playfulness that is so delightfully found in young children and so often erased from adult life. Dance, like other forms of art, provides a space in which we can touch the transcendent and experience new possibilities that are outside of the life practices we take for granted; it is a space that encourages and nurtures the ability to imagine different ways of feeling and being in the world. And it is the human body that makes dance concrete.

Imagining different ways of being in the world also correlates with the cultural context in which one lives. With reference to historical, social, and cultural perspectives, the socio-cultural issues in Aotearoa New Zealand are not necessarily unique, but they are specific. It is, therefore, the specificity or contextual aspect that is pivotal to the future of the country and, thus, the people of the land. Dance education cannot ignore this cultural relationship, nor can it assert one predominant way of knowing over another. Alliances must be sought between, not only the indigenous people, the Māori, but with all the multiple nationalities that make up the country of Aotearoa New Zealand. It is contingent on practitioners to enter into the world of others, to feel and experience difference (without appropriating or assimilating and obliterating difference), and to find new ways and languages to express ideas and feelings in dance. I return to the concepts of "making the familiar, strange" (Kincheloe & McLaren, 2000, p. 286) and of 'turning my world around' (Anttila, 2003; Olsson, 2010), which are necessary to unlearn and, thus, decenter oneself for the purpose of discovering new epistemologies. As Shapiro (2008b, p. 253) sagely elucidates: "The body knows and re-members even in the silences of our lives. In dance the familiar can become strange … more than movement it is the act of transformational possibility." Thus, in the course of encountering and experiencing the unfamiliar or unknown in and through the

body via dance, the potential for new ways of knowing or understanding can materialize.

In relation to this notion of defamiliarization and encounters with a variety of art forms from a wide range of ethnic or cultural terrains and, thus, multiple ways of seeing and knowing, Greene (1995, pp. 4–5) states:

> I will say much about such encounters on the stages of this quest, as I connect the arts to discovering cultural diversity, to making community, to becoming wide-awake to the world. For me as for many others, the arts provide new perspectives on the lived world. As I view and feel them, informed encounters with works of art often lead to a startling defamiliarization of the ordinary ... And now and then, when I am in the presence of a work from the border, let us say, from a place outside the reach of my experience until I came in contact with the work, I am plunged into all kinds of reconceiving and revisualizing, I find myself moving from discovery to discovery; I find myself revising, and now and then renewing, the terms of my life.

Thus, as Greene enunciates, reaching beyond the common or everyday into the unknown requires a re-contextualization of not only the arts, but also the discourses of the human body and life. Expanding horizons and daring to go where one has not gone before opens up a range of spaces where the familiar can become strange and the strange can become familiar through the performance of the body.

In accordance with the new sociology of childhood where creditable images of the child abound, the hegemonic practices often found in education pertaining not only to racial or ethnic differences but also to other forms of discrimination and deficiencies need to be seriously re-configured. The body as a site of social texts can act as that space for personal agency where the discourse is interrupted and renewed; something Spivak (1993) refers to as 'a menacing space'. As Leistyna (1999, p. 83) endorses; "perhaps the most prevalent ethnic/cultural forms that attempt to rupture the oppressive social order and create a space for rewriting history are found in the arts: music, performance, dance, multimedia, literature."

Historically, dance, ritual, and carnival were used as resistance movements against hierarchy, power, and the differentiation between upper and lower classes; the elite and peasant folk. Dance was particularly prominent in ritualistic events or rites of passage.

In ancient mystery cults in Greece, the participants would experience the feelings of purification, healing, and sometimes transformation. In fact, it is known from some historical recordings of these events, as Ehrenreich (2007, p. 47) points out, that one participant said "I came out of the mystery hall feeling like a stranger to myself ... [and] it is to this kind of experiencing that we owe the very word *ecstasy*, derived from Greek words meaning 'to stand outside of oneself'."

Of course, ecstatic or sensuous connotations regarding dance often places dance in an even more precarious position particularly in association with the taboo of touching and sexuality. I, on the other hand, prefer to see the allegiance of dance with ecstasy and the erotic as something that conjures up love and a passionate belief in the desires of being fully alive. As reminded by hooks (2000) love is a childhood right, yet many children do not experience this basic and inalienable right. hooks continues stating that: "There can be no love without justice. Until we live in a culture that not only respects but also upholds basic civil rights for children, most children will not know love" (2000, pp. 19–20). These are sobering words to contemplate and call for a concerted effort by everyone on behalf of children to ensure 'love' is present in their lives wherever possible. "When we love children we acknowledge by our very action that they are not property, that they have rights—that we respect and uphold their rights" (hooks, 2000, p. 30). If there is a belief in justice, these haunting words must surely resonate in the ears of all of those involved with children. I know they reverberate in my ears and remind me of the awesome undertaking I am charged with in any enterprise I engage in with young children as well as those who are present in young children's lives. Dance can be a place where love is shared as respect for each and every person's being is privileged and valued.

Dance in the Curriculum: A New Vista

Whilst addressing the concept of national curricula that claims to provide contextually and culturally situated learning processes for all, I am cautioned by Block (1998) who talks about the effects in the modern era of national curricula and national certifications. Block indicates that the nationalizing of curriculum tends to speak

to a mass mentality from the perspective of a dominant canon. While I agree with this perspective of the domineering nature of national curricula, I do believe that it is possible to develop national curricula that can envelop change and make meaningful connections to learners. This possibility is within the scope of *The Arts in the New Zealand Curriculum* (Ministry of Education, 2000) and more recently, *The New Zealand Curriculum* (Ministry of Education, 2007), but also in the conceptualization of *Te Whāriki* (Ministry of Education, 1996) despite the aforementioned shortcomings.

Together with the conception of the early childhood curriculum *Te Whāriki*, the new curriculum for schools (as referred to in Chapter Two) incorporates two languages (Māori and English) and acknowledges the indigenous people of Aotearoa, the Māori, as well as the increasingly changing ethnic face of the nation, in particular, the Pacific Island, Asian and Indian populaces. These curricula are national with an emphasis on a holistic and interpretive approach. This generates room for creative application as well as thinking on the part of each individual responsible for delivering the curriculum and for all those participating in the learning process. At the same time this can also permit looseness, which can be seen as a flaw. As a result, teacher education programs are required to provide new ways of seeing, which encourage thinking teachers based on the concept of critically reflective practice. This is something that was definitely missing in earlier eras of teacher training where there was a focus on the technical practice of teaching as opposed to fostering reflective practitioners who were able to develop programs that were contextually appropriate rather than nationally uniform. A national curriculum does not have to decree uniformity. Indeed, it should decree otherwise so that difference is nurtured, respected, and encouraged.

Despite the promise of a forward thinking national curriculum and the inclusion of dance in the arts, I am haunted by the same questions others have asked as illustrated here by Hanna (1999). She questions whether educational reform will enable dance to be seen as viable in the twenty-first century, or lag behind its counterparts in both education and the arts. As Hanna (1999, p. 68) continues to point out: "A newcomer to academe struggling to survive, dance now has a window of opportunity in which to grow

and develop in a climate of support ... Unresolved is whether entrenched curricula will make room for dance education." The same could be said of *Te Whāriki* where dance, among other areas of learning in the early childhood curriculum, is couched but not mandated. The possibility of dance in the curriculum, however, lies squarely in the hands of the teachers who can willingly choose to exercise their agency as powerful intellectuals and creators of the curriculum alongside the children.

Toward a Postmodern Paradigm

When considering education in today's world, it is important to look at the conceptualization of curriculum and the ideologies that inform teaching and learning from a postmodern, post-formal, and post-structural perspective. Slattery (2006, p. 23) states that "postmodernism is in continual growth and movement" thus, to consider a static definition of postmodernism would defeat the purpose. For this reason, it is imperative to associate the notion of fluidity and flexibility with the concept of a curriculum where nothing is set, but forever changing and being created by those involved in the process of learning and teaching; a concept encapsulated in Pinar's *currere*. How curriculum is shaped and intersects with student's lived experience necessitates a shift in knowledge production and "new ways of teaching, learning, and relating" (Villaverde & Pinar, 1999, p. 248).

Associations can also be made between the active process of *currere* and the idea of post-formal thinking put forward by Kincheloe & Steinberg (1999, p. 60) which "involves the production of one's own knowledge Post-formal thinking and post-formal teaching become whatever an individual, a student, or a teacher can produce in the realm of new understandings and knowledge within the confines of a critical system of meaning." This belief is further advanced by Kincheloe (2008, p. 164) when he states post-formalism is "committed to critical pedagogy and the notion of social justice ... it is unabashedly subjective with its celebration of intimacy between the knower and the known." Villaverde adds to this description of post-formalism by stating that a post-formal methodology is "conscious of race, gender, social justice, history, context, place, and power relations" (Villaverde & Pinar, 1999, p. 253).

In addition, there is an emphasis on in-depth critical reflection and making meaning by forming connections between students' own lives and their encounter with school knowledge (Kincheloe, 1993). I believe resolutely in the practice of critical reflection, but I also avow that this is a process that requires the notion of praxis (Freire, 1970) to enable teachers to truly become aware of the issues they face in their teaching. Teachers need to look at how issues connect to "their own ideological inheritance and its relationship to their own beliefs and value structures, interests, and questions about their professional lives" (Kincheloe & Steinberg, 1999, p. 62). Critical reflection is crucial if teachers are working toward social justice and emancipation.

Slattery (2006, p. 26) alleges that a postmodern, post-formal, and post-structural approach to education or the process of curriculum will be "dependent on disequilibrium, indeterminacy, lived experience, and chaos, rather than on rigid structuralism." This sounds scary because the modernist foundation of curriculum that has for so long been the basis for traditional education is now being shifted. However, I agree with Slattery that there is a need to engage in non-linear and open-ended processes where there are many pathways to follow. As Slattery (2006, p. 26) denotes; "the free-form processive dance of postmodernism indeed appears preferable to the lock-step linear model of modernity."

The acknowledgment of who we are; our backgrounds, our histories, our stories, plus understanding how knowledge reflects socially constructed values form the development of postmodern curriculum. A postmodern curriculum encourages revision and reconceptualization of modern ideology within a broad frame of reference, which includes the "critique of reason, totality, universal principles, and metanarratives" (Slattery, 2006, p. 40). Ultimately the aim is to work toward a transformative pedagogy.

If a transformative approach to curriculum is adopted, it is important to acknowledge, as Henderson & Hawthorne (2000, p. 88) surmise, that planning, and thus, teaching is "an ongoing learning process" where the process is creative and complex. Such an approach requires an acceptance of a range of views based on "democratic principles and equity." Central to this is the importance of storytelling, which acknowledges the role of personal narratives or the role of story as a "powerfully regenerative force" (O'Loughlin, 2009, p. 158), and, in turn, links

to the human condition. Personal engagement enables the creators of curriculum (teachers and learners) to make the learning their own. When there is recognition of ownership, there is a form of liberation, which comes with the understanding that one can affect change. Greene (1988, pp. 126–127) substantiates:

> If we are seriously interested in education for freedom as well as for the opening of cognitive perspectives, it is also important to find a way of developing a *praxis* of educational consequence that opens the spaces necessary for the remaking of a democratic community. For this to happen, there must of course be a new commitment to intelligence, a new fidelity in communication, a new regard for imagination. It would mean fresh and sometimes startling winds blowing through the classrooms of a nation. It would mean granting audibility to numerous voices seldom heard before and, at once, an involvement with all sorts of young people being provoked to make their own the multilinguality needed for structuring of contemporary experience and thematizing lived worlds.

When referring to postmodern curriculum, thought also needs to be given to encompassing an ecological approach. Under an ecological guise there is more than just the environment to consider. Globally, the world is interconnected biologically, psychologically, economically, technologically, socially, culturally, as well as environmentally. These factors are all important when considering curriculum because the world is seen as a cohesive whole rather than as a fragmented, segregated, or compartmentalized entity. This view is far removed from the traditionalist modern view where everything is segregated and unconnected. As Slattery (2006, p. 216), enlightens: "The emerging postmodern holistic and ecological models of curriculum dissolve the artificial boundary between the outside community and the classroom. Postmodern teaching celebrates the interconnectedness of knowledge, learning experiences, international communities, the natural world, and life itself."

Personally, I cannot see authentic learning without considering these aspects, albeit with the proviso that one is vigilant to what constitutes appropriate learning communities. Addressing marginalized languages, e.g. visual, sound, light, touch, taste, smell, and the language of movement or physicalized expression is one of the ways to authenticate learning. Parker Palmer (1999, p. 16) insightfully encapsulates, in a chilling account, what an education devoid of any form of authenticity can lead to when he

refers to public education in the United States as a "death dealing" affair.

So many people walk around feeling stupid, feeling like losers in the competition we call "teaching and learning." If the competition doesn't do us in, too often we go to schools where learning is made so dull that, once we get out, we don't want to learn again. Too many children have their birthright gift of the love of learning taken away from them by the very process that's supposed to enhance that gift—a process that dissects life and distances us from the world because it is so deeply rooted in fear.
...

I was formed—or deformed—in the educational systems of this country to live out of the top inch and a half of the human self; to live exclusively through cognitive rationality and the powers of the intellect; to live out of touch with anything that lay below that top inch and a half—body, intuition, feeling, emotion, relationship. (Palmer, 1999, p. 17)

"Education is about healing and wholeness. It is about empowerment, liberation, transcendence, about renewing the vitality of life. It is about finding and claiming ourselves and our place in the world" (Palmer, 1999, pp. 18–19) and should attend to who we are as capable and knowledgeable people. As reminded by Dahlberg & Moss (2005, p. 113), "what children say and do cannot be judged in relation to a predetermined course or programme; rather attention is focused on what happens in the child's encounter with her or his environment, in paying close attention to the unique events of the here and now."

Further to this Dahlberg & Moss (2005, p. 182) advise: "The idea of innovative preschools and local projects, with a strong ethical and political commitment, entering into a global civil society seems particularly interesting as a possibility for change." Indeed, all learning environments, including early childhood settings, need to be perceived in relation to the wider psychological, environmental, economic, social, cultural, and technological processes governing their very existence. When viewed from a more expansive outlook, approaches to learning and the relationship between being human become visibly transparent and achievable. In order to explore new modes of human possibility, and to be open to new ideas and new knowledges, collective thought and action can be geographically dispersed and conceptualized internationally through global networks and alliances (Dahlberg & Moss, 2005).

Dance is one of the ways to advance the notion of a connected approach to learning and education (Slattery, 1995; 2006; Stinson, 1998) where dance is not seen just as a technique, or an elitist activity, but as a part of a whole or integrated program of learning. As emphasized previously, learning in dance is an embodied and visceral experience and the importance of this as a human right affirms the role of dance in education as a viable and recognizable form of pedagogy. The practice of dance can be inscribed with the ethics of an encounter, where learning together fosters recognition of relationships and a deep respect for otherness encompassing both connectedness and difference. Relationships with each other as well as our environment contribute to a "sense of responsibility for the Other" (Dahlberg & Moss, 2005, p. 192) and to the world in which we live. Dahlberg & Moss go on to say that "to connect is to work with possibilities, with unpredictable becomings, to elude control" (p. 115).

With further reference to the role of dance in the curriculum (Stinson, 1991a, p. 190) also reminds us that: "Control is as much an issue in curriculum as it is in dance: we fear that institutions, as well as bodies, will not work without control." As in any other area of curriculum, dance can be both restricting and liberating. The real issue here, nonetheless, is how teachers perceive power and control to address the ways in which dance uses these mechanisms either positively or negatively. As Stinson (1991b, p. 29) wisely suggests:

> [Teachers need] to learn to think critically rather than reverentially about their chosen profession. They need to learn how dance is like other human ventures in that it can contribute to either freedom or oppression, personal meaning or alienation, community or isolation—and how different pedagogies offer them a choice of which of these they will promote.

Slattery (2006, p. 222) goes on to say; "Stinson's curriculum theory, like the other holistic and ecological proposals ... provides an alternative to control and manipulation by emphasizing cooperative relationships." Dance is used as a way to see how an integrated and reciprocal approach to learning and teaching can become practice, thereby contradicting the fragmentation and isolation so prevalent in socially constructed models that thrive on "domination, control and conquest" (Slattery, 1995, p. 184). In this way the postmodern curriculum is likened to "a healing dance, a

spiral of creation, and a yearning for wisdom embedded in this interrelationship of body, mind, and spirit" (Slattery, 1995, p. 185). The idea of learning as healing, or the teacher as a 'healer' (hooks, 1994) is equally relevant when addressing the intentions of curriculum where the child/learner is seen as a whole person and central to the learning and teaching process. The underlying tenets of the early childhood curriculum *Te Whāriki* (Ministry of Education, 1996) echo these intentions. When learning is viewed in an interconnected manner and linked to the learner's lived experiences, there is a form of presence or authenticity, which is meaningful, engaging, and, thus, self-actualizing. A judiciously chosen dance pedagogy, which privileges a holistic, embodied, and visceral experience, affirms the role of dance in education as a valid and accepted pedagogy. More than this, dance, as other forms of engaged pedagogy (hooks, 1994) attest to, can become an ethical encounter (Dahlberg & Moss, 2005). An ethics of an encounter, according to Dahlberg & Moss, engages the vitality of thought in encounters with otherness and difference and, thus, new ways of seeing, new possibilities, and change. As proffered by Dahlberg & Moss (2005, p. 114):

> Thought is that space outside the actual, which is filled with virtualities, movements, forces, that need release. It is what a body is capable of doing, without there being any necessity and without being captured by what it habitually does, a sea of (possible) desires and machines waiting their chance, their moment of actualization.

The meaningfulness of learning can be particularly poignant when we consider those things in life that are abhorrent. Dance can act as a visceral or vicarious means to understand our experiences in the way that our engagement with artistic renderings brings forth emotional responses (Greene, 1988; 1995) and accesses our deepest imaginings. As further expanded upon by Dahlberg & Moss, (2005, p. 115): "What is important is to find ways to open up the unpredictable and the new, to put experimentation before ontology ... [where], from a Deleuzian perspective, we could view the pedagogical relationship as events rather than fixed definitions." Dahlberg & Moss (2005, p. 116) continue stating:

> Deleuze's concept of the event expresses a kind of trust and belief: trust that something unexpected, surprising, provoking may happen through

making connections; belief in new encounters and forces and thoughts
that are not contained and classified in existing programmes and
methods. This belief calls for ethical and political responsibility, a
heartfelt *yes, yes, yes* to the unknown, whether the unknown in another
type of thinking or another human being. This form of affirmative ethics
that challenges Cartesian certainty, starts in the art of listening and
communicates a message of welcome and hospitality.

Encounters with dance, and by association the kinesthetic and
aesthetic can create new spaces, events, compositions, and
possibilities between teachers and children; something that can be
manifested in a postmodern curriculum and realized through
currere (Pinar, 1975; 1994; 2004; 2006). A postmodern curriculum
embraces "complexity, tolerance of ambiguity, acceptance of
uncertainty, and authentic, situated assessment" (Slattery, 2006,
p. 54). These form the criteria for a pedagogical approach, which
can be simultaneously both exciting and challenging.

From a bodily perspective, delving into who we are humanly
via dance enables the body to reveal those structures of oppression
and injustice, which are etched into the body memory (Shapiro,
1994). Memories imprinted into the body find their genesis very
early in life and this is something which cannot be overlooked. As
pronounced by Leavitt & Power (1997, p. 42), the child's body "is
both a biological, corporeal phenomenon and a social construction,
shaped, constrained, and invented by society." Subsequently, the
young child comes to know the self through bodily experiences and
interpersonal relationships. Eventually these interrelationships
play a role in both identifying and establishing "self-identity and
social identity" (Leavitt & Power, 1997, p. 43). As a form of deep
personal expression, dance acts as a mediator between the self and
the world in which one lives. Thus, the child's understanding of
self becomes an embodied experience—an autobiography of the self
mapped through the regressive-progressive-analytical-synthetical
paths of *currere* (Pinar, 2004; Villaverde & Pinar, 1999).

A Vision for Dance and Justice

To enable new visions to be realized through dance as *currere* in
young children's lives I draw upon prophetic wisdom as evident in
prolepsis and Utopian thought. Prolepsis (Slattery, 1995; 2006)
and Utopian thought (Dahlberg & Moss, 2005; Dewey, 1933;

Freire, 1998; Schubert, 2009) provoke other ways to imagine the world and our place in that world. The proleptic, or, as found in literary theory, "prolepsis refers to events preceding the beginning of a novel or short story. Flashbacks, foreshadowing, and *déjà vu* are literary devices used to create a prolepsis ... the experience of the 'already but not yet'" (Slattery, 2006, p. 296). In other words, the future becomes embedded in the present, rather than being separated from the present, which is influenced by the past. Further to this Slattery (1995, p. 266) states:

> In curriculum theory prolepsis is indicated by Gadamer's "fusion of horizons," Dewey's "social consequences of value," Greene's "landscapes of learning," Freire's "praxis," Pinar's "currere," Padgham's "becoming," Macdonald's "hermeneutic circle," W. Doll's "transformative recursion," Griffin's "sacred interconnections," Bergson's "duration," Neitzche's "eternal return," and M. A. Doll's "dancing circle."

All of which point to metaphorical analogies of ways to imagine alternative possibilities and inspire hope for re-visioning the world. A proleptic understanding is infused with an integration of time, place, and self, where the aesthetic and embodiment intertwine to create an empowering and liberating vision of justice.

In concert, as Dahlberg & Moss (2005) saliently advise; the future must be reinvented by opening up new possibilities guided by radical alternatives—and the only way for this to happen is via Utopia. Utopian thought deconstructs the present and reconstructs the future. "It provides a provocation to politics, both major and minor, through the act of thinking differently ... [and] through confrontation of imagination of whatever exists" (Dahlberg & Moss, 2005, p. 179). In addition, there needs to be a willingness to change. Akin to Greene's (1978; 1988) call for 'wide-awakeness', and Freire's (1970; 1998) 'conscientization', Utopian thought and action (praxis) are prone to flourish in localities such as public spaces, where critical reflection and imagination are enlivened with others in order to release a nation from a state of apathy or anesthetization. Spaces then become open to experimentation, research, reflection, critique, and argumentation (Dahlberg & Moss, 2005).

Early childhood centers and schools can create these spaces and networks for exchange and change. Using the metaphor or imagery of a rhizome (Deleuze & Guattari, 1999), non-linear and non-hierarchical interconnections can be made through

"relationships of reciprocity" together with "new perspectives acquired from border crossing" (Dahlberg & Moss, 2005, p. 180). Utopian thinking and action can explore new modes of human possibility, being open to new ideas and new knowledges. As a challenge to the existing hegemonic order of modernity, Utopian thinking disrupts the status quo commonly found in normalizing educational practice, which is reduced to technical and dogmatic methods, skill acquisition, and routines. In opposition, Utopia provides a robust and passionate alternative to strive for where uneasiness and questioning cohabitate, but also surprise and wonder thrive. This drive is nurtured by an incessant need to seek new possibilities for the future brought about by critical and imaginative thinking. Ultimately, the result is an ethical encounter where borders are crossed and differences are acknowledged in the formulation of respectful relationships with others. Envisaging what is not yet with links to the "spiritual, aesthetic, historical, socio-political, ethical, racial, gendered, sexual, and cultural dimensions of the human community" (Slattery, 2006, p. 287) opens the portals to a Utopian or proleptic vision for curriculum, which can be actualized through *currere*.

A diversified postmodern perspective of people, and thus the human body, offers promise for new visions of pedagogy in dance, as opposed to the modernistic view in education where the body was universalized, mistrusted, and, subsequently, controlled, disciplined, or admonished. When the body is included in education from a postmodern perspective through curriculum as *currere*, it is regarded as a credible site of knowledge. Hence, it is *how* the body is included and, thus, treated or valued in education that matters.

Contrarily, a disparaging of the body acts as a denial of our selves bodily, which has consequences, not only for dance, but also for humanity. Recognition of the holistic nature of the body (which includes the mind) engenders a denunciation of the Cartesian notion of the mind/body split. When our whole selves are revered mindfully and lovingly, a different form of knowing ourselves ensues and we learn to respect our multiple identities and, thus, the manifold and different identities of others.

Instead of denying the bodily self, the body in education should be regarded fully, wisely, and attentively, through a process of critical reflection, to combat societal perspectives of the body, as

well as the injustices found in life. When we live in our bodies, care for and respect our bodies, empathy for others can be developed. Under these conditions, amelioration from the social injustices our bodies, or we as people, face has a chance to prosper. Thus, the human body becomes an agent of change, where the docile body is superseded and life's situations are no longer accepted as fate, but overridden through asserting personal choice or using power positively (Foucault, 1978; 1984; 1985; 1986; 1987; 1988). The power or agency of the body has its inception during the early years of life (Leavitt & Power, 1997). For this reason alone, it is imperative our youngest citizens are honored bodily and, thus, humanly in their formative years.

If imaginations are going to soar to envisage new ways of feeling and being in the world in and through dance, it is important to ensure that the learner, whether it is the child or adult, becomes central. The voices (and actions) of the learner must be listened to and acknowledged as valuable contributions to the teaching and learning process. This correlates with the issue of power and letting go, whilst also taking responsibility as the teacher to guide the process of learning in a sentient and insightful way. It is important to be sensitive to all concerned in the teaching and learning context to engender a shift of power or authority. Ultimately, the pedagogical practice becomes one of reciprocity and dialogue, where attention is paid to those who are present and engaged in the learning process. As insightfully encapsulated by Anttila (2008, p. 162), in dance "dialogue is a prelinguistic, bodily, and concrete happening that streams from one body to another body" rendering forth the utterances of in-depth embodied knowing without reservation. From a critical perspective, a reciprocal and dialogic approach is essential if the veils of oppression and injustice are to be lifted so the voices of the unheard are listened to and the bodies of the disregarded are paid attention to.

The emergence or outpouring of emotion that accompanies such a release of injustice, or an opening of the floodgates of humanity, needs to be permitted to surge forth, even if, at times, the pedagogical experience is uncomfortable or even dangerous. It is only when the oppressor's grip on our bodies and our minds, and thus everything that is inscribed in and on the body, is released,

that a new and just 'awakened' understanding of ourselves, others, and the world will be realized.

The way the body is positioned in dance education requires attention to nurture a critical and dialogic pedagogy of dance. Bodily resistance needs to be acknowledged for what it is saying; the inarticulate body needs to be reawakened; the historical, social, and cultural body needs to be reinstated; and the feeling and thinking body needs to be given full credence in dance education for the purpose of addressing inequities and providing a sense of hope and possibility. *Currere* offers the opportunity for this to happen as a process of engendering criticality, mutual engagement, and shared conversation in dance and, in so doing, addressing what it means to be human. When the knowledge of the body is invited into the teaching and learning space and there is acceptance of multiple epistemologies, which challenge power inequalities and encourage criticality, the less than desirable aspects of dance that are perpetuated from a historical, social, and cultural perspective can be troubled and changed.

The Dancing Child

Situated within my visions for dance education is the belief that learning is forever evolving. For this reason, I see dance as part of a living curriculum, one that is open to addressing social justice and working toward sowing seeds for change. Or, at least, fostering the imagination to imagine what could be, rather than maintaining what is. It is this quest for alternative possibilities that fuels the incentive for my work in early years dance education. To imagine a world where difference is acknowledged as well as celebrated is a worthy ideal and reflective of a postmodern, post-formal, and post-structural curriculum where multiple voices are encouraged and new meaning is produced. Beyond these ideals, however, as stated by Slattery (1995, p. 126); "the postmodern curriculum must address issues of self-identity and dignity, not only to improve education but also to promote justice and compassion in society." Greene (1995, p. 3) adds to these beliefs in the power of imagination and promotion of compassion or empathy in the following quote:

> One of the reasons I have come to concentrate on imagination as a means through which we can assemble a coherent world is that imagination is

what, above all, makes empathy possible. It is what enables us to cross the empty spaces between ourselves and those we teachers have called "other" over the years. If those others are willing to give us clues, we can look in some manner through strangers' eyes and hear through their ears. That is because, of all our cognitive capacities, imagination is the one that permits us to give credence to alternative realities. It allows us to break with the taken for granted, to set aside familiar distinctions and definitions.

Dance education as both a distinct discipline in the fabric of curriculum and as an integrated subject area can begin to interweave the threads of imagination and understanding to enable connections to a larger aspiration for freedom and social justice, even in the early years. Giroux & Simon (1989, p. 223) charge educators to consider a pedagogy that works toward "the enhancement of human capacities and social possibilities" and "understand why things are the way they are and how they got to be that way" in order to work toward freedom or emancipation. In other words, as stated previously, it is about making "the familiar strange and the strange familiar" (Kincheloe & McLaren, 2000, p. 286) to expand our knowledge and critically examine not only our lived experiences but those experiences that exist outside of our own. It is important to see everything as other and be willing to make the familiar unfamiliar. Greene (1988, p. 130) states:

> There is a sense in which the history of any art form carries with it a history of occasions for new visions, new modes of defamiliarization, at least in cases where artists thrust away the auras, and broke in some way with the past.

> It has been clear in music, pushing back the horizons of silence for at least a century, opening new frequencies for ears willing to risk new sounds. It has been true of dance, as pioneers of movement and visual metaphor uncover new possibilities in the human body and therefore for embodied consciousness in the world.

But as further postulated by Greene (1988, p. 131), "such visions are unknown in most of our classrooms; and relatively few people are informed enough or even courageous enough actually to 'see'." It is my wish, however, that a conceptualization of a revolutionary curriculum for early childhood and the development of a new and visionary arts curriculum have the possibility to help people 'see' in order to educate as the practice of freedom (Foucault, 1987; Freire, 1970; 1998; hooks, 1994). In a similar way

to Dahlberg & Moss (2005) I have tried to envision a different possibility for the lives of young children by returning to the early childhood setting as the threshold "for ethical and democratic political practice, where education takes the form of a pedagogy of listening related to the ethics of an encounter, and ... confronts dominant discourses and injustice" (Dahlberg & Moss, 2005, p. 178). I have attempted to do this through the avenue of dance as *currere*.

To awaken a dream or vision for dance is to strengthen the potential to make a hopeful difference in education. When mapped through *currere* and guided by critical pedagogy, dance can stir the imagination whilst raising conscious awareness of oppressive practices. Through being involved in dance, and thereby, in touch with the human body and all that the body possesses (its thoughts and feelings, the deeply ingrained experiences, and raw emotions), as one of the ways to understand our bodies and, therefore, ourselves, there is the prospect of connecting to the lives, and, therefore, plight of others.

From the outlook of the young child, it is timely to remind ourselves here that the young child 'speaks' with her/his body, offering gestures and actions to elicit reciprocal engagement from others. When there is sensitive and contemplative receivership by others, young children's self-identities and bodily well-being are formed. Through their embodied engagement with others and with the world in which they live, young children also begin to discover their emerging agency (Leavitt & Power, 1997). A belief in cherishing the young child's nascent sense of self and agency reflect the principles of holistic development (*kotahitanga*) and empowerment (*whakamana*) (Ministry of Education, 1996), as well as the concept of *currere* as a living, breathing curriculum of humanity.

For this reason, I argue that recognition of dance and aesthetics through the ethics of *currere* should be engaged as conduits to cultivate habits of equity, social democracy, and social justice. Young children's holistic and embodied involvement in dance as *currere* has the potential to enhance their authenticity as citizens of the world and as agents of change. This, I contend, affords a proleptic or Utopian vision for dance where new ways of imagining ourselves, others, and the world through the lens of social justice can be realized. I envision that liberation

[emancipation] through dance has immense promise when connected to the early years of education. Even though, as referred to at the start of this book, these two ideologies may appear to be far apart, life from its very beginning can be conducive to understanding justice as a result of young children's propensity for bodily engagement brimming with potentiality and an enfleshed desire for hope and love.

Upon returning to one of the initial provocations, the connection between movement and dance in the young child's life, I trust that new vistas for potential engagement in dance have been opened up. When the importance of recognizing the agency of the body, and thus our human selves is connected to dance, the reason for dance in a young child's life becomes more doable. "Thinking," as Olsson (2010, p. 347) reminds us, "is not separated from bodily experience; thought is not the great organizer of experience. Before thought there is life and life is so much stronger and demands so much more than thought" which, I believe, offers avenues for expression and paves the way for movement and dance in young children's lives.

When young children dance the multilayered languages of movement, gesture, and visual symbolism intermingle in a fusion of sensations and expression conveying children's presence in the world. The honoring of the human body as a realistic source of 'language' and thereby knowledge making, is imperative, especially in the early years, because young children do not distinguish thought from feeling and their life experiences. If the moving language of dance is overlooked, so, too, is the young child. Children's interest in life and what they are engaged in generate ways of being in the world. The question is will teachers respond to children's mobile bodies and capitalize on situations where dance and the language of the body become prevalent as another form of expression? Or, as Olsson (2010, p. 347) connotes, what could be called "a different image of thought" … [where] "ideas and thinking are bodily concrete."

I would like to see dance embraced by education and acknowledged as a way of awakening possibilities that helps us to imagine what could be for the purpose of a better world. Pursuing a critical pedagogy in dance, where children are affirmed for who they are, enhances the prospect for dance to become a transformative agent in the pursuit toward social justice and

freedom. This can only be realized, however, if early childhood educators become alert to the dominance of particular ways of knowing and act as agents of change in honoring the child's wisdom of the body. As these words inspired by Dewey and Utopian thought remind us:

> The wisdom of Earthling babies is an amazing topic. It is one we ponder extensively, and still only scratch the surface. Sometimes we often wonder if babies are born with an all-knowing repertoire that gradually erodes away as they encounter situations. (Schubert, 2009, p. 103)

The existence of movement and dance in our lives can expand horizons to overcome entrenched views of who we are humanly and promote new possibilities. This requires imagination, arising from the premise of critical thought and moral aspirations for a better world. The awakening or raising of consciousness is an important step in the pursuit of freedom. To imagine the possibilities (or to be able to identify the obstacles) sometimes requires prompting from others, which is a moral and ethical action the educator must undertake. Greene (1988, p. 125) reminds us that "education for freedom must clearly focus on the range of human intelligences, the multiple languages and symbol systems available for ordering experience and making sense of the lived world." It is then that one can be in a position to see things differently, or placed in a situation to deconstruct and transform. This is the imagined world that hopefully awakens a new way of seeing with the purpose of working toward amelioration of social injustice.

Through the art of dance both the critical and the imaginative can be utilized as a new way of looking using multiple or embodied approaches to thinking and seeing. Of course, as Greene (1988, p. 131) reminds us, the potential the arts have in transforming our thinking cannot be relied upon alone "to ensure an education for freedom." The arts have not, and may never be given the credence they deserve in education; however, as Greene emphatically states the arts "ought to be, if transformative teaching is our concern, a central part of curriculum, wherever it is devised." I believe it is important to remind ourselves as educators that:

> Teachers, like their students, have to learn to love the questions, as they come to realize that there can be no final agreements or answers, no final commensurability. And we have been talking about stories that open

perspectives on communities grounded in trust, flowering by means of dialogue, kept alive in open spaces where freedom can find a place. (Greene, 1988, p. 134)

To act consciously in this world is to bring about through both critical and mindful practice a way to induce change for the purpose of social justice and liberation. This is the world our very youngest citizens deserve and, equally, have the chance to play a part in creating. Perhaps, as proposed by Damasio (1994, p. 252) "the most indispensable thing we can do as human beings, every day of our lives, is remind ourselves and others of our complexity, fragility, finiteness, and uniqueness" and, in so doing, come to understand the potentiality and preciousness of life; life which is ever-present in the moving and dancing child.

Thus, in conclusion, having identified the concerns, myths, and misnomers that I believe impact the presence and effectiveness of dance within education, but more specifically in early childhood settings, it is my hope that the presentation of alternative perspectives and approaches will offer new possibilities for dance and children, as well as educators. I maintain that movement and dance can make complementary partners because they both have the potential to value the importance of the human body in education and honor a child-centered and reciprocal approach to learning and teaching. Furthermore, dance can create that space for difference and change through honoring multiple and diverse 'voices'. Let us "receive the dance of the child" (Bond, 2000, p. 14) and help cultivate an inter-connective relationship between dance and the early years of learning.

Bibliography

Alcock, S. (2008). Young children being rhythmically playful: Creating *musike* together. *Contemporary Issues in Early Childhood, 9*(4), 328–338.

Alcock, S. (2009). Dressing up play: Rethinking play and playfulness from socio-cultural perspectives. *He Kupu: The Word, 2*(2), 19–30.

Anning, A. (2009). The co-construction of an early childhood curriculum. In A. Anning, J. Cullen, & M. Fleer (Eds.), *Early childhood education: Society and culture* (2nd Ed.) (pp. 67–79). London, England: Sage.

Anning, A., Cullen, J., & Fleer, M. (2009). Research contexts across cultures. In A. Anning, J. Cullen, & M. Fleer (Eds.), *Early childhood education: Society and culture* (2nd Ed.) (pp. 1–24). London, England: Sage.

Anttila, E. (2003). *A dream journey to the unknown: Searching for dialogue in dance education.* Helsinki, Finland: Theatre Academy.

Anttila, E. (2004). Dance learning as practice of freedom. In L. Rouhiainen, E. Anttila, S. Hämäläinen, & T. Löytönen (Eds.), *The same difference? Ethical and political perspectives on dance* (pp. 19–62). Helsinki, Finland: Theatre Academy.

Anttila, E. (2007). Children as agents in dance: Implications of the notion of child culture for research and practice in dance education. In L. Bresler (Ed.), *International handbook of research in arts education* (pp. 865–879). Dordrecht, The Netherlands: Springer.

Anttila, E. (2008). Dialogical pedagogy, embodied knowledge, and meaningful learning. In S. B. Shapiro (Ed.), *Dance in a world of change: Reflections on globalization and cultural difference* (pp. 159–179). Champaign, IL: Human Kinetics.

Ashley, L. (2002). *Essential guide to dance* (2nd Ed.). London, England: Hodder & Stoughton.

Ashley, L. (2009). Metamorphosis in dance education: Tradition and change a delicate dilemma. In C. Stock (Ed.), *Dance dialogues: Conversations across cultures, artforms and practices,* Proceedings of the 2008 World Dance Alliance Global Summit, Brisbane, 13–18 July. On-line publication QUT Creative Industries and Ausdance, http://www.ausdance.org.au.

Barlin, A., & Barlin, P. (1971). *The art of learning through movement.* Los Angeles, CA: Ward Ritchie Press.

Barlin, A. (1979). *Teaching your wings to fly: The nonspecialist's guide to movement activities for young children.* Santa Monica, CA: Goodyear.

Batt, T. (2004). *Dance upon a time: Movement stories for the feet and tongue.* Auckland, New Zealand: Playcentre.

Benzwie, T. (1987). *A moving experience: Dance for lovers of children and the child within.* Cheltenham, Victoria, Australia: Hawker Brownlow Education.

Bhabba, H. (1994). *The location of culture.* New York, NY: Routledge.

Blenkin, G., & Kelly, A. V. (Eds.). (1994). *The national curriculum and early learning: An evaluation.* London, England: Paul Chapman.

Block, A. (1998). Curriculum as affichiste: Popular culture and identity. In W. Pinar (Ed.), *Curriculum: Toward new identities* (pp. 325–341). New York, NY: Garland.

Blumenfeld-Jones, D. (2004). Bodily-kinesthetic intelligence and the democratic ideal. In J. Kincheloe (Ed.), *Multiple intelligences reconsidered* (pp. 119–131). New York, NY: Peter Lang.

Bolwell, J. (1998). Into the light: An expanding vision of dance education. In S. B. Shapiro (Ed.), *Dance, power, and difference: Critical and feminist perspectives of dance education* (pp. 75–95). Champaign, IL: Human Kinetics.

Bolwell, J. (2009). Dance education in New Zealand schools 1900–2008. *Tirairaka: Dance in New Zealand 2009, 1–24.*

Bolwell, J., Cossey, J., & Oliver, L. (1998). *Creative dance in New Zealand primary schools: A handbook for teachers.* Wellington, New Zealand: Wairarapa Education Resource Centre.

Bond, K. (1994a). How "Wild Things" tamed gender distinctions. *Journal of Physical Recreation and Dance,* February, *65*(2), 28–33.

Bond, K. (1994b). Personal style as a mediator of engagement in dance: Watching Terpsichore rise. *Dance Research Journal. 26*(1), 15–25.

Bond, K. (2000). Revisioning purpose: Children, dance and the culture of caring. In J. E. LeDrew & H. Ritenburg (Eds.), Conference Proceedings, *8th Dance and the Child International Conference 2000, Extensions and Extremities* (pp. 3–14). Regina, Saskatchewan, Canada: University of Regina.

Bond, K., & Deans, J. (1997). Eagles, reptiles and beyond: A co-creative journey in dance. *Childhood Education, 73*(6), 366–371.

Bond, K., & Stinson, S. (2001). 'It feels like I'm going to take off!' Young people's experiences of the superordinary in dance. *Dance Research Journal, 32*(2), 52–87.

Bond, K., & Stinson, S. (2007). 'It's work, work, work, work': Young people's experiences of effort and engagement in dance. *Research in Dance Education, 8*(2), 155–183.

Boorman, J. (1969). *Creative dance in the first three grades.* Ontario, Canada: Longmans.

Brehm, M. A., & McNett, L. (2007). *Creative dance for learning: The kinesthetic link*. New York, NY: McGraw-Hill.

Bresler, L. (Ed.). (2004a). *Knowing bodies, moving minds: Towards embodied teaching and learning*. Dordrecht, The Netherlands: Kluwer Academic.

Bresler, L. (2004b). Dancing the curriculum: Exploring the body and movement in elementary schools. In L. Bresler (Ed.), *Knowing bodies, moving minds: Towards embodied teaching and learning* (pp. 127–151). Dordrecht, The Netherlands: Kluwer Academic.

Bresler, L. (Ed.). (2007). *International handbook of research in arts education*. Dordrecht, The Netherlands: Springer.

Bresler, L., & Thompson, C. M. (Eds.). (2002a). *The arts in children's lives: Context, culture, and curriculum*. Dordrecht, The Netherlands: Kluwer Academic.

Bresler, L., & Thompson, C. M. (2002b). Context interlude. In L. Bresler & C. M. Thompson (Eds.), *The arts in children's lives: Context, culture, and curriculum* (pp. 9–14). Dordrecht, The Netherlands: Kluwer Academic.

Brooker, L. (2008). *Supporting transitions in the early years*. New York, NY: Open University Press.

Cannella, G. (1998). Early childhood education: A call for the construction of revolutionary images. In W. Pinar (Ed.), *Curriculum: Toward new identities* (pp. 157–184). New York, NY: Garland.

Cannella, G. (2002). *Deconstructing early childhood education: Social justice and revolution*. New York, NY: Peter Lang.

Cannella, G. (2010). Introduction. In G. S. Cannella & L. D. Soto (Eds.), *Childhoods: A handbook* (pp. 1–6). New York, NY: Peter Lang.

Cannella, G., & Viruru, R. (2004). *Childhood and postcolonization: Education, and contemporary practice*. New York, NY: RoutledgeFalmer.

Carr, M. (2001). *Assessment in early childhood settings: Learning stories*. Thousand Oaks, CA: Sage.

Churchill, W. (1996). *From a native son: Selected essays in indigenism*. Boston, MA: South End.

Conway, T. (2007). Jerome Bruner. In J. Kincheloe & R. Horn (Eds.), *The Praeger handbook of education and psychology*, Vol. 1, (pp. 57–61). Westport, CT: Praeger.

Cowhey, M. (2006). *Black ants and Buddhists: Thinking critically and teaching differently in the primary grades*. Portland, ME: Stenhouse.

Crain, W. (2003). *Reclaiming childhood: Letting children be children in our achievement-oriented society*. New York, NY: Henry Holt.

Cullen, J. (2003). The challenge of *Te Whāriki*: Catalyst for change? In J. Nuttall (Ed.), *Weaving te whāriki: Aotearoa New Zealand's early childhood curriculum document in theory and practice* (pp. 269–296). Wellington, New

Zealand: New Zealand Council for Educational Research: Te Rūnanga o Aotearoa mō te Rangahau i te Mātauranga.

Cullen, J. (2009). Adults co-constructing professional knowledge. In A. Anning, J. Cullen, & M. Fleer (Eds.), *Early childhood education: Society and culture* (2nd Ed.) (pp. 80–90). London, England: Sage.

Curtis, D., & Carter, M. (2008). *Learning together with young children: A curriculum framework for reflective teachers.* St. Paul, MN: Redleaf Press.

Dahlberg, G., & Moss, P. (2005). *Ethics and politics in early childhood education.* New York, NY: RoutledgeFalmer.

Dahlberg, G., Moss, P., & Pence, A. (1999). *Beyond quality in early childhood education and care: Postmodern perspectives.* London: England: Falmer.

Damasio, A. (1994). *Decartes' error: Emotion, reason, and the human brain.* New York, NY: HarperCollins.

Dance and the Child International Conference (11th Ed.), Programme Guide, (2009). *Cultures Flex: Unearthing Expressions of the Dancing Child,* 2–8 August. Kingston, Jamaica: Pear Tree.

Davidson, J. (2004). Embodied knowledge: Possibilities and constraints in arts education and curriculum. In L. Bresler (Ed.), *Knowing bodies, moving minds: Towards embodied teaching and learning* (pp. 197–212). Dordrecht, The Netherlands: Kluwer Academic.

Davies, M. (2003). *Movement and dance in early childhood.* London, England: Paul Chapman.

Deleuze, G., & Guattari, F. (1999). *A thousand plateaus: Capitalism and schizophrenia.* London, England: Athlone.

Department of Education. (1968). *Music and movement.* Wellington, New Zealand.

Department of Education. (1987). *Physical education: A guide for success.* Wellington, New Zealand.

Department of Education. (1989). *Music education: Early childhood to form seven.* Wellington, New Zealand.

Dewey, J. (1933). Dewey outlines utopian schools. *New York Times,* April 23, p. 7. Reprinted in W. Schubert, (2009), *Love, justice, and education* (pp. 11–12). Charlotte, NC: Information Age.

Dewey, J. (1959). *Dewey on education.* New York, NY: Teachers College Press, Colombia University.

Dissanayake, E. (1992). *Homo aestheticus: Where art comes from and why.* New York, NY: The Free Press.

Duhn, I. (2006). The making of global citizens: Traces of cosmopolitanism in the New Zealand early childhood curriculum, Te Whāriki. *Contemporary Issues in Early Childhood, 7*(3), 191–202.

Duhn, I. (2010). Mapping globalization and childhood: Possibilities for curriculum and pedagogy. In G. S. Cannella & L. D. Soto (Eds.), *Childhoods: A handbook* (pp. 309–318). New York, NY: Peter Lang.

Dunn, J. (2003). Linking drama education and dramatic play in the early childhood years. In S. Wright (Ed.), *Children, meaning-making and the arts* (pp. 117–133). Frenchs Forest, NSW, Australia: Pearson Prentice Hall.

Edwards, C., Gandini, L., & Forman, G. (1998). Introduction: Background and starting points. In C. Edwards, L. Gandini, & G. Forman (Eds.), *The hundred languages of children: The Reggio Emilia approach—advanced reflections* (2nd Ed.) (pp. 5–25). Westport, CT: Ablex.

Egan, K. (1999). *Children's minds, talking rabbits and clockwork oranges: Essays on education*. New York, NY: Teachers College Press.

Ehrenreich, B. (2007). *Dancing in the streets: A history of collective joy*. London, England: Granta.

Elkind, D. (2007). *The power of play: How spontaneous, imaginative activities lead to happier, healthier children*. Cambridge, MA: Da Capo Press.

Ellis, C., & Bochner, A. (2000). Autoethnography, personal narrative, reflexivity: Researcher as subject. In K. N. Denzin & Y. Lincoln (Eds.), *The handbook of qualitative research* (pp. 733–768). Thousand Oaks, CA: Sage.

Espenak, L. (1981). *Dance therapy*. Springfield, IL: Charles C. Thomas.

Farley, P. (1969). *A teacher's guide to creative dance*. Auckland, New Zealand: A. H. & A. W. Reed.

Fels, L. (2010). Coming into presence: The unfolding of a moment. *Journal of Educational Controversy: Art, Social Imagination and Democratic Education,* 5(1), Winter 2010, e-Journal, Woodring College of Education, Western Washington University, http://www.wce.wwu.edu.

Filippini, T., Giudici, C., & Vecchi, V. (2008). *Dialogues with places*. Reggio Emilia, Italy: Reggio Children.

Fleer, M. (2010). *Early learning and development: Cultural-historical concepts in play*. Melbourne, Australia: Cambridge University Press.

Fleer, M., Anning, A., & Cullen, J. (2009). A framework for conceptualising early childhood education. In A. Anning, J. Cullen, & M. Fleer (Eds.), *Early childhood education: Society and culture* (2nd Ed.) (pp. 187–204). London, England: Sage.

Fleer, M., & Richardson, C. (2009). Cultural-historical assessment: Mapping the transformation of understanding. In A. Anning, J. Cullen, & M. Fleer (Eds.), *Early childhood education: Society and culture* (2nd Ed.) (pp. 120–144). London, England: Sage.

Foucault, M. (1978). *The history of sexuality: An introduction: Volume 1*. New York, NY: Vintage.

Foucault, M. (1984). On the genealogy of ethics: An overview of work in progress. In P. Rabinow (Ed.), *The Foucault reader* (pp. 340–372). New York, NY: Pantheon.

Foucault, M. (1985). *The history of sexuality: Volume 2, the use of pleasure.* New York, NY: Vintage.

Foucault, M. (1986). *The history of sexuality: Volume 3, the care of self.* New York, NY: Vintage.

Foucault, M. (1987). The ethic of care for the self as a practice of freedom: An interview with Michel Foucault. In J. Bernauer & D. Rasmussen (Eds.), *The final Foucault* (pp. 1–20). Cambridge, MA: MIT Press.

Foucault, M. (1988). An aesthetics of existence. In L. Kritzman (Ed.), *Politics, philosophy, culture: Interviews and other writings 1977–1984.* New York, NY: Routledge.

Fraser, D., Price, G., & Aitken, V. (2007). Relational pedagogy and the arts. *set: Research Information for Teachers, 1,* 113–118. Wellington, New Zealand: NZCER Press (The New Zealand Council of Educational Research).

Freire, P. (1970). *Pedagogy of the oppressed.* New York, NY: Continuum.

Freire, P. (1996). *Pedagogy of hope: Reliving pedagogy of the oppressed.* New York, NY: Continuum.

Freire, P. (1998). *Pedagogy of freedom: Ethics, democracy, and civic courage.* Lanham, MD: Rowman & Littlefield.

Gandini, L., & Malaguzzi, L. (1998). History, ideas, and basic philosophy: An interview with Lella Gandini. In C. Edwards, L. Gandini, & G. Forman (Eds.), *The hundred languages of children: The Reggio Emilia approach— advanced reflections* (2nd Ed.) (pp. 49–97). Westport, CT: Ablex.

Gardner, H. (1993). *Frames of mind: The theory of multiple intelligences.* New York, NY: Basic.

Gardner, H. (1999). *Intelligence reframed: Multiple intelligences for the 21st century.* New York, NY: Basic.

Giroux, H. (1988). *Teachers as intellectuals: Toward a critical pedagogy of learning.* Westport, CT: Bergin & Garvey.

Giroux, H. (2001). *Theory and resistance in education: Towards a pedagogy for the opposition.* Westport, CT: Bergin & Garvey.

Giroux, H. (2006). *The Giroux reader.* Boulder, CO: Paradigm.

Giroux, H., & Simon, R. (1989). Popular culture as pedagogy of pleasure and meaning. In H. Giroux & R. Simon (Eds.), *Popular culture: School and everyday life* (pp. 1–29). New York, NY: Bergin & Garvey.

Green, J. (2004). The politics and ethics of health in dance education. In L. Rouhiainen, E. Anttila, S. Hämäläinen, & T. Löytönen (Eds.), *The same difference? Ethical and political perspectives on dance* (pp. 65–76). Helsinki, Finland: Theatre Academy.

Green, J. (2007). Student bodies: Dance pedagogy and the soma. In L. Bresler (Ed.), *International handbook of research in arts education* (pp. 1119–1132). Dordrecht, The Netherlands: Springer.

Green Gilbert, A. (1992). *Creative dance for all ages: A conceptual approach.* Reston, VA: American Alliance for Health, Physical Education, Recreation, and Dance.

Greene, M. (1978). *Landscapes of learning.* New York, NY: Teachers College Press.

Greene, M. (1988). *The dialectic of freedom.* New York, NY: Teachers College Press.

Greene, M. (1995). *Releasing the imagination: Essays on education, the arts, and social change.* San Francisco, CA: Jossey-Bass.

Greenwood, J. (2001). Within a third space. *Research in Drama Education, 6*(2), 193–205.

Greenwood, J. (2003). Drama as a way of knowing. In E. Grierson & J. Mansfield (Eds.), *The arts in education: Critical perspectives from Aotearoa New Zealand* (pp. 119–136). Palmerston North, New Zealand: Dunmore.

Griss, S. (1998). *Minds in motion: A kinesthetic approach to teaching elementary curriculum.* Portsmouth, NH: Heinemann.

Grumet, M. (1978). Songs and situations: The figure/ground relation in a case study of *currere.* In G. Willis (Ed.), *Qualitative evaluation* (pp. 276–315). Berkley, CA: McCutchan.

Hallowell, E. M. (2002). *The childhood roots of adult happiness.* New York, NY: Routledge.

Hanlon Johnson, D. (1992). *Body: Recovering our sensual wisdom.* Berkeley, CA: North Atlantic.

Hanlon Johnson, D. (2002). Sitting, writing, listening, speaking, yearning: Reflections on scholar-shaping techniques. In S. Shapiro & S. Shapiro (Eds.), *Body movements: Pedagogy, politics and social change* (pp. 97–115). Cresskill, NJ: Hampton.

Hanlon Johnson, D. (2009). The cultivation of children's bodies toward intricate thinking and sensitive behavior. In H. S. Shapiro (Ed.), *Education and hope in troubled times: Visions of change for our children's world* (pp. 157–167). New York, NY: Routledge.

Hanna, J. L. (1982). Children's own dance, play and protest—An untapped resource for education. *Proceedings of the International Conference of Dance and the Child International.* Stockholm: Dance and the Child International, 51–73.

Hanna, J. L. (1986). Interethnic communication in children's own dance, play, and protest. In Y. Y. Kim (Ed.), *Interethnic Communication, Vol. 10, International and Intercultural Communication Annual* (pp. 176–198). Newbury Park, CA: Sage.

Hanna, J. L. (1988). *Dance and stress: Resistance, reduction, and euphoria.* New York, NY: AMS Press.

Hanna, J. L. (1999). *Partnering dance and education: Intelligent moves for changing times.* Champaign, IL: Human Kinetics.

Hanna, J. L. (2006). *Dancing for health: Conquering and preventing stress.* Lanham, MD: AltaMira.

Hanstein, P. (1990). Educating for the future: A postmodern paradigm for dance education. *Journal of Physical Education, Recreation and Dance,* 56–58.

Harrison, K. (1990). *Look! Look! What I can do! Creative action ideas for under sevens.* London, England: BBC Educational Publishing.

Henderson, J., & Hawthorne, R. (2000). *Transformative curriculum leadership.* City, NJ: Merrill Prentice Hall.

Henry, A. (2001). Stuart Hall, cultural studies: Theory letting you off the hook? In K. Weiler (Ed.), *Feminist engagements: Reading, resisting, and revisioning male theorists in education and cultural studies* (pp. 165–182). New York, NY: Routledge.

Hong, C. (2003). Taking the road less travelled: Developing dance literacy in Aotearoa New Zealand. In E. Grierson & J. Mansfield (Eds.), *The arts in education: Critical perspectives from Aotearoa New Zealand* (pp. 137–159). Palmerston North, New Zealand: Dunmore.

Hong-Joe, C. (2002). *Developing dance literacy in the postmodern: An approach to curriculum.* Doctoral Dissertation. Brisbane, Queensland, Australia.

hooks, b. (1994). *Teaching to transgress: Education as the practice of freedom.* New York, NY: Routledge.

hooks, b. (2000). *All about love: New visions.* New York, NY: HarperCollins.

Jones, A. (2003). A short history of anxiety about touch in early childhood education. *The First Years: Nga Tau Tuatahi: New Zealand Journal of Infant and Toddler Education,* 5(1), 22–24.

Jones, E., & Nimmo, J. (1994). *Emergent curriculum.* Washington, DC: National Association for the Education of Young Children.

Jovanovic, S. (2008). Our dancing journey. Unpublished Learning Story, Bambinos Toddler Group, Auckland, New Zealand.

Joyce, M. (1980). *First steps in teaching creative dance to children* (2nd Ed.). Palo Alto, CA: Mayfield.

Kaa, K. (1993). Unpublished interview conducted by J. Whatman, 13 July, New Zealand.

Kaa, K. (1999). The web of learning. *Dance Aotearoa New Zealand (DANZ) Magazine,* Issue 9, p. 8.

Kálló, É., & Balog, G. (2005). *The origins of free play.* Translated from German by M. Holm and edited by U. Strub & A. Zinser. Budapest, Hungary: Association Pikler-Loczy.

Kincheloe, J. (1993). *Toward a critical politics of teaching thinking: Mapping the postmodern*. Westport, CT: Bergin & Garvey.

Kincheloe, J. (2008). *Critical pedagogy*. New York, NY: Peter Lang.

Kincheloe, J., & McLaren, P. (2000). Rethinking critical theory and qualitative research. In K. N. Denzin & Y. Lincoln (Eds.), *The handbook of qualitative research* (pp. 279–313). Thousand Oaks, CA: Sage.

Kincheloe, J., & Steinberg, S. (1999). A tentative description of post-formal thinking: The critical confrontation with cognitive theory. In J. Kincheloe, S. Steinberg, & P. Hinchey (Eds.), *The post formal reader: Cognition and education* (pp. 55–90). New York, NY: Falmer.

Kipling Brown, A. (2008). Common experience creates magnitudes of meaning. In S. B. Shapiro (Ed.), *Dance in a world of change: Reflections on globalization and cultural difference* (pp. 141–157). Champaign, IL: Human Kinetics.

Koff, S. (2000). Toward a definition of dance education. *Childhood Education, 77*(1), 27–31.

Krogh, S. (1990). *The integrated early childhood curriculum*. New York, NY: McGraw-Hill.

Laban, R. (1947). *Modern educational dance* (3rd Ed.). Revised by Lisa Ullmann (1988). Plymouth, England: Northcote.

Lange, D. (1988). *Before five: Early childhood care and education in New Zealand*. Wellington, New Zealand: Government Printer.

Leavitt, R., & Power, M. (1997). Civilizing bodies: Children in day care. In J. Tobin (Ed.), *Making a place for pleasure in early childhood education* (pp. 39–75). New Haven, CT: Yale University Press.

Leistyna, P. (1999). *Presence of mind: Education and the politics of deception*. Boulder, CO: Westview.

Lindqvist, G. (2001). The relationship between dance and play. *Research in Dance Education, 2*(1), 41–52.

Liu, S-Y. (2008). Transferable theory: Researching movement concepts in different cultural contexts. In S. B. Shapiro (Ed.), *Dance in a world of change: Reflections on globalization and cultural difference* (pp. 181–203). Champaign, IL: Human Kinetics.

Lynch-Fraser, D. (1982). *Danceplay: Creative dance for very young children*. New York, NY: Walker.

Lynch-Fraser, D. (1991). *Playdancing: Discovering and developing creativity in young children*. Pennington, NJ: Princeton.

McArdle, F. (2008). The arts and staying cool. *Contemporary Issues in Early Childhood, 9*(4), 365–373.

MacNaughton, G. (2005). *Doing Foucault in early childhood studies: Applying poststructural ideas*. New York, NY: Routledge.

MacNaughton, G. (2009). Exploring critical constructivist perspectives on children's learning. In A. Anning, J. Cullen, & M. Fleer (Eds.), *Early*

childhood education: Society and culture (2nd Ed.) (pp. 53–63). London, England: Sage.

Malaguzzi, L. (1998). History, ideas, and basic philosophy: An interview with Lella Gandini. In C. Edwards, L. Gandini, & G. Forman (Eds.), *The hundred languages of children: The Reggio Emilia approach—advanced reflections* (2nd Ed.) (pp. 49–97). Westport, CT: Ablex.

Matos, L. (2008). Writing in the flesh: Body, identity, disability, and difference. In S. B. Shapiro (Ed.), *Dance in a world of change: Reflections on globalization and cultural difference* (pp. 71–91). Champaign, IL: Human Kinetics.

May, H. (2009). *Politics in the playground: The world of early childhood in New Zealand.* Dunedin, New Zealand: Otago University Press.

McLaren, P. (1992). Critical multiculturalism and democratic schooling: An interview with Joe Kincheloe. *International Journal of Educational Reform, 1*(4), 392–405.

McLaren, P. (1999). *Schooling as a ritual performance: Toward a political economy of educational symbols and gestures.* City, MD: Rowman & Littlefield.

Melchior, E. (2009). Teaching and learning dance in a culturally inclusive classroom. In C. Stock (Ed.), *Dance dialogues: Conversations across cultures, artforms and practices,* Proceedings of the 2008 World Dance Alliance Global Summit, Brisbane, 13-18 July. On-line publication QUT Creative Industries and Ausdance, http://www.ausdance.org.au.

Miller, R. (2009). Education after the empire. In H. S. Shapiro (Ed.), *Education and hope in troubled times: Visions of change for our children's world* (pp. 121–133). New York, NY: Routledge.

Ministry of Education. (1993a). *Music education for young children: A handbook for early childhood staff and teachers of junior classes.* Wellington, New Zealand: Learning Media.

Ministry of Education. (1993b). *The New Zealand curriculum framework: Te anga mātauranga o Aotearoa.* Wellington, New Zealand: Learning Media.

Ministry of Education. (1996). *Te whāriki: He whāriki mātauranga mō ngā mokopuna o Aotearoa: Early childhood curriculum.* Wellington, New Zealand: Learning Media.

Ministry of Education. (2000). *The arts in the New Zealand curriculum.* Wellington, New Zealand: Learning Media.

Ministry of Education. (2007). *The New Zealand curriculum.* Wellington, New Zealand: Learning Media.

Naden, N. (1990). *Te reo kori waiata Māori.* [kit] Volume 1. Auckland, New Zealand: Kimihia Resources.

Naden, N. (1991). *Te reo kori waiata Māori.* [kit] Volume 2. Auckland, New Zealand: Kimihia Resources.

Nicholson, S., & Shipstead, S. (1994). *Through the looking glass: Observations in the early childhood classroom.* New York, NY: Macmillan.

Nieto, S. (2002). *Language, culture, and teaching: Critical perspectives for a new century.* Mahwah, NJ: Lawrence Erlbaum.

Noddings, N. (2003). *Happiness and education.* Cambridge, England: Cambridge University Press.

Noddings, N. (2007). War, violence, and peace in the arts. In L. Bresler (Ed.), *International handbook of research in arts education* (pp. 1021–1030). Dordrecht, The Netherlands: Springer.

O'Loughlin, M. (2009). *The subject of childhood.* New York, NY: Peter Lang.

Olsson, L. M. (2010). Using molecular politics in early childhood education. In G. Cannella & L. D. Soto (Eds.), *Childhoods: A handbook* (pp. 345–354). New York, NY: Peter Lang.

Paley, V. G. (2004). *A child's work: The importance of fantasy play.* Chicago, IL: The University of Chicago Press.

Palmer, P. (1999). The grace of great things: Reclaiming the sacred in knowing, teaching, and learning. In S. Glazer (Ed.), *The heart of learning: Spirituality in education* (pp. 15–32). New York, NY: Jeremy P. Tarcher/Putnam.

Parker-Rees, R. (1999). Protecting playfulness. In L. Abbott & H. Moylett (Eds.), *Early education transformed* (pp. 61–72). London, England: Falmer.

Pere, R. (1994). *Ako: Concepts and learning in the Māori tradition.* Wellington, New Zealand: Te Kohanga Reo National Trust Board.

Pere, R. (1995). *Te uri te Aorangi: A sharing of wisdom with Rangimarie Turuki Rose Lambert Pere* [Video Recording]. Thames, New Zealand: Te Haeata Hauraki Education Centre.

Perry, M., & Rockel, J. (2007). A revolution in our own time—Magda Gerber's legacy to New Zealand education. *The First Years: Nga Tau Tuatahi: New Zealand Journal of Infant and Toddler Education, 9*(1), 3–5.

Pinar, W. (1975). *Currere:* Toward reconceptualization. In W. Pinar (Ed.), *Curriculum theorizing: The reconceptualists* (pp. 396–414). Berkley, CA: McCutchan.

Pinar, W. (1978). *Currere:* A case study. In G. Willis (Ed.), *Qualitative evaluation* (pp. 316–342). Berkley, CA: McCutchan.

Pinar, W. (1994). *Autobiography, politics, and sexuality: Essays in curriculum theory, 1972–1992.* New York, NY: Peter Lang.

Pinar, W. (2004). *What is curriculum theory?* Mahwah, NJ: Lawrence Erlbaum.

Pinar, W. (2006). *The synoptic text today and other essays: Curriculum development after the reconceptualization.* New York, NY: Peter Lang.

Pinar, W. (2010). Introduction. In W. Pinar (Ed.), *Curriculum studies in South Africa: Intellectual histories and present circumstances* (pp. 1–18). New York, NY: Palgrave Macmillan.

Pinar, W., Reynolds, W., Slattery, P., & Taubman, P. (2008). *Understanding curriculum: An introduction to the study of historical and contemporary curriculum discourses.* New York, NY: Peter Lang.

Purcell, T. (1994). *Teaching children dance: Becoming a master teacher.* Champaign, IL: Human Kinetics.

Purcell Cone, T. (2009). Following their lead: Supporting children's ideas for creating dances. *Journal of Dance Education 9*(3), 81–89.

Reedy, K. M. (2007). Guardian of the dance. An interview with F. Horsley. *DANZ Quarterly New Zealand Dance, 8,* 14–16.

Reedy, T. (2003). Toku rangatiratanga na te mana-mātauranga: Knowledge and power set me free. In J. Nuttall (Ed.), *Weaving te whāriki: Aotearoa New Zealand's early childhood curriculum document in theory and practice* (pp. 51–77). Wellington, New Zealand: New Zealand Council for Educational Research: Te Rūnanga o Aotearoa mō te Rangahau i te Mātauranga.

Richardson, L. et al. (2005). *Bateman New Zealand encyclopaedia* (6th Ed). Auckland, New Zealand: David Bateman.

Rinaldi, C. (1998). Projected curriculum construction through documentation— *progettazione:* An interview with Lella Gandini. In C. Edwards, L. Gandini, & G. Forman (Eds.), *The hundred languages of children: The Reggio Emilia approach—advanced reflections* (2nd Ed.) (pp. 113–125). Westport, CT: Ablex.

Rinaldi, C. (2006). *In dialogue with Reggio Emilia: Listening, researching and learning.* New York, NY: Routledge.

Risner, D. (2007a). Critical social issues in dance education research. In L. Bresler (Ed.), *International handbook of research in arts education* (pp. 965–982). Dordrecht, The Netherlands: Springer.

Risner, D. (2007b). Rehearsing masculinity: Challenging the 'boy code' in dance education. *Research in Dance Education, 8*(2), 139–153.

Risner, D. (2008). When boys dance: Cultural resistance and male privilege in dance education. In S. B. Shapiro (Ed.), *Dance in a world of change: Reflections on globalization and cultural difference* (pp. 93–115). Champaign, IL: Human Kinetics.

Ritchie, J. (2001). Implementing a bicultural curriculum: Some considerations. *Early Childhood Folio 5,* 23–26.

Ritchie, J. (2008). Honouring Māori subjectivities within early childhood education in Aotearoa. *Contemporary Issues in Early Childhood, 9*(3), 202–210.

Ritchie, J. (2010). Kia mau ki te wairuatanga: Countercolonial narratives of early childhood education in Aotearoa. In G. S. Cannella & L. D. Soto (Eds.), *Childhoods: A handbook* (pp. 355–373). New York, NY: Peter Lang.

Ronai, C. (1992). The reflexive self through narrative: A night in the life of an erotic dancer/researcher. In C. Ellis & M. Flaherty (Eds.), *Investigating subjectivity: Research on lived experience* (pp. 102–124). City, CA: Sage.

Russell, J. (1975). *Creative dance in the primary school* (2ⁿᵈ Ed.). London, England: MacDonald & Evans.

St. Pierre, E. (2001). Coming to theory: Finding Foucault and Deleuze. In K. Weiler (Ed.), *Feminist engagements: Reading, resisting, and revisioning male theorists in education and cultural studies* (pp. 141–163). New York, NY: Routledge.

Sapon-Shevin, M. (2009). To touch and be touched: The missing discourse of bodies in education. In H. S. Shapiro (Ed.), *Education and hope in troubled times: Visions of change for our children's world* (pp. 168–183). New York, NY: Routledge.

Sasaki, B. (2002). Toward a pedagogy of coalition. In A. Macdonald & S. Sanchez-Casal (Eds.), *Twenty-first century feminist classrooms: Pedagogies of identity and difference* (pp. 31–57). New York, NY: Palgrave Macmillan.

Schiller, W., & Meiners, J. (2003). Dance—Moving beyond steps to ideas. In S. Wright (Ed.), *Children, meaning-making and the arts* (pp. 91–116). Frenchs Forest, NSW, Australia: Pearson Prentice Hall.

Schon, D. (1987). *Educating the reflective practitioner: Towards a new design for teaching and learning in the profession.* San Francisco, CA: Jossey-Bass.

Schubert, W. (2009). *Love, justice, and education: John Dewey and the utopians.* Charlotte, NC: Information Age.

Shapiro, S. (2002a). Introduction: The life-world, body movements and new forms of emancipatory politics. In S. Shapiro & S. Shapiro (Eds.), *Body movements: Pedagogy, politics and social change* (pp. 1–24). Cresskill, NJ: Hampton.

Shapiro, S. B. (1994). Re-membering the body in critical pedagogy. *Education and Society, 12*(1), 61–79.

Shapiro, S. B. (1998). Toward transformative teachers: Critical and feminist perspectives in dance education. In S. B. Shapiro (Ed.), *Dance, power, and difference: Critical and feminist perspectives of dance education* (pp. 7–21). Champaign, IL: Human Kinetics.

Shapiro, S. B. (1999). *Pedagogy and the politics of the body: A critical praxis.* New York, NY: Garland.

Shapiro, S. B. (2002b). The body: The site of common humanity. In S. Shapiro & S. Shapiro (Eds.), *Body movements: Pedagogy, politics and social change* (pp. 337–352). Cresskill, NJ: Hampton.

Shapiro, S. B. (Ed.). (2008a). *Dance in a world of change: Reflections on globalization and cultural difference.* Champaign, IL: Human Kinetics.

Shapiro, S. B. (2008b). Dance in a world of change: A vision for global aesthetics and universal ethics. In S. B. Shapiro (Ed.), *Dance in a world of change: Reflections on globalization and cultural difference* (pp. 253–274). Champaign, IL: Human Kinetics.

Shapiro, S. B. (2008c). Reflections. In S. B. Shapiro (Ed.), *Dance in a world of change: Reflections on globalization and cultural difference* (pp. 66–67). Champaign, IL: Human Kinetics.

Shapiro, S. B. (2009). Worlds of change: A vision for global aesthetics. In H. S. Shapiro (Ed.), *Education and hope in troubled times: Visions of change for our children's world* (pp. 184–197). New York, NY: Routledge.

Shapiro, S., & Shapiro, S. (Eds.). (2002a). *Body movements: Pedagogy, politics and social change.* Cresskill, NJ: Hampton.

Shapiro, S., & Shapiro, S. (2002b). Silent voices, bodies of knowledge: Towards a critical pedagogy of the body. In S. Shapiro & S. Shapiro (Eds.), *Body movements: Pedagogy, politics and social change* (pp. 25–43). Cresskill, NJ: Hampton.

Simon, J., & Tuhiwai Smith, L. (2001). *A civilising mission? Perceptions and representations of the New Zealand native school system.* Auckland, New Zealand: Auckland University Press.

Slade, P. (1954). *Child drama.* London, England: University of London Press.

Slattery, P. (1995). *Curriculum development in the postmodern era.* New York, NY: Garland.

Slattery, P. (2006). *Curriculum development in the postmodern era* (2nd Ed.). New York, NY: Routledge.

Soto, L. D. (1999). *Politics of early childhood education.* New York, NY: Peter Lang.

Soto, L. D. (2010). Constructing critical futures: Projects from the heart. In G. S. Cannella & L. D. Soto (Eds.), *Childhoods: A handbook* (pp. 375–379). New York, NY: Peter Lang.

Spivak, G. (1992). *Thinking academic freedom in gendered post-coloniality.* Cape Town, South Africa: University of Cape Town.

Spivak, G. (1993). *Outside in the teaching machine.* New York, NY: Routledge.

Springgay, S., & Freedman, D. (2007). Introduction: On touching and a bodied curriculum. In S. Springgay & D. Freedman (Eds.), *Curriculum and the cultural body* (pp. xvii–xxvii). New York, NY: Peter Lang.

Steinberg, S. (1996). Early education as a gendered construction. In W. Pinar (Ed.), (1999), *Contemporary curriculum discourses: Twenty years of JCT* (pp. 474–482). New York, NY: Peter Lang.

Steinberg, S., & Kincheloe, J. (2004). *Kinderculture: The corporate construction of childhood.* Boulder, CO: Westview.

Stinson, S. (1988). *Dance for young children: Finding the magic in movement.* Reston, VA: American Alliance of Physical Education, Health, Recreation, and Dance.

Stinson, S. (1990b). Dance and the developing child. In W. Stinson (Ed.), *Moving and learning for the young child* (pp. 139–150). Reston, VA: American Alliance for Health, Physical Education, Recreation, and Dance.

Stinson, S. (1991a). Dance as curriculum, curriculum as dance. In G. Willis & H. Schubert (Eds.), *Reflections from the heart of educational inquiry* (pp. 190–196). Albany, NY: State University of New York Press.

Stinson, S. (1991b). Reflections on teacher education in dance. *Design for Arts in Education, 92*(3), 23–30.

Stinson, S. (1991c). Transforming movement into dance for young children. In L. Overby Young (Ed.), *Early childhood creative arts: Proceedings of the International Early Childhood Creative Arts Conference* (pp. 134–139). Reston, VA: American Alliance for Health, Physical Education, Recreation, and Dance.

Stinson, S. (1995). Body of knowledge. *Educational Theory, 45*(1), 43–54.

Stinson, S. (1997). A question of fun: Adolescent engagement in dance education. *Dance Research Journal, 29*(2), 49–69.

Stinson, S. (1998). Seeking a feminist pedagogy for children's dance. In S. Shapiro (Ed.), *Dance, power, and difference: Critical and feminist perspectives on dance education* (pp. 23–47). Champaign, IL: Human Kinetics.

Stinson, S. (2002). What we teach is who we are: The stories of our lives. In L. Bresler & C. M. Thompson (Eds.), *The arts in children's lives: Context, culture, and curriculum* (pp. 157–168). Dordrecht, The Netherlands: Kluwer Academic.

Stinson, S. (2004). My body/myself: Lessons from dance education. In L. Bresler (Ed.), *Knowing bodies, moving minds: Towards embodied teaching and learning* (pp. 153–167). Dordrecht, The Netherlands: Kluwer Academic.

Stinson, S. (2005). Why are we doing this? *Journal of Dance Education 5*(3), 82–89.

Stinson, W. (Ed.). (1990a). Introduction. *Moving and learning for the young child* (pp. 3–4). Reston, VA: American Alliance for Health, Physical Education, Recreation, and Dance.

Sturken, M., & Cartwright, L. (2003). *Practices of looking: An introduction to visual culture.* Oxford, England: Oxford University Press.

Te One, S. (2003). The context for *Te Whāriki*: Contemporary issues of influence. In J. Nuttall (Ed.), *Weaving te whāriki: Aotearoa New Zealand's early childhood curriculum document in theory and practice* (pp. 17–49). Wellington, New Zealand: New Zealand Council for Educational Research: Te Rūnanga o Aotearoa mō te Rangahau i te Mātauranga.

Thwaites, T. (2008). Designing literacy education as modes of meaning in globalised and situated contexts: Towards a restoration of the self through embodied knowing. In P. Smith (Ed.), *The arts in education: Critical perspectives from teacher educators* (pp. 75–96). Auckland, New Zealand: The University of Auckland.

168 *Movement and Dance in Young Children's Lives*

Tobin, J. (2004). The disappearance of the body in early childhood education. In L. Bresler (Ed.), *Knowing bodies, moving minds: Towards embodied teaching and learning* (pp. 111–125). Dordrecht, The Netherlands: Kluwer Academic.

Trancossi, L. (2008). Introduction. In T. Filippini, C. Giudici, & V. Vecchi (Curators), *Dialogues with places* (p. 8). Reggio Emilia, Italy: Reggio Children.

Villaverde, L. (2008). *Feminist theories and education.* New York, NY: Peter Lang.

Villaverde, L., & Pinar, W. (1999). Postformal research: A dialogue on intelligence. In J. Kincheloe, S. Steinberg, & L. Villaverde (Eds.), *Rethinking intelligence: Confronting psychological assumptions about teaching and learning* (pp. 247–256). New York, NY: Routledge.

Walker, C. (2008). Dance inna dancehall: Roots of Jamaica's popular dance expressions. In S. B. Shapiro (Ed.), *Dance in a world of change: Reflections on globalization and cultural difference* (pp. 41–67). Champaign, IL: Human Kinetics.

Webber, M. (2008). *Walking the space between: Identity and Māori/Pākehā.* Wellington, New Zealand: New Zealand Council of Educational Research (NZCER).

Weikart, P. (2004). *Movement + music: Learning on the move, ages 3–7,* (3rd Ed.). Ypsilanti, MI: High/Scope Press.

White, J., Ellis, F., O'Malley, A., Rockel, J., Stover, S., & Toso, M. (2009). Play and learning in Aotearoa New Zealand early childhood education. In I. Pramling-Samuelson & M. Fleer (Eds.), *Play and learning in early childhood settings: International perspectives* (pp. 19–49). London, England: Springer.

Winnicott, D. W. (1999). *Playing and reality.* New York, NY: Routledge.

Wood, E. (2009). Developing a pedagogy of play. In A. Anning, J. Cullen, & M. Fleer (Eds.), *Early childhood education: Society and culture* (2nd Ed.) (pp. 27–38). London, England: Sage.

Woodson, S. (2007). Children's culture and mimesis: Representations, rubrics, and research. In L. Bresler (Ed.), *International handbook of research in arts education* (pp. 923–938). Dordrecht, The Netherlands: Springer.

Wright, S. (Ed.). (2003a). *Children, meaning-making and the arts.* Frenchs Forest, NSW, Australia: Pearson Prentice Hall.

Wright, S. (2003b). Ways of knowing in the arts. In S. Wright (Ed.), *Children, meaning-making and the arts* (pp. 1–33). Frenchs Forest, NSW, Australia: Pearson Prentice Hall.

Wright, S. (2003c). Arts education as a collective experience. In S. Wright (Ed.), *Children, meaning-making and the arts* (pp. 217–249). Frenchs Forest, NSW, Australia: Pearson Prentice Hall.

Wu, Y. (2005). Dancing with little spirits: A journey towards enhancement of pedagogical relationship and intersubjectivity in a third grade dance

education setting. Unpublished Doctoral Dissertation. Temple University, Philadelphia.

Māori Whakatauki retrieved from http://natswb.wikispaces.com/Whakatauki

Index

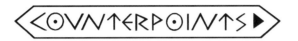

Studies in the Postmodern Theory of Education

General Editor
Shirley R. Steinberg

Counterpoints publishes the most compelling and imaginative books being written in education today. Grounded on the theoretical advances in criticalism, feminism, and postmodernism in the last two decades of the twentieth century, Counterpoints engages the meaning of these innovations in various forms of educational expression. Committed to the proposition that theoretical literature should be accessible to a variety of audiences, the series insists that its authors avoid esoteric and jargonistic languages that transform educational scholarship into an elite discourse for the initiated. Scholarly work matters only to the degree it affects consciousness and practice at multiple sites. Counterpoints' editorial policy is based on these principles and the ability of scholars to break new ground, to open new conversations, to go where educators have never gone before.

For additional information about this series or for the submission of manuscripts, please contact:

Shirley R. Steinberg
c/o Peter Lang Publishing, Inc.
29 Broadway, 18th floor
New York, New York 10006

To order other books in this series, please contact our Customer Service Department:

(800) 770-LANG (within the U.S.)
(212) 647-7706 (outside the U.S.)
(212) 647-7707 FAX

Or browse online by series:
www.peterlang.com